Affairs of the Art

KATRINA STRICKLAND

Affairs of the Art

LOVE, LOSS AND POWER IN THE ART WORLD

MELBOURNE
UNIVERSITY
PRESS

MELBOURNE UNIVERSITY PRESS
An imprint of Melbourne University Publishing Limited
11–15 Argyle Place South, Carlton, Victoria 3053, Australia
mup-info@unimelb.edu.au
www.mup.com.au

First published 2013
Text © Katrina Strickland, 2013
Design and typography © Melbourne University Publishing Limited, 2013

Every attempt has been made to locate the copyright holders for material quoted in this book. Any person or organisation that may have been overlooked or misattributed may contact the publisher.

Edited by Paige Amor
Cover design by Trisha Garner
Typeset in Baskerville 12/17pt by Cannon Typesetting
Printed in Australia by McPherson's Printing Group

National Library of Australia Cataloguing-in-Publication entry

Strickland, Katrina.
Affairs of the art: love, loss and power in the
art world/Katrina Strickland.

9780522858624 (pbk.)
9780522864083 (ebook)
Includes index.

Artists—Australia—Biography.
Decedents' estates—Australia.
Executors and administrators—Australia.

709.2294

This project has been assisted by the Australian Government through the Australia Council, its principal arts funding and advisory body.

Contents

Preface

It was only when I joined *The Australian Financial Review* newspaper in 2006, having covered the arts as a journalist for more than a decade, that I began attending art auctions as a regular part of my job. It was the perfect time for a reporter to enter this weird and wonderful world; in 2006 and 2007 a new record for the sale of Australian art at auction seemed to be set every few months. 'Seemed' is the operative word—the opaqueness of the auction process meant we had to take the auctioneer's word for it that there was a genuine bidder on the other end of the telephone, and that they would be paying the full price quoted. It was after seeing Helen Brack at one of these auctions, and realising that she did not like watching her husband John's work sell for millions, that I began wondering what life must be like for the widows of some of Australia's best-known artists. Lyn Williams, Wendy Whiteley, Barbara Tucker and Helen Brack were regularly mentioned in the same breath as their famous painter husbands, in reverential tones but also in less positive asides by auction executives, art dealers and curators. They seemed to be quite powerful, and resented for it. It was often they who stood between an art dealer and profit, wielding their copyright wand either to bless

or damn a painting, deciding to whom to give paintings and how much time to spend with curators in need of information in their bailiwick. Beyond what it was like to live with an artist, I was interested in what it was like now, having to deal with the business end of the art world, where creativity and commerce intersect, in not always the purest of ways. I couldn't help but notice those conspicuous by their absence, too. Alison Burton, the widow of contemporary painter Howard Arkley; Yvonne Boyd, the widow of Arthur; and Mary Nolan, who lived on the other side of the world, in a property on the border of England and Wales bought when Sidney was still alive. Why did they not seem as engaged with the Australian art sector as some of the others?

What began as a 2009 feature for *The AFR Magazine* turned into a book when Louise Adler, chief executive of Melbourne University Publishing, told me that she, too, had long been interested in the women who control the estates of our most prominent artists. Suddenly I was in the position of all of those curators and dealers, in need of something these people could grant or deny—in my case, an interview. The difference in how they responded was instructive. Barbara Tucker was the first to agree to participate in the book, inviting me around for a cup of tea and giving me *Bert and Ned* (2006), a book on Albert Tucker and Sidney Nolan, only to pull out ahead of the interview, explaining in the friendliest of manners that she just didn't have anything interesting to say. After two more interview dates were cancelled, I took her at her word, although the interview I did with her in 2008 for *The AFR Magazine* article—from which I quote in this book—stands as proof that she does have some thought-provoking observations. Lyn Williams was guarded and

super cautious, keen to know which of her quotes I was going to use and to ensure that they were correct. A reluctant participant, she was in the end generous with her time and information.

Drinking tea from a floral cup and saucer and eating short-bread direct from the packet with Helen Brack, whose dining room table was strewn with dried flowers on the day I visited, was a most enjoyable experience, her razor-sharp remarks making me think what an intellectual match she must have been for husband John. Ditto my morning with Yvonne Boyd, whose face lit up when I gave her a dog-eared photo of myself with Arthur in his studio at Bundanon, taken in the mid 1990s when I was there to interview him for a newspaper story. 'Can I keep this?' she asked. Yes, of course.

Wendy Whiteley barked, 'Why the hell would I want to do that?' down the phone when I asked her to participate in that initial 2009 magazine feature. Agreeing that she probably wouldn't, I got off the line as fast as I could. Later, when the book was on the boil, having met me a few times in the interim, she agreed and was great company, regaling me with stories as she smoked cigarettes and drank coffee in the kitchen of her Lavender Bay home. 'What on earth are you going to make of all that?' she said with a throaty laugh as she waved me out the door. With its blue-and-white crockery, white floorboards, Whiteley paintings on every wall and *that* view, the home is testament to the visual style Wendy brought to her partnership with Brett.

I felt privileged to sit with Alison Burton, Tess Edwards Baldessin and Huon Hooke, and hear of their grief at losing artists Howard Arkley, George Baldessin and Bronwyn Oliver respectively, and how this infused the way they dealt with their

estates. Each account was heartbreaking, but each of them has found a positive and effective way to deal with the challenges of their particular situation. I very much wanted to meet Mary Nolan and, after some written correspondence, agreed that I would ring her when I was in London with a view to travelling to her home, The Rodd, in Hertfordshire, for an interview. When I rang, however, she explained that she does not like rehashing old ground and had recently been quite unwell, and that it would not be possible. To push a woman in her eighties seemed churlish, so I left it. Her sister-in-law Yvonne Boyd was not surprised by her response. 'Mary likes it all to be kept private,' she said. 'I don't go in for it as a general rule, either, but you've been very nice. And look at me, I've been talking my head off.'

The central idea of this book is that how an artist's estate is handled can feed into their reputation. It's a mercurial concept that disappears every time you try to put your finger on it; for every instance in which it seems the case, there are alternative explanations for the outcome. Yet as a general proposition, provided not too much is made of it, it seems true.

It is worth stating here that an estate is finished when all of the assets are dispersed to its beneficiaries. Thus, in strict legal terms, the people in this book are not handling estates. Rather, they are handling the assets that came to them via the estates of their respective artists. But the term is used in the art world as a shorthand way of referring to an artist's copyright and remaining work. Thus, while not strictly legally correct, I have used the term this way throughout the book. I overcame the difficulty of distinguishing between couples with the same surname by referring to all artists by their surnames and all partners by their first names.

Among the aims of this book, I set out to paint a picture of a particular moment in time, when the sale of work by a handful of artists came to symbolise one of the greatest eras of wealth creation Australia has seen. To this end I have not explored any international artists' estates, which are on a much bigger scale and operate in a very different world. Nor have I taken an art historian's approach. I am a reporter, and have largely let people tell in their own words how it was. This in itself was fraught; one person's fact is another's fiction. Everyone remembers things differently.

This is not intended to be a definitive account of the most interesting or important artists' estates in the country, either. Every person I interviewed came up with someone new whom I really should see. In the end I had to stop somewhere. Within these pages are thus case studies, of which there are no doubt dozens more that are equally compelling.

As I talked to more people, in particular more women, I realised that their individual stories were just as compelling as their work building reputations. Many artists' widows are determined not to be defined by the reflected glory of their late husbands, and to ring-fence a job that threatens on occasion to engulf them. But, equally, they want to do justice to their late life partners, some of whom died prematurely and in shocking circumstances. The same applies to the men and children who are keeping the flame alive for their artistic relatives and friends. In the end, the human stories won out, as they so often do. As a result, this is as much a book about love, grief and survival as it is about power, duty and the machinations of the Australian art world.

Chapter 1

The Power of One

Never write a book about an artist until the widow is dead.
SASHA GRISHIN[1]

Gala exhibition openings are all about people, not paintings. Drinking champagne, nibbling on canapés and circulating through the room is the priority, as evidenced by the amount of time people spend in the function space. Want to take a closer look at the art? Come back another day.

For the host gallery it's all about thanking donors, dealers, sponsors and lenders. It's also about recognising the tireless toil of staff, usually run ragged in the lead-up to an opening and more desperate for sleep than champagne. So when Lyn Williams and Deborah Hart mounted the stage at the August 2011 opening of the National Gallery of Australia's *Fred Williams: Infinite Horizons* exhibition, the 600 people in the room knew that this was not the sideshow—this was the main event.

The two women were not on stage to speak—that job is left to the men who dominate institutions such as this—but to be

presented with giant floral bouquets. Hart curated the show (and had the red rims around her eyes to prove it), but as director Ron Radford made clear in his opening speech, it would not have been possible without the 'generous cooperation' and 'wise advice' of Lyn Williams, Fred Williams' widow. Over the previous three years Hart made many trips to Melbourne, where Lyn provided access to her extensive database of paintings, the artist's diaries, other archival material, and personal recollections from her 21-year marriage to Williams, who died of lung cancer in 1982, aged fifty-five. This was Lyn's night as much as Hart's. Holding hands, the two women bathed in an applause that extended beyond the merely polite.

Lyn Williams is not an outsider looking in, wheeled out for special occasions but otherwise living a life outside the art scene. To the contrary, she's the quintessential insider, a regular attendee at openings, someone who has sat on the governing councils of both the NGA and the National Gallery of Victoria, for a time chaired the Australian Centre for Contemporary Art, and is on the foundation that manages the McClelland Gallery and Sculpture Park on the outskirts of Melbourne. Over the past two decades she has judiciously organised selling exhibitions of her husband's work, and has donated art and cash to cultural institutions both in Australia and abroad. Auction house executives consult her for information and copyright approval whenever they have a Williams for sale. Lyn would be on the invitation list for most big art events in her hometown of Melbourne. As her friend and Brisbane dealer Philip Bacon observes, 'Since Fred died, nothing much happens in the Melbourne art world without Lyn being involved in one way or another.'

Most of the collectors, curators, gallery directors and art dealers at the opening of *Fred Williams: Infinite Horizons* knew Lyn Williams. They make it their business to know such women—and many of their businesses depend on it. Through a combination of good luck and good management, the widows of Australia's best-known modernist painters ended up guarding the treasure troves most valued by the Australian art market in the late twentieth and early twenty-first centuries. Many art buyers are not original in their taste—having more in common with sheep than lone wolves—and throughout the art boom that began in the mid 1990s and continued until the global financial crisis in 2008 it was works by Australia's post–World War II masters for which they paid most handsomely. Fred Williams, Arthur Boyd, John Brack, Albert Tucker, Brett Whiteley, Sidney Nolan; they're the artists many bankers, lawyers, doctors and stockbrokers wanted on their walls.

By the start of the twenty-first century, all of these artists had died—Williams in 1982, Whiteley and Nolan in 1992, and Brack, Boyd and Tucker in 1999. With art to disperse just when the market wanted it, their widows Lyn Williams, Mary Nolan, Helen Brack and Barbara Tucker, and Whiteley's ex-wife Wendy, have become powerful within the small and insular Australian art cosmos. It's an odd kind of power, one that reflects reciprocal self-interest rather than a broader cultural influence. They have paintings that dealers and institutions want, information that curators and scholars need, and the copyright control that allows them to dictate terms. It's a power that ebbs and flows with the market's appetite for their husbands' work, one that is intricately entwined with duty, and which is welcomed and resented in equal measure. As is often the case for those with something

someone else wants, it sees them courted and criticised, feted to their faces and on occasion bitched about behind their backs. An ever-so-polite dance goes on, with the dealers, academics and curators trying to get what they want—loans, gifts, information, copyright approval—and the widows trying to ensure that they're not taken advantage of in the process.

Contemporary art sales also grew rapidly during the extended boom of the 1990s to 2000s, with artists such as Howard Arkley, Bronwyn Oliver, Rosalie Gascoigne and Paddy Bedford in strong demand, albeit by a mostly younger, funkier collector. These artists, too, have died—Arkley and Gascoigne in 1999, Oliver in 2006 and Bedford in 2007. Fewer works were left in their estates than in those of Williams, Whiteley and Tucker; the market was so much bigger during the lives of these contemporary artists, and their period of production so much smaller. This has left those handling their estates in a less powerful position, but nevertheless facing many of the same issues as the wives of the mid-twentieth-century masters.

The artworks left behind when an artist dies are invested with multiple meanings. Beyond being the widow's most valuable potential income stream, they are a tangible repository of memories; the last physical proof of a lost loved one. Promoting the work now has emotional, financial and reputational spin-offs, so it's no surprise that the human tendency towards eulogising the dead, forgetting their foibles and emphasising their virtues, comes to the fore. Couples who were partly estranged, on the verge of breaking up, or even separated, can become very much together once the artist has died, the messy, difficult aspects of their life story pushed to one side. 'It's like being a super barrister, isn't it?' muses Barry Pearce, the former long-time

head of Australian art at the Art Gallery of New South Wales. 'The widow is the super barrister. You take on the case and you believe it.'

Questions of what to sell and when and how to sell it will arise, and if the artist is revered there will also be the issue of what to donate, when and to where. The federal government's cultural gifts program, which offers a tax deduction for works gifted to public collecting institutions, will become a useful way to offset the income earned from sales and thus reduce a tax bill. What to do with the studio, if and when to push for a book, a retrospective, a name on a gallery wall; these are all issues the widow will grapple with. The perennial problem of fakes may arise, and copyright concerns—when to allow usage and when to withhold it, when to charge and how much—will become a new constant in life. So, too, will the resale royalty, which mandates 5 per cent of the price of some works sold on the secondary market goes to the artist or their estate. Introduced in mid 2010, this royalty is coming in gradually. Over time it will put substantial monies into the pockets of the biggest sellers on the secondary market, and that means artists' estates.[2]

It is not only widows who are left with the privilege and burden of handling an artist's estate. In some cases, such as for sculptors Gascoigne and Robert Klippel, the artists' children have responsibility. In other instances a small group of close associates take on the role, as is the case for William Dobell, who never married or had children, and Bedford, an Aboriginal painter who lived in remote Australia. And in yet other cases control of an estate can unexpectedly land with an ex-partner. Huon Hooke had broken up with Oliver five weeks before she died but now handles the sculptor's legacy; Wendy Whiteley

took control of ex-husband Brett Whiteley's estate after their daughter Arkie died in 2001.

What these keepers of the flame do can have a real effect on the artist's reputation, as well as their own financial security. Do too little and the artist can drop out of sight and favour. When George Baldessin died in 1978 he was as well known and lauded in Melbourne as Brett Whiteley was in Sydney. A subsequent, devastating blow meant his widow, Tess, left Australia five years later, and did very little with the estate over the following two decades. She did not return permanently until late 2000, when she found that Baldessin had largely fallen from public view. Roger Kemp's wife, Merle, could not bear to part with many of his paintings after the artist's death in 1987; the couple's daughter, Michel, concedes that her job may have been easier if there had been a more consistent release of works from the estate in the first decade after her father's death.

On the flip side, if too much is done too quickly there is a risk of flooding the market and depressing prices. The lion's share of what was left in William Dobell's studio was sold off in a gala auction at the Sydney Opera House in 1973. While the sale did exceptionally well, Dobell's prices fell the following year. Add to this changing tastes and the fact that his best paintings are tightly held, and Dobell does not fetch anywhere near the prices of Brack, Williams or Whiteley at auction today. It may have been savvier to sell the works left in his studio over years, or even decades. Yet selling a large number of works slowly only succeeds in a rising market, and sometimes the buzz created around a single-owner estate sale can trump the steady-as-she-goes approach. Often there is no right answer, only 20–20 hindsight.

Melbourne art dealers Rod Eastgate and Jillian Holst have helped many families work through how to respond when the artist among them dies. They say it often takes a while for family members to realise that what they do with the artist's remaining work can make a tangible difference to his or her reputation, particularly if the artist is respected but not a superstar. The best thing for some pieces left in the studio is to make sure they never see the light of day. The studio is where an artist experiments, thus along with completed art there will be unfinished work and pieces the artist never intended to exhibit, either because they were working sketches or because the artist was not happy with them. Assessing what among all this should be put in front of the public, and how and when to do so, is the lot of those left behind. 'It's a full-time job,' says Eastgate. 'I often say, "Look, give up your part-time job. If you sell one painting, you'll make more money than you will from a full year's work. If you address these issues properly, sales will come to the fore and you won't need to work."'

The art market is an odd place, and it would be folly to judge a dead artist's reputation on prices achieved at auction. Yet this measure is not as insignificant as some in the public gallery sphere would have you think—those who see the market as being somehow dirty and the government-subsidised world clean. Like it or not, the two are part of the one ecosystem. When John Brack's 1954 painting *The Bar* fetched $3.1 million at Sotheby's in 2006 it set what was then a record price for an Australian artwork at auction. That was followed by a string of multi-million-dollar Brack sales, as opportunistic collectors consigned to auction paintings they had in some cases owned for decades, and traders tried to cash in on the interest. In the

wake of all this, but planned well before, the NGV held a Brack retrospective. That 2009 show attracted double the number of visitors the gallery had expected, making it one of their most attended solo shows by an Australian artist. Two years later, when the gallery polled visitors about their favourite works in its collection as part of its 150th birthday celebrations, Brack's *Collins St, 5p.m.*, 1955—which is often described as a companion piece to *The Bar*—came out on top. There's no empirical evidence to suggest that these successes were linked to the publicity surrounding the record auction prices, and *Collins St, 5p.m.* had long been a favourite of school groups visiting the gallery. Yet at the very least it's an interesting coincidence. A high profile often boosts public interest—why else do galleries employ public relations teams?—and while curators do not judge artists on their popularity, public demand can help ensure a permanent presence on public gallery walls.

More than once during the research for this book I was reminded of an observation made by former NGV director Patrick McCaughey in his monograph on Fred Williams: 'The reputation of artists, even the greatest, is a mysterious and unpredictable aspect of art history.'[3] It seems axiomatic, yet we so often assume without much thought that the artists who appear on gallery walls and in auction catalogues are, by virtue of being there, the best. But just as the artists get there on talent, but not talent alone, many factors will determine whether they stay there, and for how long. These include luck, changing public taste, how many works are left, the social standing of an artist's supporters and their influence in the art world, the degree to which other factors keep an artist in the public eye and, yes, the quality of the work itself. How the estate is handled feeds into

all of this. There are probably not many bad artists who stand the test of time, but there are plenty of good ones who fall into obscurity. Less so these days, argues McCaughey, thanks to the growth of the art market. There are many more artists trying to make a living from their art today than there were before the late-twentieth-century boom. So, too, are there many more dealers on the hunt for artists they can develop and promote.

McCaughey tells me:

> Art sorts itself out in the end. Don't you worry, the good, the bad and the ugly all go to the right boxes in the end. Some people get overlooked, like poor old Vermeer for 200 years. But in the end, and more so now in the twentieth and twenty-first centuries, people are looking, because there's such a huge market, which is devouring of Boyd, Nolan, Picasso, Pollock, whatever comes up. Dealers, auction houses, they look around for those neglected figures who are inexpensive and can be brought forward. On the whole, artists of the recent past, the past fifty to seventy years, are less likely to be overlooked than those who came before them.

Wendy Whiteley makes a similar point, albeit in saltier prose: 'There aren't too many geniuses suffering in garrets these days because there are too many fucking dealers looking for them, trying to unearth them from under the pile. It's always been the same, there's just a lot more of it now.'

It's one of those quirks of reputation that artists who were equally well celebrated in their lifetimes—Whiteley and Baldessin, Williams and Kemp—now have such vastly different

markets. This was starkly illustrated in August 2012, when Wesfarmers decided to sell fifty-four works from its renowned art collection. The Perth-based conglomerate had bought Roger Kemp's c. 1964–66 painting *Experience* for $36 000 at auction in 1988, the year after the artist died. When put back up for sale through Deutscher and Hackett in August 2012, the painting fetched only $19 200. A Fred Williams painting for which Wesfarmers had paid $101 500 in 1999 fetched $264 000 in the same sale. There are many reasons for the price differential, chief among them that Australian collectors favour figurative and landscape imagery over abstract art, and paintings on canvas (which the Williams was) over pieces like Kemp's *Experience*, which was paint on paper on board. But overarching all this is the fact that Fred Williams is now more sought after than Roger Kemp. Does that make him a better artist? Many authorities on art would not necessarily believe so.

How much the handling of the estates of these artists had to do with all this is impossible to quantify. Lyn Williams is referred to as the 'gold standard' for managing an artist's estate, primarily because she has kept Williams' work in the public eye through regular, and regularly spaced, exhibitions and donations. Michel Kemp has been much more cautious about selling, worried that if she sold all of the works the market wanted first it would leave gaps in the estate. That said, she has had a number of successful shows of her father's work. Perhaps something more fundamental has also been going on with the Kemp estate: a lack of prioritising sales. 'They were not commercially motivated, so for them it was never about money,' Michel says of her parents.

As a result of their now very different markets, the challenges for those handling the estates of artists who were once

contemporaries are also vastly different. Wendy Whiteley and Lyn Williams are in constant demand, batting away many more requests than they accept, while Michel Kemp and Tess Edwards Baldessin, widow of George Baldessin, have to argue a little more persuasively for, well, pretty much everything.

The difference is emblematic of the overall divide between the 'haves' and 'have-nots' in the art world. Everyone wants a piece of a highly successful artist's estate, and the minders of those estates have to decide where to place the finite amount of artworks left behind. But for the families of those less sought after—the vast majority of artists—it's more a question of 'Is there a market for any of this?' and 'What do we throw out?' Just as Vermeer and Van Gogh prove that what is considered junk today might be highly valued tomorrow, so too, closer to home, do artists such as Clarice Beckett. A Melbourne painter who was most prolific in the 1920s and 1930s, Beckett sold little in her lifetime but was rediscovered in the 1960s, three decades after her death. At that stage many of her works were found rotting in a barn in regional Victoria; today they are highly sought after and sell for tens of thousands of dollars. Public galleries have built exhibitions around her in recent decades, and many now regard her as the finest exponent of Max Meldrum's school of tonalism.

'Artists' families don't know what to keep and what not to keep,' says Helen Brack, who has managed the Brack estate since her husband John's death in 1999, aged seventy-eight. 'The minute you start throwing things out, if the artist later becomes desired, it's "Why did you get rid of that?"' For Helen, an artist herself, one of the most important jobs is defining what fits into the artist's oeuvre, or formal body of work. Brack did not

consider juvenilia, student work or work done before he became a qualified artist as part of his oeuvre, nor preparatory work or pieces done for friends or other obligatory reasons. 'There's always this terrible issue of memorabilia. Doodles on the telephone pad are nothing to do with the artist's work whatsoever, but lots of artists think differently, so a scribble before breakfast can be worth $10 000 after breakfast,' Helen says. 'If you think that anything the artist does is magic, and the community thinks that, then there you are. But I don't agree.' Helen is fighting a losing battle in this regard: public collecting institutions, particularly libraries, are interested in this kind of material as much as auction houses and the art-going public. Anything that shines a light on the artistic impulse is considered valuable these days.

As Lyn Williams chatted to people in the crowd at the NGA on that cold Canberra night in 2011, her Order of Australia pin glinting from the lapel of her long blue jacket, she didn't look ecstatic, but nor did she look unhappy. She looked a bit like the staff of the gallery; like someone who was working—saying hello to all the right people, receiving flowers, hugs and kisses of congratulations, and making sure she moved around the room. Was it difficult to be there, celebrating the life's work of a husband who died nearly thirty years before but who lived on, very palpably, through his art? She answered that question many months later, in her Melbourne home: 'Of course. You're hoping that he's been done justice, or at least that it's the best it can possibly be,' she says. 'It's very emotional, it's very draining to look at all those things again.'

Some of the widows interviewed for this book are regularly described as 'tricky'. As one gallery director said, 'some of them are wonderful, others are nightmares'. Another coined the term

'complicated selfishness' to refer to their way in the art world. The most powerful among them are well used to controlling information and image, to dictating the terms of engagement with everyone from authors to dealers and curators. It is definitely their way or the highway. But put more positively, 'tricky' is making sure that things are done properly, that you are not taken advantage of by an avaricious art scene, and that you control the parts of your life story that are put out for public consumption. Barry Pearce ponders whether the widows get a reputation for being overly controlling because in their position it's mandatory to be careful—about everything, including whom they trust. 'Maybe the widows have to be like this,' he says. 'Dealing with agents, with people who sell pictures, they're not all squeaky clean. You have to put your armour on.'

Helen Brack calls the handling of an artist's estate 'a custodial duty' and says that on occasion the families of artists do resent it. Barbara Tucker calls it a privilege, but not an easy one: 'I was never groomed for this kind of thing. You can't do a course in it.' Married to Albert Tucker for thirty-five years, she says artists' wives often get a bad reputation that is undeserved. 'I would screen any phone calls that came in because he didn't want to be interrupted. People ring up and treat you as if you're the maid. I'd say, "Look, can I help you? He's busy." "Oh no, he'd want to speak to me," they'd say. I'd ask who they were, and it would be someone he'd never heard of, so I'd know he wouldn't want to speak to them. Sometimes they'd get quite irritable, as if I was being an interfering wife, not knowing that I had strict instructions not to interrupt.'

Even before Tucker died in 1999, Barbara knew she didn't want the responsibility of becoming the major beneficiary of his

estate. In 2008, sitting in the lounge room of her home in one of Melbourne's more affluent suburbs, with striking Tuckers lining the walls, she recalled a fight they had only a few weeks before he died, in which she asked him not to leave anything to her in his will. 'Then five minutes later I'd say, "Do you want a cup of tea, Bert?"' she said with a laugh. 'It sounds horrible, people would say what a horrible woman she must be. But it is interesting that it was on my mind even then—don't leave me anything, I don't want the responsibility. And it is an enormous responsibility, it really is. I'm not complaining, but I just wish I didn't have quite as much to do as I have. But again, I wouldn't want to be doing nothing.'

Mary Nolan has had her share of drama over the handling of the estate of husband Sidney Nolan. The artist sold well during his life, and had already donated many works to a range of public institutions by the time of his death in 1992. But such was his productivity—Nolan is estimated to have made as many as 35 000 works—that there were still many pieces left in the estate. London art dealer Julian Agnew successfully sold works from the estate in the 1990s. He wanted to sell the remaining works slowly, pricing them high and keeping many of the best pieces aside for sale over the longer term. Mary, however, was keen to get on with her life in Herefordshire and had a big tax bill left by Nolan to pay off. She wanted it all done sooner than this. She took the estate away from Agnew and turned instead to Sotheby's, consigning ninety-five works to the auction house for sale. That 2001 Melbourne sale grossed $4.4 million on an impressive clearance rate of 98 per cent by lot, allowing her to pay her bills. The auction was clouded with uncertainty, however, as Jinx Nolan—the artist's adopted daughter by his previous

wife Cynthia—claimed ownership of three of the paintings up for sale. Jinx tried unsuccessfully to get an injunction to stop the sale, and in 2003 lost a court battle over them. Justice Julie Dodds-Streeton of the Victorian Supreme Court—coincidentally married to one of Arthur Streeton's grandsons—decided that the three paintings in dispute, which had sold for an aggregate $700 000 at Sotheby's, had indeed been owned by Mary.

Agnew read about the court battle in Australia with great interest. Declaring himself one not to hold a grudge—for many years he says he still sent Mary a Christmas card—he is sympathetic to the circumstances in which the widows of all famous artists find themselves.

> The widows are in a funny position. They're not the creators of the work, but they're often more feudalist than the king. Suddenly they're landed with moral and financial responsibility—they're guarding the house, the treasures, the memory, the reputation, and at the same time they have to deal with the brutal realities of the commercial art market, and their own grief and personal lives. It requires a very steady head and hand to navigate your way through these difficult waters.

Chapter 2

Before the Widow Comes the Wife

In a way it's about the poetic thoughts, the notion that you were there when something quite wonderful was happening and you happened to be holding the hose. What price that?

RAY HUGHES[1]

Gallery director Stuart Purves often laughs when he meets someone who says they're an artist. 'Oh really?' he replies, thinking to himself: If you really knew what it was to be an artist, you'd run for the hills. True artists, he has concluded after a lifetime surrounded by the breed, live at a quarter to midnight. When and if they reach the magical hour, it's often all over. 'Some die, others disappear, others still turn to drink.'

Purves' parents, Tam and Anne, established Australian Galleries in 1956 in Melbourne's Collingwood, a suburb that was not then the upwardly mobile place it is now. Their gallery became a meeting place for many interested in art, and an important part of the cultural landscape, representing Arthur Boyd, Sidney Nolan, Albert Tucker and John Perceval, and later

John Brack, Fred Williams, Brett Whiteley, John Olsen and, for the last thirty years, Jeffrey Smart. Purves joined the family business in 1966 and has owned and run it since his mother died in 1999, representing mostly contemporary living artists and a handful of modernist estates. He is one of only a few gallerists with spaces in two cities, in his case Sydney and Melbourne. A larger-than-life character, he gets about in a red ute with a tiger emblazoned across the bonnet and 'Art' written down the sides. He's partial to bright red shoes, too, and for more formal occasions, a lacy white shirt worn under a long, black, collarless jacket. Always running to a tight schedule—the words 'we must sit down and chat' were uttered many times before we eventually did—he's one of those people you assume will trot out patter to suit his business objectives (praising the widows he deals with, careful not to say anything too controversial), but who surprises with his frankness. If his take on the life of an artist sounds bleak, his view on the wife's role is even more so:

> The wife during the lifetime of an artist, it's a very particular role, and not pretty in a lot of cases. They have to bear the brunt of the spirit and personality of a creative person, and it's often irrational. They are incredibly protective, and incredibly important. They are the editor. And I think the fury that is lashed upon them by a creative person out of sorts must be appalling.

It would be naïve to think that such generalities apply to all artists and all artists' wives, but by the same token, what Purves says will have a ring of truth to many. Families, lovers and friends are often fuel for and collateral damage in the face of an

artist's all-consuming *raison d'être*. In a 2009 documentary about Sidney Nolan, film-maker Storry Walton observed of Nolan's three wives: 'Most of the women in his life saved him from burning out, because Sid was mercurial, and mercurial on its own can burn itself out.'[2]

Curator Barry Pearce has a similar take to Purves on artists and their home lives, stomping on the notion that they should necessarily be good fathers, husbands, wives, mothers, even friends. He's not giving absolution, or saying that many don't fulfil those roles admirably. Rather, he's pointing out that society's rules of engagement have always been flouted, entirely or in part, by its most creative members: 'It's like Baudelaire writes: flowers grow out of shit,' Pearce says. 'Artists are often ruthless, narcissistic, egomaniacs. But somehow out of that comes a magic.'

A gentle man with blond hair and glasses, Pearce understands the artist's temperament because he has some of it himself. It's the case with many dealers and curators. Pearce studied art in Adelaide and London, but chose to curate rather than practise as an artist. Since retiring in late 2011, however, he has discovered a renewed urge to put marks on paper. 'I have this niggle going on. When I look at a sketchbook I want to pick it up and sketch in it,' he says, surprised by the impulse. 'It's just come out of nowhere. I've had this curatorial, intellectual life for forty-odd years, and yet it's come back as if it's been implanted in my bloodstream. I'm almost embarrassed to admit to it.' Over his thirty-three years at the AGNSW, thirteen of which were spent as head of Australian art, Pearce became close to a lot of artists and their families. Margaret Olley was something of a mother figure to him, and when she died at her Paddington

home in Sydney in mid 2011, aged eighty-eight, Pearce was floored with depression. Olley never wanted another partner after the death of her great love, Sam Hughes, in 1985. She suffered her own depression, for which painting was a partial fix. 'She talked about having the grim reaper on one side, and the black dog on the other,' says Pearce. 'The sun would shine on the flowers and then she would feel better, saying, "The world is lovely and I can still paint." That was her pick-me-up, to pick up the brush. She did it the night before she died.'

Pearce is also close to Wendy Whiteley, with whom he co-curated the AGNSW's 1995 Whiteley retrospective and whom he has interviewed extensively for an as-yet unpublished memoir. He also worked with her on the Brett Whiteley Studio, the artist's final work space in Surry Hills, Sydney, which the New South Wales Government bought from the Whiteleys' daughter, Arkie, in 1993. Where others see difficult women, Pearce's take on the wives of artists is more nuanced and forgiving. This is particularly so for Wendy, whose lacerating tongue has made some in the small Australian art world either fear or loathe her. Not so Pearce, who says Wendy left Whiteley when she realised that she needed to get off heroin, and that he wouldn't, or couldn't. Where some see her control of the Whiteley legacy as ironic, given their acrimonious split years before his death, Pearce sees it as a remarkable act of forgiveness:

> She decided to save her life by separating from him. He was on a voyage to the damned, with his drugs. He refused to believe he could never stop. 'I could stop anytime I want,' that was Brett. She could see the fork in the road, death or life, so she went her own

way, with this baggage of resentment about how he'd fucked her up, fucked her life over. Yet in the end, she has come back to save his reputation. That is the really extraordinary thing about her, this loyalty for the talent. Her belief in him as an artist never wavered.

Belief in the brilliance of the artists with whom they shared their lives is present in all of the partners and children of artists interviewed for this book. It is perhaps necessary to survive the ups and downs, to believe that the artist is creating something that transcends the everyday and will grant immortality. In many cases that certainty about a partner's talent was there long before the public recognition.

Lyn Watson was a primary school teacher in her early twenties when she met Fred Williams. It was 1960, and the artist had only a few years before returned from five years in London, where he had trained at the Chelsea School of Art and studied etching at the Central School of Arts and Crafts. Before that he had studied at the National Gallery School in Melbourne—he enrolled in night classes when he was only sixteen—and with George Bell in Melbourne. This extremely long apprenticeship meant that Williams, who was nine years older than Lyn and now into his thirties, was keen to get on with things, both in terms of his career and his personal life. The couple married in 1961. When asked whether she was worried about signing up to the precarious existence of life with an artist, Lyn indicates that, even then, she believed in his talent:

> There was a fair bit of discussion about it. But I saw how other artists were surviving, and I just felt that what he

did, there was something about him, and the authority with which he worked. I just somehow believed that that part of it would work out, that he would get by. He always said: 'It will be an interesting life, but there probably won't be a living in it.' As other artists seemed to survive with teaching and various other jobs, I knew that if need be, something like that would happen.

Melbourne accountant Tom Lowenstein believes that most artists want someone to take the onus of handling their business affairs from them. A small man with wire-rimmed glasses and a warm manner, Lowenstein built his practice being that person. He has provided financial advice to a wide range of artists since the 1970s, and formed the Australian Artists Association in 1984 to lobby government for better tax breaks and other incentives. He says that wives and husbands often help to fill the administrative role. 'The real artists have always needed someone like a good partner who has a more practical approach,' Lowenstein says. 'That's one of the things I've found very interesting, that most artists somewhere along the line select a spouse who is more practical than they are.' For the wives of many of Australia's best-known, mid-twentieth-century painters, this meant taking on some combination of being bookkeeper, housekeeper, personal assistant, chauffeur, emotional crutch, child minder, gatekeeper, and first editor and critic. This has changed, as the role of wives in general has changed, such that today's artists might well have a wife—or husband—pursuing their own career with as much vigour as the artists themselves. But for the women who handle the estates of some of the most celebrated Australian artists, being the artist's wife was a job in itself.

Michel Kemp says her mother Merle 'wrote all the letters, negotiated the exhibitions and the work, and would have done the tax' for her artist father Roger, leaving him to focus almost exclusively on his art. He didn't drive, didn't cook and didn't think much about sales. She says:

> With that generation of modernists, the committed, passionate artists, the art took up their whole life. They didn't seem to have the business acumen that later generations are trained in, now that art education has shifted from the tech colleges to the universities. Normally they had a wife or someone looking after them. A lot of those women were actually feminists, too. It wasn't a subservient role, it was teamwork.

Lyn Williams also adopted the traditional role of artist's wife, doing the books, typing letters, keeping house, raising their three daughters and—given that Williams, like Kemp and a number of other artists, never got his driver's licence—driving him around when needed. She took on the bookkeeping after discovering that Williams would get his group certificate from the picture framers where he worked, but never bother to lodge a tax return. 'He didn't believe it was necessary,' she says. When the youngest of the three Williams girls went to school, Lyn considered returning to primary school teaching, but did not. '[Fred] was anxious about how the household would be managed, the bookkeeping and so on. He knew that I tended to do things fairly wholeheartedly,' she says. It was resolved when the family accountant told Williams that he should pay his wife a salary for her work. 'It gave my role a bit more dignity,' she

says now. 'As it turned out, when Fred became ill, my experience and knowledge of all that administration, and dealing with Rudy [Komon, Fred's dealer] on the commercial side, was certainly a big help.'

Helen Brack is quick to point out that artists' wives in her day were no more supportive, or special, than the wives of other working men:

> Over the course of my life, I've had lots of people wanting to say we're the forgotten heroes, raising the children and so on, but I've always disagreed. In this street, particularly when we first came here in 1957, every wife was supporting her husband in whatever it was that he did. I was in awe of some of the women in this street. There was a family that had the lolly shop on the corner that isn't there anymore, and she was marvellous. She did the books, everything. There was a plumber further up and his wife was wonderful, too. You supported your husband, not because of any goodness, but because it was in your interests. It was terribly much in my interest that John was a success; he wouldn't have taken kindly to not being. I would have had to cope with the grumps, you know. It seems silly to say that artists' wives were particularly supportive. Most wives were like that in other fields. It was just what you did.

Seven years Helen's senior, John Brack was already twenty-six, and a rehabilitation student after six years in the army, when he started studying art at the National Gallery School, where

Helen was also studying in the mid 1940s. The couple married in 1948 and by 1954 were raising four daughters. Throughout their marriage they both pursued their art in tandem with other responsibilities—in Helen's case raising their girls, in Brack's teaching art at Melbourne Grammar and then the National Gallery School, which he eventually headed up. Brack joined Rudy Komon's stable in the late 1960s, and it was only at that stage, as he neared fifty, that he could quit his job as head of the National Gallery School to concentrate full-time on his art. As with many of his artists, Komon paid Brack a stipend that the artist returned via works from subsequent shows and commissions on sold paintings. Helen highlighted her role as 'bad cop' in a eulogy for her husband, written shortly after his 1999 death. Komon's deal was 'to finance John for a year, then to have a show in Sydney taking two pictures as part repayment, the remaining debt to be taken from commission on sales. Rudy required no restrictions other than deliverance of the work.' However, nothing sold from Brack's end-of-year show, nor the next year, causing Helen some concern because the debt was mounting. 'Against John's wishes I had it out with Rudy,' she writes. The following week Rudy telephoned Brack and said, 'Tell Helen everything is all right. I have made a sale to the Tasmanian Gallery, the papers will come and you will sign and the money will come.' The only catch was that the picture 'belonged to Rudy—it was one of those taken as part repayment from the first exhibition and sold for considerably more than the original price'. Brack did not have his first sell-out show until 1980, more than twenty-five years after he started painting. When he did, his response was that he must be doing something wrong. He stayed with Komon until the dealer's

death in 1982. 'He was amazing. He and John were an equal match of humanity, deviousness and antagonism,' writes Helen.[3]

Life was tough in the early and mid careers for this generation of artists, with financial security—and indeed great wealth—coming relatively late. This is explored evocatively in *Glass After Glass: Autobiographical Reflections*, the 1997 memoir of Barbara Blackman, the former wife of artist Charles Blackman. Barbara notes that 'sales of paintings were rare, swapping was more common' and thus wealth wasn't generated in a monetary sense. 'Among ourselves we knew that a lot of the paintings were good, but nobody in their wildest imagination contemplated a latest model Mercedes car, sales to the Tate, high-price sell-out exhibitions and celebrity status, London houses and whirlwind European trips as a possibility in ten or twenty years' time.'[4]

It's not that paintings weren't collected in the decades up to the 1970s and 1980s. The portraits of William Dobell and the rural depictions of Russell Drysdale and Arthur Streeton all sold well in the artists' lifetimes. But for those young artists pushing into new territory after World War II, sales were a bonus, a day job mostly a necessity. 'That was the art world at the time. Very few people were able to survive from their painting, and that wasn't ever the expectation,' says Lyn Williams. 'You knew there would have to be supplementary jobs.' Williams was nearly forty when he had his first sell-out show. Albert Tucker, thirteen years older than Williams, had been painting for nearly three decades when, in his late forties, he returned to Melbourne after eleven years abroad and had his first successful Australian show, in 1962. His survival during the 1940s, when he painted his most renowned series, *Images of Modern Evil*, depended on the generosity of John and Sunday Reed, whose home Heide,

on the outskirts of Melbourne became a hub for many artists of the time, including Nolan, Perceval and Tucker. The Reeds provided Tucker with a weekly stipend until he left Australia.

Barbara Blackman saves some of her best barbs in *Glass After Glass* for the Reeds, noting 'the wisdom of Sunday Reed was that artists should not have wives'. Perhaps they threatened her role as a muse, she writes. Barbara Blackman and Wendy Whiteley both fulfilled the role of muse, Wendy featuring most famously in Whiteley's languid *Bathroom* series, done in the 1960s when the then newlyweds were living in London, and Barbara in Blackman's *Alice in Wonderland* paintings. It's no wonder then, when visiting a Blackman exhibition long after she had separated from him, that Barbara felt she was in the presence of 'my own Rosetta stone'.[5]

Despite having gone to art school, Wendy did not pursue her own painting during married life. She worked in boutiques in the couple's early years, but for the most part her creative outlet was the house, styling the tableaux Whiteley painted in Lavender Bay, and helping him hang shows. 'There was no way I could have lived with Brett and painted at the same time, because there were other things to do,' she says. As to whether it would have worked to have two artists in the relationship: 'I've never seen it work … but it was never of concern to me.'

Yvonne Boyd is another artist's wife who, despite going to art school, did not pursue her own art after her 1945 marriage to Arthur Boyd. Yvonne Lennie was working in a bank and attending weekend art classes in 1942 when she met Boyd. She had won a prize for drawing at the National Gallery School night classes she took in the late 1930s, but deflects any suggestion that she also had talent:

I couldn't make it work as a career; I wasn't in the league where I could have had exhibitions and made any money at all. I probably hadn't pursued it properly, not very purposefully. I went to the gallery school, but I worked at the bank, and I couldn't really pretend that I wasn't. I'd like to have pretended that I really wasn't working in a bank, that I was an artist. [But] we night students weren't regarded with much respect. We weren't real artists, we were just night students. When I was with Arthur I did the odd bit occasionally, but it just faded away, I'm afraid to confess. Shameful thing to confess nowadays, that a woman would do that, but it's a sort of confession of the norm, in a way.

Certainly nobody kept her from painting; that was her own doing, she says, fuelled by circumstance. 'Arthur would have been most encouraging, and he probably was,' she says. 'Oh, he wouldn't have minded. He would have been extremely encouraging, but I think having children superseded the whole thing.' Encouragement seems to have been one of the magic ingredients of the Boyd artistic dynasty, which began with Arthur's artist grandfather Arthur Merric Boyd. All three of Boyd and Yvonne's children are artists, as are their nine grandchildren, some in music or acting rather than the visual arts. Yvonne was not pleased when an art dealer told her son Jamie to stay away from landscapes. 'Silly man, if he'd let a few landscapes in they would have both been better off … Jamie does lovely landscapes.' Boyd would often ask Yvonne for her view on his work but, she tells me, she would never respond by saying a painting was no good:

Oh no, I couldn't say that, I would never say that.
I might be uncertain or surprised, and could sound like
that probably, but I was a professional encourager I
think. I didn't want to distract him by being negative
in any way. If I saw the finished thing, I'd be pretty
appreciative usually. I might be amazed—some of them
were very strange.

Like Helen Brack, Yvonne doesn't want too much made
of her contribution to her late husband's work or reputation.
Be careful not to overplay the role of the wives, she says, 'We
really didn't do that much. My influence was simply to be there
as an encouraging one. I had no part in finding avenues for the
work to go, because he was quite able to do all that. I was useful
now and again doing the odd message.' Those who have studied
the Boyd family rate her contribution more highly than that,
however. In her book on the Boyd dynasty Brenda Niall quotes
a London friend who says that Yvonne was 'the perfect artist's
wife—and nice as well'. Niall makes her own summation: 'In the
demanding role of artist's wife her strength was that she under-
stood and identified with Arthur's work, and that in their long,
loving marriage she neither worshipped nor infantilised him.'[6]
Darleen Bungey also explores Yvonne's contribution in her 2007
biography, *Arthur Boyd: A Life*. Bungey details Yvonne's multi-
faceted role in the artist's working life and, like Niall, records
that Yvonne got sick of people describing Boyd as an innocent.
Bungey writes:

Apart from raising the children, bolstering their income
with part-time jobs, and taking language and literature

courses through the 1960s, Yvonne was Arthur's amanuensis. She deciphered the hieroglyphics of the replies he scrawled across incoming correspondence; she typed his dictated letters, wrote the rest herself, kept the books, booked the transportation of works to exhibitions and galleries around the UK and across to Australia; she organised family, friends and the days and nights around Arthur's schedule.[7]

Melbourne art dealer Lauraine Diggins names Helen Brack and Yvonne Boyd as the two artists' widows she most admires, in part because they are interested, but not interfering. Diggins has a gallery in a suburban street in North Caulfield from which she deals in Australian art ranging from colonial through to contemporary, including Indigenous. A regular at art auctions, and selling to clients beyond her home base, she has been observing artists and their wives since first entering the fine art business in 1974:

Neither of those artists made bundles of money for many years, so there had to be a really strong, cohesive family unit, and understanding, for them to do what they did. The women were selfless, I think, because it's not an easy life. They're women I respect a lot. They haven't in any way tried to change or control the direction of their husbands' estates, or how the public views their husbands. They're not interfering. I haven't had much dealing with either of them, but if I needed help I would have absolutely no hesitation in picking up the phone and ringing them. They have an open

door. There's an understanding of sharing the legacy
their husbands left behind.

Helen Brack is one who has pursued her own art, exhibiting
throughout her marriage and beyond under her maiden name,
Helen Maudsley, and since 2000 through Bill Nuttall's Niagara
Galleries in Melbourne. While represented in some public collec-
tions, Maudsley has not received the public accolades or prices
of Brack. Her abstract, geometric paintings sell for between
$2000 and $35 000, his into the hundreds of thousands and in
some cases millions of dollars. Hers do not have permanent wall
space in the country's most prominent public galleries; his do.
But if there was any competitiveness between them, she does not
display it. 'No, it wasn't like that; it wasn't competitive in any
way,' she says firmly. 'We were doing very different things, and I
think if you're doing very different things, it doesn't matter.'

She is insightful about the psychological challenges faced by
artists, who must believe in themselves but not too much, and
for whom success can be a double-edged sword. 'The trap of
being so much admired that you admire yourself. Nearly all
artists somewhere along the line have to face that issue, until
they realise they are fancying themselves, and fancying yourself
just doesn't do,' Helen says. 'When John went to teach at the
gallery school he came home one day and said, "I can't bear it.
There are all these raw, rude, raucous smart-arsing boys there,
who all think they're great artists, and I have the most horrible
feeling that I'm looking at myself." That was the most salutary
lesson to him, but that's how you mature.' The flip side is that
if you don't believe in yourself as an artist, 'it's very hard to
have the faith to go on'. She continues: 'You need traction in the

community to not feel like a charlatan. Freddie [Williams] was always talking about the charlatan—obviously he was frightened about that. We're all frightened of being charlatans.'

Art historian Sasha Grishin believes the fact that Helen is an artist gives her an advantage in managing Brack's estate, because she has a visual literacy that not all in her position possess. Professor of Art History at the Australian National University, Grishin says:

> She looks at a work and will say that's not very good—her husband's work or her work; she has that perspective of being able to see it. Sadly, people who are not very visually literate would not know a good picture from a bad one, and why would they? It's like asking which sort of fighter jet the Australian air force should buy. If I say the red ones, they're sexier, it doesn't make much sense. If I said that, everyone would laugh at me. Unfortunately if people said that about art, no one would laugh at them. The professionalism isn't necessarily respected.

These days, when people ask Helen what she does, she likes to say she runs a mixed business. It is perhaps surprising to hear that despite the central role of art in her life, she would not advise anyone to take it up. 'I would never recommend it to anyone. If they want to be a serious artist, don't, because it's a stupid thing to do,' she says emphatically. 'I really do think that. I think it's unhealthy in that there isn't any interaction. If you're in the medical or teaching fields, you get interaction. In nearly all other fields there's a real interaction between the public and

you. But you don't get that in the art world.' But what about critics, curators, viewers—surely that is tangible interaction? 'Very little art writing reflects actual thinking about what the picture is. They're always just thinking about whether it's good or bad, whether they like it or don't like it.' Not for Helen, either, the notion that art chooses a person, that it's a calling one can't resist. 'Everyone can make choices; you don't have to do things.' Why continue then? 'Once you've done twenty years you're too far in to get out, really, so you just continue.' Does she at least, in some way, love it? She's enjoying confounding expectations. 'No, I don't love it. I just notice things in the world, and write visual essays about them. It's work, it's frustrating, it's a job to be done as well as I can do it. It's not a pastime.'

At the other end of the spectrum are partners who happily stayed out of the studio. One such wife was Barbara Tucker, who met Albert Tucker in 1961 when his career was already nearly three decades in. Tucker had been painting and exhibiting since 1933, and had recently returned to Australia after many years in Europe and the United States when he met Barbara. Both had previously been married, Tucker for eleven years to the artist Joy Hester. Barbara's role was as an emotional support, a life partner who had her own jobs and interests outside the art world. Barbara worked for most of their 35-year marriage, as a film librarian in New York in the late 1960s, then in the book industry back in Melbourne, including running her own bookshop in Carlton until 1992. Tucker did not encourage her, nor anyone else, to enter his studio: 'He was a very private painter, he didn't like people observing him work,' she says. 'I'd drop in with a cup of tea or to ask him something, but I never commented on what he was doing, and he knew that I wouldn't, because that would

put him off. I didn't act as a critic for him; I don't know anything anyway, so he probably wouldn't have taken any notice. So I think I was a strength to him, but I wouldn't say I played a vital role, apart from being his wife.'

Nor was Huon Hooke involved in the development of the work of contemporary sculptor Bronwyn Oliver. Oliver came to prominence in the 1990s and 2000s, her intricate copper sculptures becoming highly sought after by private collectors, companies and public institutions alike. Huon is a wine writer for a range of publications, including *The Sydney Morning Herald*, and his own career was very busy, and very separate from that of Oliver. While he sometimes helped Oliver name her works, many of which reflect items from nature such as seed pods, plants and vines, he was no muse and was seldom involved in the creation of her sculptures. Nor was he the bookkeeper, organiser, chauffeur or first line of defence in keeping people out. Oliver did not fit the stereotypical concept of the disorganised artist; to the contrary, she kept an electronic database listing the details of every work she made, complete with pictures. She did not need a partner to take on that role. 'A lot of artists completely neglect record keeping and filing and stuff like that, but Bronwyn was incredibly neat and organised,' Huon says. What Huon did provide, until their 22-year relationship began to unravel, was a reliable presence for a woman who liked her solitude. On many days Oliver's human contact extended only to her Sydney art dealer, Roslyn Oxley, and the workers at the foundry that produced some of her larger-scale pieces. Huon recalls: 'I'd go away for a week on a wine trip and I'd come back and say, "Who have you seen this week?" She'd say, "No-one." I'd say, "How can you not have seen anyone for an entire

week—have you spoken to anyone on the phone?" She'd say, "No, only Roslyn." It was an incredibly isolating existence.' The importance of that emotional support became all too clear when Huon decided to leave the relationship, and the couple's home, in May 2006. Five weeks after the split, Oliver took her own life. She was forty-seven.

Despite discovering other things that contributed to Oliver's state of mind at the time of her suicide, including possible copper poisoning, the inevitable guilt for Huon was shattering. 'Your rational self knows it wasn't your fault, and that it could have happened either earlier or later, or in entirely different circumstances, but you know the action you took led to the state of mind that caused the death, and that's pretty hard to accept.' He adds by way of afterthought: 'I'll never forget how completely unforgiving Patrick White was of Sidney Nolan when [Nolan's second wife] Cynthia took her own life. I think White was probably just a bastard really. He was a sensitive soul, though, he should have understood that these things are not necessarily one person's fault.'

Alison Burton is another whose presence was crucial to the wellbeing of the artist, in this case contemporary painter Howard Arkley, with whom she spent the 1990s. Alison conformed to the more traditional role of artist's wife, in that she helped organise Arkley's life inside and outside of the studio, where she worked as his assistant. The third of Arkley's wives—she jokes that he liked to call himself a 'serial monogamist'—she was a school teacher in her late thirties when she enrolled in a fine arts course at Melbourne's Moorabbin TAFE. Arkley, a professional artist who had been showing at Tolarno Galleries since 1975, was one of her teachers, and it was shortly after she finished

her course that they got together. She was happy to support his talent, including working with him on his creations for the 1999 Venice Biennale, where he was Australia's representative artist. She says:

> I wasn't teaching. I did odd jobs here and there, I did some tutoring, and I worked as Howard's studio assistant right up to his death. I'd do the menial stuff of washing brushes and cleaning up, right up to having to block in sections of paintings, that sort of thing. Howard had often had assistants over the years, students or people working professionally in the area who would assist, so it wasn't unusual for me to step into the position.

She loved the job. 'The big decisions were obviously his, but we talked about things a lot. He was very open in the way he worked. We'd talk about the work and where it was going, but all the creative decisions in the end were his.'

Jan Minchin, who owns Tolarno Galleries and was Arkley's art dealer, acknowledges Alison's role in his career, saying he 'really valued her opinion' and that she 'tried to get the practice in order'. In 1991 the couple moved to Oakleigh in Melbourne's south-east, in part because the father of Alison's two boys lived there and they shared custody, but also because Arkley wanted to experience living in the suburbs, which he had immortalised on canvas through his paintings of house exteriors and interiors. Minchin says Alison provided Arkley with a home, with all the stability, normality and at times uncomfortable ordinariness that the word implies for someone who was used to occupying the fringe. 'Everyone smiles because it was a little suburban house in

Oakleigh, but the reality was it was a real family home,' Minchin says. 'She tried really hard to ensure the future would be great, because she wanted to pursue her own career.'

John Gregory, Alison's brother-in-law and author of one of a number of books about Arkley, *Carnival in Suburbia*, writes in the preface to his book that Alison has not been given proper recognition for her 'tireless and self-effacing role, throughout the 1990s, in helping Howard through enormous difficulties, while also serving as his principal studio assistant'. He adds, 'I sincerely believe he would not have lived to produce many of the most brilliant works of his later career without her.'[8] The difficulties to which he alludes revolve mostly around Arkley's addiction to heroin, which Alison says she knew about when she got involved with him. Arkley got himself off heroin for Venice, but within a few days of returning home from that mid-1999 trip to Europe and the United States, during which he and Alison had married in Las Vegas, he was dead from an overdose, taken alone in his studio late one night. Like Wendy Whiteley, Alison rejects the idea that Arkley's drug use made him some kind of tragic-romantic figure, or that it was essential to the creation of his art:

> People are fascinated by this whole idea of the tortured artist, the fact that he had an addiction. Let me tell you, there is nothing fascinating about it. And he was more than just somebody who had a serious addiction. I don't know why I use 'serious' and 'addiction' in the same sentence, because an addiction is serious. It influenced a lot of his behaviours, but it wasn't what he was about. His art was what he was about. That was the dominant thing.

The notion that the role of an artist's partner is dictated by generation or gender is defied by the example of Rosalie Gascoigne. Born in the same decade as Tucker, and the same year as Nolan, Gascoigne's career did not take off until the mid to late 1970s, hitting its peak in the 1980s and 1990s. The way her husband, Ben, an astronomer, adapted from the supported to the supporter was also contemporary in nature; it's easy to imagine other husbands of his generation being less supportive of their wife's time in the spotlight. Ben completed a welding course in the early 1970s so he could help ensure that his wife's sculptures stayed up, and later documented all her work, taking photographs and detailing the specifications of each piece. These records are the valuable beginnings of what the couple's three children, Martin, Toss and Hester, hope will eventually be a catalogue raisonné, or comprehensive list, of their mother's oeuvre. Ben writes in an amusing account of his role that he 'glued, screwed and made steady, or fabricated', but adds that he 'rarely had anything to do with the creative process'.[9] Gascoigne hinted in 1997 that her artistic metamorphosis was not always easy for her husband to comprehend: 'Dear Ben is still adapting to the notion that he's had two wives, and there's nothing he can do about it.'[10]

Gascoigne was the supportive wife and mother the times demanded for the first part of her married life, when the family lived on Mount Stromlo where Ben worked. The 1940s and 1950s were mostly occupied with having babies and raising children, and it was not until the late 1960s that she started making large constructions of natural materials such as old tree stumps, cattle bones and rusted farm metal, which drew on her experience with the Japanese floral arrangement art of ikebana. By this stage the family was living in nearby Canberra. In the early 1970s, when Gascoigne began thinking about herself as an

artist, her eldest son Martin was in his late twenties and working in the Philippines. He had been buying contemporary art himself, and when he was posted abroad left his modest collection in his parents' care. 'Before I went to Manila we'd go around the Sydney galleries and she'd be introduced as Martin's mother,' Martin says. 'By the time I got back I was Rosalie's son. It was an interesting reversal.' When asked whether his father liked the role he took on in those last few decades of his life, Martin says undoubtedly. 'Oh yes, Dad enjoyed it. I think he liked all the attention that came with it, though as Mum's engagement deepened he sometimes felt left behind.'

The pin-up girl for everyone who harbours a dream of still achieving something later in life, Gascoigne was fifty-seven when she held her first solo show, sixty-four when she represented Australia at the Venice Biennale, and had just completed several major works—including the *Earth* series and the retro-reflective *Metropolis*, both now in public collections—when she died in 1999, aged eighty-two. Created over a 25-year art career, her poetic assemblages, made from old soft-drink crates, electricity cable drums, feathers from swans and cormorants, mesh-wire, reflective road signs, builders' form-board, and other found objects, are held by galleries and corporate and private collectors in Australia and abroad.

Gascoigne held her first commercial show at Macquarie Galleries in Canberra in 1974. The following year an artist friend, Michael Taylor, included her in a group show called *Artist's Choice* at Sydney's Gallery A. So impressed was its director, Ann Lewis, that she offered Gascoigne a solo show the following year, from which seven public galleries bought work. It was about this time that Ben turned down a job that might have put an

end to his wife's budding art career. 'In 1975 work wasn't going particularly well for Dad, and he was offered a job in Sydney to work with the big, new Anglo-Australian telescope,' says Martin. 'It was professionally very tempting for him, but on the week that Mum's Gallery A show opened he wrote a letter declining the offer. He couldn't see Mum moving out of Canberra; going up to Sydney would have put an end to everything for her.' Staying put paid off. Gascoigne was given a survey at the NGV in 1978, the influential curator Nick Waterlow selected her for the 1979 Sydney Biennale, and she was picked up by dealers Ray Hughes in Brisbane and Bruce Pollard from Pinacotheca Gallery in Melbourne.

Ben and Rosalie Gascoigne were each honoured for their respective careers, but while Ben's career came first chronologically, she was the first to receive a pin. Rosalie Gascoigne was made a member of the Order of Australia (AM) for services to the arts in 1994, two years before Ben received an Order of Australia (AO) for services to Australian astronomy. (In 2001, he was also awarded a Centennial Medal.) But Gascoigne was well aware that her husband's success had contributed to her own, not least because she had spent years observing creative scientists at work. When asked by a student what the most important thing was for someone setting out to be an artist, she answered: 'A partner with enough money to keep you for the rest of your life.'[11]

The quip belies the truth that there are no rules for what an artist needs in a partner, any more than there are for anyone, beyond someone who loves and supports them. Some artists' partners are intimately involved in their work, others handle the administration, while others still have fairly separate lives.

As the role of the wife in society has changed, however, the wife who devotes herself to her husband's work has become less common, the reverse even rarer. Separate careers are now the norm rather than the exception. As a result, in the future there are likely to be fewer in the mould of Lyn Williams, who has turned the handling of the Williams estate into something of a career; or Wendy Whiteley, whose close involvement in the creation of Whiteley's work is still his best protection against fakes; or Helen Brack, who can talk so eruditely about her husband's work, and art in general.

Given the vast increase in the number of people calling themselves artists, there will be more artists' estates in the late twenty-first century, but not necessarily more valuable ones. Successful contemporary artists will likely have sold better in their lifetimes than those who were working mid last century and thus will probably leave barer studios. The passage of time will see some reputations rise from the pack; which ones do so will depend, among other factors, on how their estates are handled. Today's contemporary artists would thus be wise to contemplate why some earlier artists are so omnipresent, and others all but forgotten.

Chapter 3

The Crimson Line

The whole reason for art is to communicate with others.
You can't just put it under lock and key.

TESS EDWARDS BALDESSIN[1]

That factors beyond their work can influence
an artist's reputation is no better highlighted than by the public
profiles of Brett Whiteley and George Baldessin. Born in the
same year, 1939, Baldessin was as popular in 1970s Melbourne
as Whiteley was in Sydney. The two artists were emblematic of
their cities: Baldessin was dark, handsome and of European atti-
tude and origin; Whiteley was blond, wild and hedonistic. Both
had charismatic, magnetic personalities that were as responsible
for their big reputations as was their art, and both loved depict-
ing the sexualised female form, albeit often in a distorted way.
Even their creations reflect the ethos of their respective cities;
a printmaker and sculptor, Baldessin worked mostly in black,
white and silver, while Whiteley was primarily but not only a
painter, and a master of colour. Both spent time overseas in their
twenties, but really consolidated their reputations on home soil

41

through their thirties. Both had children—Whiteley's daughter, Arkie, was born in 1964, Baldessin's sons, Gabriel and Ned, in 1975 and 1977, respectively. Both artists died young. Baldessin perished in a car accident in 1978, aged only thirty-nine. Whiteley lived for fourteen more years, dying in 1992, when he was fifty-three, after many years of heroin use. Whiteley's death was that of a national celebrity, and was treated as such. Of Baldessin's death, art historian Sasha Grishin says: 'He was a huge, huge figure. It was almost to the point of declaring a public holiday to commemorate his death. People were in such shock, there were thousands at the funeral.'

That is, however, where the similarities end. Whiteley remained a household name, and now has a Wikipedia page that runs for multiple screens and wall space in many big institutions. He even has a boutique public museum, the Brett Whiteley Studio, to his name. His work continued to be in demand, too. More than 2200 of Whiteley's works have traded at auction since the 1970s, with the top price of $3.5 million fetched in 2007 for his 1985 painting *The Olgas for Ernest Giles*. Whiteley accounts for three of the ten top non-Indigenous Australian art prices at auction. Baldessin, by contrast, has pretty much dropped from public view. His name is recognised today in art circles, but not by the wider public. He has no Wikipedia page, is rarely on show in the state galleries, and has a top auction price of $54 550. Fewer than 350 of his works have been traded at auction since the early 1970s.[2] Baldessin is the artist behind the giant Corten steel pears that have pride of place in front of the NGA. They were commissioned in 1973, before the gallery even opened, and four years later Baldessin and his friend Les Kossatz won a competition to design the ceremonial doors for the nascent High

Court of Australia. Many visitors to Canberra love the pears, which are so associated with the gallery that its gift shop sells small glass and stone versions. Few, however, could name the artist who made them. Art critic Peter Timms has observed that when Baldessin died, 'most of us thought Australia had lost one of its most important artists', but that by 1997 he was 'regarded as a relatively minor historical figure'.[3] The TarraWarra Museum of Art held exhibitions on Baldessin and Whiteley in 2009–10 and 2010–11 respectively. The Baldessin exhibition was the more significant of the two, an important step in a campaign to revive the artist's reputation led by his widow, Tess Edwards Baldessin, which featured work not seen in public for decades. Many who saw it were bowled over. Even so, its 12 657 visitors were dwarfed by the 27 638 who saw the Whiteley show the following year.

There are many reasons for the divergent reputations of two of the biggest art stars of the 1970s. Oil paintings fetch higher prices and attract greater kudos than prints, and while Whiteley did many, many oil paintings, Baldessin was primarily a print-maker. So in market terms, Whiteley had a head start. Oil paintings can also be displayed year round, in contrast to prints, which have to be rotated on and off gallery walls to avoid light damage. In addition, much of Baldessin's sculpture was made from non-permanent materials, or remains unfinished.

Reviewing a printmaking show in 2007, critic Sebastian Smee observed that artists including Baldessin 'might have been regarded more highly than a lot of their better-known painter peers' if printmaking weren't considered inferior to painting. As to why this is so, he looked to economics: 'Whereas paintings are unique and therefore—according to the law of supply and

demand—likelier to be valued highly, the point of printmaking since its inception has been to make images cheaper and more widely available.'[4] Whiteley might have been drugged out on occasion, but he kept painting at a workhorse rate through the late 1970s and 1980s, the extra fourteen years he had on Baldessin thus making his oeuvre a lot broader and deeper than that of the Melbourne artist. It is for paintings done during those fourteen years, many looking out on Sydney Harbour from his home in Lavender Bay, that collectors pay a very high price. And in crass marketability terms, colour tends to trump black and white. Whiteley has become known for the blue he used to depict Sydney Harbour; Baldessin mostly didn't use colour. 'George was mostly a black and white artist, and they haven't fared as well as artists who deal in colour,' observes curator Barry Pearce. 'Graphics are a bit exclusive of public engagement, something people collect and put in their attic, so to speak.'

Perhaps there's also a more obvious reason for this division: that Whiteley was simply a better artist. While some would agree with such a statement, others, including Grishin, would not. Artistic reputations are anything but straightforward, and rarely is there a consensus. There is certainly not a direct correlation between what the art market values and what the curatorial world thinks worthy. Grishin argues:

> Baldessin was a far more serious artist than Whiteley, who looks very thin and facile by comparison. Whiteley's not as bad an artist as some people think he is—he's an interesting draughtsman, not a bad printmaker, and his early paintings, the *Bathroom* and *Christie* series, the landscapes, are really quite brilliant. But you

could argue, albeit controversially, that while Baldessin was doing some of his best work when he died in 1978, the best of Whiteley's oeuvre was by then probably behind him.

Australian Galleries represented Whiteley during the artist's lifetime, and now handles the Baldessin estate, so owner Stuart Purves has a foot in both camps. While he says he respects Grishin, he disagrees with his thesis, arguing that he could mount exhibitions of drawings by both artists that would equally impress. 'You do not need to bury one to raise the other.'

Grishin adds that there is another important factor in all of this. Baldessin disappeared from view in part because his widow, Tess, left the country, living from 1983 until late 2000 in France. Grief-stricken by the death of her husband and the subsequent death of two others close to her, Tess left because it was too hard to stay. It is a potent example of how emotions can influence decisions that affect the reputation of the dead. Thus, in the decades that Lyn Williams was systematically and strategically dispersing works from her husband's estate, and when the Whiteley name was seemingly never out of the news, the works left in Baldessin's estate were being nibbled at by silverfish and gathering cobwebs in his St Andrews studio. Whiteley's charismatic back-story lived on after his death through Wendy and Arkie, and their constant media presence. Baldessin's, by contrast, seemingly died with him.

Tess now lives in the St Andrews home that she and Baldessin began building in the early 1970s. About three-quarters of an hour north-east of Melbourne's CBD, St Andrews is a beautiful, semi-rural township that was much further from suburbia

when Tess and Baldessin paid $7500 for 13 acres there in 1970, complete with an asbestos shack. 'It was all very secluded. There wasn't even a road at the front—you had to come up over the top,' Tess recalls. 'Les Kossatz was living up here with Judy Jacques, the jazz singer, and Judy found out about this place through somewhere that she was singing. It was a deceased estate, so we put in a tender.' It's a tranquil spot, with gum trees and birds outside the window, and polished floorboards and rugs underfoot. Tess sips rosehip tea in front of a pot-belly stove as she begins to tell her remarkable story. It's not hard to picture her as the 22-year-old bohemian bride who got married here in 1971. 'George had driven down to the Melbourne Oyster Supply and got a few crates of oysters, and a few crates of champagne from somewhere else. I painted garlands around the asbestos walls, and that was it, basically.'

The couple had met at the Royal Melbourne Institute of Technology in 1967, where Baldessin was teaching art. Like Whiteley, Baldessin drew people to him. The author of a 2009 book on Baldessin, Harriet Edquist, writes that his achievements have been mediated through the filter of his 'charismatic persona, elegance and urbanity'.[5] Tess confirms the effect he had on people. 'George was like a magnet: he attracted all sorts of people to him, interesting and not interesting, helpful and not helpful. People would fall in love with him, male and female, and they'd really want a part of him.' Baldessin was emerging from a four-year marriage, and had an aura of European sophistication to him. Edquist's book fills in his history. Born in Italy, Baldessin had spent the first nine years of his life living there with his father and relatives before being reunited with his mother in Australia in 1949 (World War II had forced a longer

separation than anticipated). As soon as he finished school he enrolled in fine art at what is now RMIT, where in the last two years of his four-year course he turned to printmaking and sculpture. He spent much of his early twenties abroad, studying at the Chelsea School of Art in London, then at Marino Marini's studio in Milan, and in 1965–66 he won a scholarship to pursue further studies in Japan. Amid all of this he was picked up by the influential Sydney tastemaker, art dealer Rudy Komon.

The early 1970s were blissful times for the newly married Baldessins. Kossatz and Jacques lived just down the road, and Roger Kemp would often work in Baldessin's studio in the city. There were regular cricket games at St Andrews in which artists including Fred Williams, Jan Senbergs and Dale Hickey would compete against a group of writers and critics led by Stephen Murray-Smith. Tess taught art at Eltham High School, teaching among others the three Hails brothers, Rob, Doug and Don, who helped the couple build a bluestone studio and the beginnings of a house on the property. 'Artists didn't have money in those days,' Tess says. 'Jan Senbergs bought a house in Cheltenham. He'd ring around and say, "Okay, next Saturday, bring your gardening tools and paintbrushes." It wasn't a club as such, just the art community.' Baldessin commuted each day to Melbourne from St Andrews, where since 1967 he had worked out of a first-floor studio in the Winfield Building in Collins Street (now part of Rialto Towers), as well as lecturing at RMIT.

One of the words often used to describe Baldessin is 'enigmatic', and this is partly because he kept details of his Italian heritage secret, even from his new wife. 'I knew of his Italian background, but not in any great detail,' Tess says. 'We went to Tuscany twice to stay in Arthur Boyd's house. We got lost once

and George had to get out and ask someone directions. He was out of earshot, but when he came back to the car I said, "Were you speaking Italian?" He said, "No, no, they spoke English." It was not a plus to be Italian in those days.' The couple had travelled to Tuscany from Paris, where they lived from 1975 until late 1977, after Baldessin, along with Imants Tillers, had represented Australia at the 1975 São Paolo Biennale in Brazil. Tess had given birth to the couple's first son, Gabriel, earlier that year. The rent on their Paris flat was being paid by Komon, on the understanding that the Baldessins would pay him back through exhibitions when they returned to Australia. It was for this reason that they did return in 1977, the year their second son, Ned, was born. 'George felt he couldn't impose on Rudy's generosity any further,' Tess says. 'It was unfortunate in a way that we did come back. George was just beginning to make inroads into the Paris scene. If he'd stayed on another year, he would have been accepted into a gallery in Paris.'

It was a howling wet August night when Baldessin's car hit another on the commute from his studio in town back to St Andrews. 'He probably had been drinking, and nobody wore seatbelts or anything like that in those days,' says Tess. Living in a half-finished house on a bush property, Tess, twenty-nine, was now solely responsible for three-year-old Gabriel and nine-month-old Ned. It didn't help that Baldessin had always said he would die young. 'A fortune teller had read his palm when he was on a cruise once. He used to do cruise ships to earn money. He'd work in the art room in the nursery teaching kids to do arts and crafts, and wait the tables at night to earn enough money to put himself through the next few months of art school,' says Tess. 'He was in the Suez Canal and this gypsy read his

palm and said he would die young, so he always believed that.' He had drawn up a will in April of the year he died in which he left her his estate, such as it was.

Melbourne's artistic community was small and tight at the time, and Baldessin's friends rallied around his widow, holding a fundraising exhibition and working bees on the St Andrews property until the house was finished. There was no therapy or counselling. 'I had people crying all over me. I'm the one meant to be crying and I was comforting everyone else,' Tess says. 'I couldn't let myself go to pieces because I had two little kids.' The last thing she could deal with was Baldessin's art, which was 'all over the place', much of it unsigned and undated. 'I couldn't bear to think about it,' Tess says. 'It was a matter of survival: get through this hour and this day.'

Robert Lindsay was working as a curator of contemporary art at the NGV at the time. He had been speaking to Baldessin about a show of his work, and after the artist died the then director of the NGV, Patrick McCaughey, asked Lindsay to turn it into a full retrospective. He had a very modest budget, but wanted to give the exhibition the sense of style that character-ised the late artist. He put a giant photograph of Baldessin at the entrance and covered the walls with black and maroon felt, against which the silver-hued works looked striking. The show opened in 1983, five years after Baldessin died. Lindsay recalls: 'It wasn't closure, but it was highly successful. It felt like all of Melbourne turned up.' Reviews, according to Edquist, ranged from the 'hagiographical to the terse'.[6]

Around this time Tess had begun a relationship with John Tittensor, an author who had two children similar in age to the Baldessin boys. Tittensor shared custody of his children with

his former wife. The children all got along well, and it seemed as if life was beginning to turn around for this newly blended family. But within five years of Baldessin's death Tittensor's two children were killed in a house fire on the other side of town. Tittensor did what most writers do in order to try and make sense of the world; he wrote about it. His book, *Year One: A Record*, was released in 1984, the year after the NGV's Baldessin retrospective opened. Tittensor and Tess were not there, however; in September 1983 they had bought one-way tickets to the south of France. 'We were known as the tragedy family,' Tess explains. 'I just wanted to get these kids away from this awful vibe.' The couple had the name and address of someone in the south of France, but little else. 'We just went.' They settled into a small village about an hour north-west of Avignon, put the boys into school and 'miraculously' got ten-year visas and work permits. It was liberating to leave Australia behind. 'Everyone in France thought we were just a normal family—that John was the father of my two kids, and we didn't need to talk about it. We just pulled down the roller door and didn't want to know about Australia or anything that happened there,' she says. 'It did wonders for the kids, they just blossomed. We were really welcomed into the village and we really took part in it. We went truffle hunting, olive picking, all the things you do in the south of France. It was fantastic.'

Eventually, however, the relationship broke down:

> The kids were adolescents at that stage, and it was just so painful for the four of us to be together. Talk about skeletons in the closet. We'd never mention [Tittensor's children's] names … and we'd change the subject as

fast as we could if it ever came up. I used to try to talk about George to the boys, but they didn't really want to know about it, either. They'd grown up in this atmosphere of denial about anything to do with death. It just evolved [that] none of us could advance together, so we had to split up.

In late 2000 Tess returned to Australia, drawn back, she says, by Baldessin. A practising artist herself, she had used her own art as therapy, exhibiting across Europe as well as back in Australia on occasion. Her sons had been only five and eight when they moved to France. They were now in their twenties, pursuing careers in Paris and '99 per cent French'.

Gabriel and Ned had grown up not only without their father, but without even one of his prints on their walls. Edquist's book details the effect of Baldessin's early life on his art—his estrangement from his mother until age nine, and the experience of being 'a wog' in 1950s Melbourne. 'My sons have remarked that George suffered because he was a migrant coming to a strange country, having to learn the language and the culture, and that I did exactly the same to them,' Tess reflects. 'My mother has said, "Australia is the place people come to; they don't go and migrate somewhere else from here. My grandsons, you've turned them into Frenchmen."'

In the seventeen years that Tess had been away, Baldessin's name had slowly but surely slipped off the radar. There had been the odd public show—one in 1991 at Heide in Melbourne and the Ivan Dougherty Gallery in Sydney, and another that toured regional Victorian galleries in the mid 1990s—but no substantial commercial shows until the late 1990s. In a case

of bad timing, Baldessin's dealer Rudy Komon had died the year before Tess left. It threw everything into further disarray. Reflecting now, Tess says:

> If I'd managed the estate properly, if I'd had proper advice, I would have allowed a certain amount out at a time, I would have done what Lyn [Williams] has done, and it would have built up and created a market price. I think if I'd not had the second blow of the children's deaths, I might have been able to slowly climb out of it. I might have stayed in Australia, and I would have been up against it all the time, meeting people who knew George, who could have given me advice, and so on. By removing myself I had nobody to talk to about it, no reference. We really slammed the door on Australia— that included, which was silly, but we were desperate. It was about survival. You do what you can do at the time.

Tess moved Baldessin's estate to a Melbourne gallery after Komon died, but told the owners that she didn't want to sell anything, which inevitably dampened their interest in doing much with it. A major work was lost, but Tess says now, 'I can't really blame them because I just forgot about it really. I didn't want to know.' The estate then moved to Tolarno Galleries, but this partnership ended when its founder Georges Mora died—his successor Jan Minchin didn't deal with estates. Upon Minchin's recommendation Tess moved the estate to Stuart Purves' Australian Galleries in 1994. Purves talks evocatively about the day he went to St Andrews to see what exactly was left in the Baldessin estate. Tess, home on holidays but not yet living

back in Australia, was not convinced that she wanted to start selling things. Says Purves:

> We literally brushed the cobwebs off the studio door as we went in. We had a very emotional day. She wanted to do it, and yet at the same time didn't want to do it. It was really something, to get her to unhinge and allow it to happen. I was like the obstetrician and I had to break the umbilical cord. One day I just brought the axe down on it; that was quite a tough day. She couldn't bear to have it all brought to the surface again, and yet that was what she wanted to do.

Inside the St Andrews studio were etchings and drawings, sculpture moulds, etching plates and some paintings. There were different variations on certain images, some editions that had not been finished, and many works that were unsigned, untitled and undated. There was also a fibre and resin mould of Mary Magdalene, a sculpture Baldessin had been working on at the time of his death. (This had been cast posthumously in 1983 for the NGV retrospective.) Purves returned on another day with a truck, a clipboard and curator Julianna Kolenberg, who noted down everything as it was taken out of the studio and loaded into the truck, destined for Australian Galleries' premises in Collingwood. It took Purves a decade to put the estate in order. He now has drawers in his Melbourne gallery filled with Baldessin's prints. 'I promised Tess that we'd put the estate into beautiful order for her children, and that's what we've done,' he says with pride. His services didn't come cheap, but to Tess it was money well spent. 'Stuart is a good psychologist. He nurtured

me through the various stages, saying George wouldn't want his work sitting in a back alley somewhere.'

In 1997 Australian Galleries held the first of two exhibitions of the prints, accompanied by a catalogue that lists and depicts 228 works. An estate edition was posthumously printed from many of the remaining uncancelled etching plates, using better quality paper and ink than was available in the artist's day, and new editions of some sculptures were released. Some critics question posthumous works if they improve on the original, but Purves is firm, particularly with sculpture. 'If there was no posthumous casting in Australia, we would only have seen half the sculpture that was ever made, because so many of the important artists were not able to afford to cast them in their own lifetimes.' Tess started off saying that the works could be sold only to public galleries, before realising the folly of such a stance. 'My attitude has matured and changed a lot. I've realised that George died, but he left this estate for me and the kids, for our futures. And it's got to be seen.'

To reignite interest in an artist who has fallen below what Patrick McCaughey calls 'the crimson line' between recognition and obscurity is an almighty job, one that ideally involves the reappearance of their work in both the commercial and public spheres. Tess and Purves tried for years to get a public institution interested in staging a Baldessin show, with no success. Nor was anyone much interested in publishing a book on the artist, unless the family footed the bill. In 2005, however, talks began with Maudie Palmer, then director at TarraWarra. Housed in an Allan Powell–designed building on 10 acres of land in the Yarra Valley, the museum, with its elegance and links to Melbourne's art community, was the perfect place to 'raise George Baldessin',

albeit one that was never going to get the size of audience a state institution show would have. The 2009–10 exhibition featured more than 100 works and Edquist's hefty book, published by Australian Galleries, as the exhibition catalogue. It might have had fewer than half the visitors of the Whiteley show the following year, but it was a triumph in its own way. 'That TarraWarra show was fantastic,' says Barry Pearce. 'You walked in and thought, Why isn't this guy better known as one of our great artists of the twentieth century? It's to do with marketing, and being placed. Being made a brand, in a way. It's almost a commercial thing.' Not all critics were wowed, but many who saw the show came away reminded of the power of Baldessin's work. 'All the people who had known him, especially artists, came to the exhibition,' says Palmer. 'It was more than a quarter of a century since a comprehensive survey of his work had been seen.'

For Tess the best part was watching the reactions of Ned and Gabriel, who came out from Paris for the opening. 'They'd seen some images in photographs, but this was really them seeing their father's work almost for the first time. On top of that there were 400 people there who knew George, knew the Baldessin name. I didn't tell the boys much beforehand. They would have been too scared to come.' She can't wipe the smile off her face as she adds: '[NGA director] Ron Radford, who opened the exhibition, led a round of applause for George's sons.'

Tess has re-partnered, with New Zealand artist Lloyd Godman. Together with Robert Hails, one of the three local boys who helped her and Baldessin build the studio all those decades ago, and photographer Silvi Glattauer, they have re-established the Baldessin Press at St Andrews. The four artists work in the studio using the same equipment Baldessin used.

They also hold occasional workshops and rent out a garret flat and stand-alone cottage on the property for artist retreats. The property that she once had to get away from now has positive connotations. 'I don't think you ever stop grieving, but grief can be good. All things can be good—anything can be transmuted into something positive—and all that pain can be a source of healing,' Tess says.

It might be too late to raise George Baldessin in the wider public consciousness, and maybe that doesn't really matter. In the fifteen years that Australian Galleries has been handling his estate, Baldessin has not become a household name again, although his reputation is inching upwards. Maitland Regional Art Gallery in New South Wales put together a survey on Baldessin in 2012, and two exhibitions of work from it will tour to more than eighteen regional venues in Victoria, New South Wales and Queensland through to the end of 2015. Purves says he has sold well in excess of $1 million worth of Baldessin's sculptures since he took on the estate, as well as many prints and drawings, including in 2012 a drawing for close to $100 000 to the NGA. Curator Barry Pearce sums up the state of play like this:

> Tess has had a long struggle to do the right thing by him, and they finally did that beautiful exhibition and book on him. Will he sell out like Whiteley does? I don't think so, somehow. Maybe he'll be known as a Melbourne artist. Do they talk of George Baldessin in Sydney, or Brisbane for that matter? No, whereas they talk of Whiteley everywhere. He's an Australian artist, whereas George will be known as a Melbourne artist.

Ever the salesman, Purves adds, 'John Olsen once said to me that if you haven't made it in Melbourne, you haven't made it in Australia. It's still the place that counts.'

Brett Whiteley does not struggle for profile anywhere in Australia. That his name remained a constant in the news even after his death, thanks to court battles, books, record prices and fakes, as well as a studio and annual scholarship in his name, helps explain his continued recognition among the general public, in contrast to Baldessin. Writer Barry Dickins observes that Whiteley was 'the only Australian painter to make the grade as a pop superstar', a person who 'seemed afraid of nothing except being forgotten'.[7] Accountant Tom Lowenstein (who acts for Wendy Whiteley) sounds nostalgic when he tells me that there has been 'nobody with that kind of pizzazz and flourish' since. Wendy has not had to 'raise Brett Whiteley', because he never went away. As a result, her job has been altogether different from that of Tess Edwards Baldessin. From helping Arkie sort through the studio and remaining work after Whiteley's death in 1992, to overseeing the hang of exhibitions, her biggest involvement has been with the Brett Whiteley Studio, primarily in helping to set the visual sensibility of the place.

Attention came to Whiteley from the beginning, and also to Wendy, who started going out with the artist when he was seventeen, she fifteen. By their early twenties the couple were living in London, catapulted to the northern hemisphere by an Italian government travelling art scholarship that Whiteley had won at the age of twenty. It was the swinging 60s and he

was a star on the rise, with his abstracts and then his *Bathroom* and *Christie* series finding critical and popular acclaim there. At twenty-two he became the youngest artist to have a work bought by Britain's Tate gallery.

'Australia in the 50s—who didn't want to get out?' Wendy says now. 'We walked into the full rebirth of activity in London, mostly because of [Whitechapel Gallery director] Bryan Robertson. Australia had these two big exhibitions, one at Whitechapel and one at the Tate. I think it was the first time anybody thought there were artists in Australia at all.'

Later that decade Whiteley won a Harkness Fellowship, which took the couple and their toddler daughter to New York, where they lived in the famed Chelsea Hotel, partying with the likes of Bob Dylan and Janis Joplin, and getting increasingly disillusioned about the United States and its Vietnam War. Angry when his New York dealer refused to exhibit his eighteen-panel 1968–69 painting *The American Dream*, Whiteley left New York for a stint in a quieter place, Fiji, taking his family with him. The peace did not last, however; Whiteley was caught with drugs and thrown out of the country. Neither he nor Wendy was addicted to heroin yet; that was to come in Sydney in the early to mid 1970s. Journalists and photographers were waiting for the family when they landed back in Australia, however, the first of many life moments recorded by a media that never tired of the Whiteley story. And why would it? The story kept evolving. It wasn't just the artist, either; people were fascinated with Wendy and Arkie, too, not least because they were both beautiful. In the public consciousness the whole crazy package came to embody the clichéd artistic life. Wendy recalls arriving home from Fiji in 1969:

We weren't kind of mad, desperate bloody drug addicts, [but] that was the focus, as well as having long hair and funny clothes, and a bit of success in other countries. We weren't living an enormously destructive, drug-addled life. We'd experimented, were messing about with experimenting, really ... That photograph of us walking along with Arkie hanging onto my skirts and trying to hide, that was us in a state of absolute shock. My God, what's all this about? And the customs going through all the stuffed birds and things, thinking we probably had a huge supply of drugs hidden in there or something.

Interest in Whiteley remained high throughout the 1970s and 1980s, as he painted Lavender Bay vistas from the family's home on Sydney's North Shore, and became the first artist to win the AGNSW's Archibald, Wynne and Sulman prizes in the one year. The artist continued to paint and party at a prodigious rate. He and Wendy split up in 1987–88, and Whiteley started seeing a younger woman, Janice Spencer (who looked remarkably like his former wife). Eventually, prematurely but not completely unexpectedly, Whiteley died. His body was discovered in a motel room in Thirroul, on the New South Wales south coast, after Spencer raised the alarm when she could not get him on the phone.

Wendy and Whiteley had divorced but were in the midst of a bitter property battle at the time of the artist's death. Copyright in his oeuvre, plus many works, came to her nine years later in the saddest of circumstances, namely the death of Arkie from adrenal cancer, aged only thirty-seven. Arkie had gone to court in the year after her father's death to fight a 1989 will that would

have left half the artist's estate to the establishment of a museum in his name. She argued that a subsequent 1991 handwritten will, which she said had been taped to the bottom of a kitchen drawer but could not be found, left the lion's share of Whiteley's estate to her. This will made no mention of the planned museum, which Arkie and others told the court was simply a device to keep property from Wendy during their divorce. Whiteley had hidden artworks in the wall of his studio for the same reason. Although that 1991 will was never found, the judge believed Arkie's account, and it was this will that was upheld. Spencer ended up with just one painting, which within two years she had put up for auction.

The museum happened anyway. In 1993 Arkie sold the Surry Hills studio, together with ten paintings including the eighteen-panel *Alchemy*, to the New South Wales Government for $3 million. The sale allowed her to pay off her father's debts and legal fees without having to sell any paintings privately. It was a neat financial outcome, given what she had argued in court, with the cost of the museum now to be borne by the state. Over the coming years there were other court cases and disputes involving the 'Whiteley women'—Wendy, Arkie, Spencer, Whiteley's mother Beryl and sister Frannie—and battles with publishers over who had the right to tell the Whiteley story, and how it should be told. The media lapped it all up. The deaths of Spencer in 2000 from heroin, aged forty-one; Arkie in 2001; and even Beryl in 2010, aged ninety-three, all made newspaper headlines—not because of their own achievements, but because of their roles in the Whiteley soap opera. Covering the 1993 court case over the wills, journalist Brook Turner finished one of his reports in *The Australian Financial Review* with the memorable

line: 'The case is complicated but the "Whiteley women" kept it simple yesterday—the artist's ex-wife Wendy in white, Ms Spencer in black and Ms Whiteley in black and white'.[8]

That Whiteley was equal parts artist and pop star is high-lighted by the half-a-dozen books written about him, which run the gamut from serious art texts to a memoir by his sister Frannie, to journalistic explorations of his life. The contrast is stark with Fred Williams, about whom there are two serious tomes, both written by former public gallery directors, and John Brack, whose scholarly catalogue raisonné by Sasha Grishin is out of print and now a collector's item. Wendy has mixed feelings about the 'pop star stuff', telling a journalist in 1994 that 'my focus is Brett Whiteley as an artist, not as a pop star', adding caustically that 'a very good idea to find out about an artist's life is to actually go and look at his fucking pictures'.[9] When we speak in 2012 she has softened, agreeing that it was part of Whiteley's persona:

> There's nothing wrong with the pop star stuff, because he did have a pretty out-there personality. He didn't go out there consciously working on that, it's just who he was. He was charismatic, he was funny when he chose to be, he was interested in other people, very generous when he chose to be, fucking mean as shit when he changed his mind about something. You know, he was not a saint.

The big downside of the celebrity back-story, and the seemingly non-stop public appetite for it, is that it has become difficult, if not impossible, to judge Whiteley's art purely on its own terms. Barry Pearce begins his essay in *Brett Whiteley:*

Art and Life with the observation that 'the greatest obstacle to appreciating the art of Brett Whiteley may be his life and his death'. Whiteley, he writes, is 'the antithesis of a painter about whom we know nothing and whose works make entirely their own argument'.[10] The subtitle of the catalogue, *Art and Life*, says it all: when it comes to Whiteley, the two are inextricably entwined. It is not unrelated that there's a schism between the paintings liked by many in curatorial circles—the early works, done in the 1960s and 1970s before the drugs took hold—and those the market pays the most money for, which tend to be the Sydney harbour and bird paintings executed in the 1980s. This odd dichotomy was illustrated at Sotheby's August 2012 auction, which included two 1962 Whiteley abstracts that had been in the same private collection since the 1960s. Their sale coincided with an exhibition at the Brett Whiteley Studio that focused on the artist's early career in London. Both paintings in the Sotheby's auction had appeared in a book and catalogue raisonné of Whiteley's work up to 1967, *Brett Whiteley: A Sensual Line*, which was published in 2010 by former auction house executive Kathie Sutherland. She argues that Whiteley made important strides as an artist in his decade overseas, including the defining move from abstraction to figuration.[11]

This didn't influence collectors, though. One of the 1962 paintings sold for $75 000, $5000 below its low estimate, and the other was left unsold. In the same sale the artist's 1984 painting *The Dove in the Mango Tree* made $660 000, $10 000 above its high estimate. The chasm reflects a wider debate about Whiteley, who more than any other Australian artist splits both expert and non-expert opinion. Overhyped narcissist or one of the best artists Australia has produced? Both views can be found

inside and outside the public gallery sector. Pearce believes the difficulty of separating the Whiteley life story from the art helps explain the divide:

> Brett was an extrovert; he paraded himself like he dressed up. I think that's a distraction from his real talent. I like the idea of stripping away all that egotism, narcissism, and when you do, what you find is a really good painter. I think Brett was a really good, hard-working painter, but it's hard to see that through the performance and the showing off. The showmanship is I think what has brought about the envy and resentment of him.

The Whiteley fame has inevitably affected Wendy's life, and her handling of the artist's legacy. She has about her the classic celebrity combination of being aware of her status and its uses, yet wanting the world to leave her the hell alone, to stop trying to get another piece of her. She is the closest thing to a celebrity widow the Australian art world has, without actually being the widow. Lyn Williams, Helen Brack, Mary Nolan and Barbara Tucker are all well known in the art business, but none would be recognised outside of it. Not so Wendy, who has lived her whole adult life in the fishbowl of fame. If she's at an opening, hers is a face social photographers will always hone in on. People regularly interrupt her when she's tending the public garden below her home in Lavender Bay, Sydney, which she began building on disused rail land as a physical release from the grief of losing Whiteley and then Arkie. The garden has now become Wendy's own creative legacy, a place noted on tourist websites and given the tick of approval by North Sydney Council. Wendy

jokes that she must look like a bag lady, tending the dirt, her trademark headscarf keeping the twigs out of her hair and, less successfully, serving as camouflage. The interruptions are kind of nice—people mostly just want to talk about gardening and say how they love what she's done—and kind of annoying; she's there to work:

> You can't be doing something and also be charming, and they're charming people mostly, and they just want to be friendly, but you can't be doing both at the same time. It's why artists' wives often get the reputation for being a monster. Some person feels they'd like to push the doorbell—you're a bit famous and they know where you live. The artist is busy working so you get sent to the door to say, 'Brett's not available.' And they say, 'That woman. I know if I had just met Brett he would have loved and adored me and invited me to come and live with him for six weeks.' That kind of fantasy is going on in their minds, which we did a bit of ourselves.

Wendy can be a daunting figure, even if, as Australian Galleries' Stuart Purves observes, her bark is worse than her bite. Ring her on a good day, or for a reason she deems worthy, and you'll get a very direct form of charm. Along with Helen Brack, she has the most interesting things to say about the art world, cutting through the posturing and blather with blunt words, a wry laugh and a heavy smoker's cough. Get her on a bad day, however, or ask about the Whiteley fakes that have appeared on the market in recent years, and you'll get withering Wendy. Barry Pearce

observes that artists' widows need to put their armour on; none seem to have more armour than Wendy. Yet few are as prepared to speak their mind, consequences be damned.

Arkie's will left Wendy with most of the paintings from Whiteley's estate, along with copyright control over his work. But Wendy had been involved in the legacy business long before that, helping Arkie get the studio into order ahead of its 1993 sale, and co-curating the 1995 AGNSW retrospective with Pearce. At various stages Arkie had asked other people to help her catalogue, photograph and sort out what was in the studio, but those relationships fell apart. Wendy says the estate was 'messy' for a long time, and that while they 'managed to limp through', it was exhausting. 'It was too much for Arkie to handle, plus she didn't have enough fact, and involvement in the work, like I had,' she says. 'So she kind of went, oh well, will you do it? And I said yes okay, to try to give her some freedom ... She really wanted to go back to London and continue with her life as an actress.'

Wendy has not done much with the artworks left to her, about 1700 of which are on long-term loan to the AGNSW, which stores, conserves and insures them.[12] Not for Wendy the steady release of work onto the market through one or two blue-chip dealers, à la Lyn Williams. Wendy has sold works sporadically rather than strategically, mostly privately and when she has needed the money, and has not made a habit of donating to institutions. It has not been necessary—plenty of Whiteleys turn up for sale anyway, and the long-term loans to the AGNSW plus the existence of the studio museum means there are always Whiteleys on public display. 'I could sell everything in the studio, and give [the proceeds] to who? Young emerging artists?

I think they have to earn their stripes,' she tells me. Wendy has bought back works on occasion, including a delicate gouache drawing of a tree with a pale pink bird in it that she bid $250 000 for at Sotheby's in 2007. That May auction, held at the height of the art boom, stands as the most lucrative art sale held in Australia to date; the following year the art market went into a nose dive. Wendy was there to see Whiteley's *Opera House* go under the hammer. Painted over a decade between 1971 and 1982, and among twenty-two works being sold off by Qantas, the kitsch depiction of Australia's most recognisable monument made $2.9 million. Wendy, however, had her eye on a gentler, prettier work; the bird in the tree, *Everything*, 1970. 'I paid a huge price to buy that back,' she says. 'I thought it was a very high-quality drawing. There were two drawings for sale and I was torn between the two I think. I was resisting bidding on the first. I don't think I made a bad choice, but I paid a very high premium for it.'

The Brett Whiteley Studio opened to the public in 1995. A former T-shirt factory that Whiteley had bought in 1985 and converted into a studio (and also lived in after he and Wendy separated), it evokes the spirit of the artist beautifully. Paintings including *Alchemy* and the 1978 Archibald Prize–winning *Art, Life and the Other Thing* hang downstairs, where Don Featherstone's 1989 documentary on the artist plays on rotation. Upstairs is a final, unfinished painting that was to be the start of another multi-panel work, taking in the vista from Bondi Beach to Uluru. It stands upright on the floor in a room with a crumpled bed, a bookshelf of art books, ashtrays, brooches, painting utensils and other paraphernalia. The walls and doors are covered with photos and quotes—the best among them including 'Life is brief

but my god Thursday afternoon seems incredibly long'—and the visitor can pick up the handset of an old Bakelite telephone to hear a radio interview with Whiteley by the late Andrew Olle. Visitors to the studio can also buy reproduction limited-edition Whiteley prints, books, Featherstone's documentary, cards, T-shirts and other items. It is here that the Brett Whiteley Travelling Art Scholarship has been awarded to a young, emerging painter every year since Whiteley's mother Beryl set it up in 1999. Administered by the AGNSW and publicised by its media team, the scholarship is yet another annual moment when the Whiteley name gets an outing. No other Australian artist has a flagship state gallery so intricately involved in buttressing their legacy, and it all helps.

There are no photos of Janice Spencer in the Brett Whiteley Studio, nor any reference to her in the studio's handbook. She gets two lines in *Art and Life*. How serious her relationship with the artist was, and how long it lasted, have been the subject of competing stories over the years. Wendy called the claim of a five year de facto relationship 'ludicrous' on the television show *Australian Story* in 2004; Spencer's friends painted a different picture, referring to her sorrow after Whiteley's death as 'disenfranchised bereavement'.[13] There were reports that she had been working on her own biography, 'The Last Five Years with Brett Whiteley', but such a book never surfaced. Whatever the reality, the absence of Spencer in the New South Wales Government–sponsored story is yet another reminder that decisions about artists' legacies, even those made by state employees, are not immune from the emotions and power of those involved.

In keeping with the fact that she worked with Whiteley to hang his shows, and often styled the internal scenes he

painted, Wendy's biggest contribution to the studio has been curatorial, namely overseeing each re-hang. In this she has tried to follow Whiteley's line. 'We always worked together, and I'm conscious when I'm hanging a show, in the back of my mind, about knowing that Brett would be happy with the way I did it, would be content, because he was very, very specific,' Wendy says. Those organising Whiteley shows elsewhere also tend to involve her. As well as being invited to co-curate with Pearce the AGNSW's 1995 retrospective, Wendy was asked by the then director of TarraWarra, Jane Scott, to curate its 2010 Whiteley exhibition. Wendy amused the crowd with her opening speech at the TarraWarra show, joking about wanting to clean some of the works with a dab of Ajax, much to the horror of the TarraWarra curators, and remarking how envious she was of the museum's numerous staff, compared with the studio, which 'struggles along ... with minimal funding'.

It was a pointed comment, which reflects the fact that the Brett Whiteley Studio is not what it could be. It certainly isn't 'to Sydney and Australia what the Picasso Museum is to Barcelona and Spain', as the then New South Wales arts minister Peter Collins envisaged when he opened it.[14] The Picasso Museum gets about one million visitors a year, the Whiteley studio 14 311 in calendar 2012. There are many reasons for this, including restricted opening hours due to its residential location in a Surry Hills laneway, and its maximum capacity of sixty people at any one time. Its $150 000-a-year operational grant from the AGNSW allows it to employ only one full-time staff member, who is paid for working four days a week but tends to do a lot more. Not for nothing does this chronically under-resourced museum advertise itself as 'Sydney's best kept secret'. Its operational grant has remained virtually unchanged

since it opened. But the lack of government vision is not the only reason the Brett Whiteley Studio has remained underdeveloped. In its first seventeen years as a public space it has lacked a strong, driving leader. The AGNSW staff are committed but stretched in many different directions, and Wendy has tended to be involved in curatorial decisions but not in setting its strategic direction or raising funds. Financial firm JP Morgan has sponsored free entry since 2007, with other income taking the studio's annual budget up to about $250 000 a year. But the Brett Whiteley Foundation, which oversees the studio and on whose board Wendy sits, is only now turning its attention to fundraising. Wendy has not seen it as her role to donate, and was affronted when the AGNSW suggested that she might like to help raise money for much-needed maintenance. She said no.

> Why did I say that? Because it was quite a lot of money, and because the government owned it in the first place, and it was part of the undertaking of the thing that they would do that. First of all to open it to the public, which meant they had to make some changes, like the public toilets and the entrance desk and all that kind of stuff, which was done on a shoestring. Then there are things that happen, like the roof needs fixing. But the family doesn't own the building. I thought that was the least they could do … I just said no. If you're going to start pushing this onto the [Brett Whiteley] Foundation or me, when you know full well that most of this stuff is going to be left to you at the end of [my life], then you have to make up your mind whether the government or the people of Australia want this thing or not. And that's the bottom line.

Change is, however, underway. Formal ownership of the studio is set to transfer from the New South Wales Government to the AGNSW, which means that it won't have to keep going direct to government for maintenance. The studio has also moved from being open to the public two days a week to three. Most of Beryl Whiteley's nearly $3 million estate has gone into the foundation to support her scholarship, which now looks secure into the future, and Wendy is mulling over whether to leave her own estate, including her Lavender Bay home and all the paintings on long-term loan at the gallery, to the AGNSW for the benefit of the studio. Before she does so, she wants to ensure the gallery is committed to keeping the studio open over the longer term. No doubt the closure of the Nolan Gallery at the Lanyon Homestead near Canberra in 2007 has exercised her mind about the risk of the AGNSW losing interest once she is no longer around. She is also working with the chairman of the foundation, John Meacock, to get a corpus of many millions together, the interest from which would underlay studio operations. Some of this will likely come from the sale of works in the estate.

The fund-raising job will not be easy. The best moment to convince people to contribute to the studio was probably in its early years, and raising money for day-to-day operations is difficult. On the other hand, it is in the interest of collectors who own expensive Whiteley paintings to stoke the fire. Pearce, who was responsible for the studio during his time at the AGNSW, hopes that a substantial capital fund could be the reboot needed. 'It is being run on a shoestring. It's a place that can't stretch its wings,' he says with frustration. 'It can't get too popular because the residents will complain, so it's never been given a really good go. All artist museums in the world have similar problems, but the

whole game could change if we got $8 million to $10 million in the foundation, so it could run on $600 000 to $700 000 a year.' Given the opening hours restrictions, Pearce would like to see the studio focus more effort on taking Whiteley to the world. It began touring shows from its collection in 2005–06. A show on Whiteley and one of his great early influences, Lloyd Rees, drew attendances of more than 5000 in Armidale in regional New South Wales—more than a third of the number who visited the studio in Surry Hills in 2012. Says Pearce:

> My dream is for the studio to stop being anxious about making itself more popular. If you put on a show there and you get 300 to 400 people a day, they'll be queuing in the street, the residents will complain and the council will get upset, so we can't be too popular. The foundation and the studio have to be a bit more like the Dobell Foundation, putting its energy out there in the community, by touring shows, doing publications, funding scholarships. A studio without walls. We happen to be located in Surry Hills, but don't make that the be-all and end-all of measuring your success. Measure your success by the dynamic influence you can have on the creative lives of Australians everywhere.

Like many artists' widows, Wendy appears to be in two minds about the whole legacy caper. She is keen to promote Whiteley as an artist, to do the best by his talent, yet gets annoyed by how much of her life the Business of Brett sucks up. There is something poetic about the fact that her garden is mentioned first in the citation for her 2009 medal of the Order of Australia, her role

as a 'supporter of the visual arts' second. 'Brett business' might fund it, via copyright fees and the sale of work when needed, but the garden is one achievement that has nothing to do with him. Perhaps her equivocation about the handling of Whiteley's estate reflects her mixed feelings about the man himself, from whom she was, after all, divorced. In 1995 art critic and academic Joanna Mendelssohn noted the cynic's quip that Wendy and Whiteley had enjoyed a rare 'post-mortem reconciliation',[15] so fully had Wendy taken on the role of artist's widow. Does she find it ironic to have ended up guardian of Whiteley's legacy?

> I don't find it ironic, but when I'm not in the mood for
> it I feel it's a fucking tragedy. And why didn't I change
> my name and say, 'Get fucked, I'm taking everything
> that's mine, and leaving this entire situation'? But at the
> time, when I made those decisions, my daughter was
> still alive, and I was thinking that she would probably
> end up with children ... When I die I don't want to
> leave another messy thing for someone to work out. So
> now I'm trying to think very carefully about how not
> to leave a mess.

As to that name, she says she did consider changing it, 'briefly, when I was really pissed off with Brett'. She continues:

> But I think I was equally pissed off with my father, so it
> was a catch-22 situation. Whichever name I chose had
> its own burdens, you know. Plus it would have meant
> a huge amount of reinvention at a time when I'd been
> a Whiteley longer than I'd been a Julius [her maiden

name]. And having to explain why, and everybody thinking it was just because you were pissed off with your husband or ex-husband.

Wendy had thirty-two years with Whiteley, literally growing up with him. She was intimately wrapped up in the creation of his work, serving as muse, stylist and life model, as well as wife, lover and combatant. Of course she has a sense of ownership over his paintings, metaphorically as well as, now, literally. The Family Court recognises the contribution of the wife in long marriages that end, but some in the art business find it harder to credit. Wendy does not have much time for those who question her motives regarding the garden or the studio. It's tempting to say this is the wisdom of age, but she probably never cared too much what other people thought:

> If I had a lot of people coming around saying what the hell are you doing this for, is it just to make your house worth more money, being suspicious of what I was up to down there [in the garden], I'd just walk away from it. If I felt the studio attracted nothing but negativity I'd walk away from that, too, because I'm not into pushing things down people's throats that they don't want. I'm perfectly happy, I'm old enough now to think I'll be dead soon, and it's not going to be my problem.

What remains her problem in this life, and a problem for many estates of well-known artists, is the issue of fakes. Plenty in the art world raises Wendy's ire, but little as much as this.

Chapter 4

The F Word

I don't want to spend my life being angry running around after some crooks.

WENDY WHITELEY[1]

In 2010 a series of highly priced Lavender Bay paintings, all purported to have been painted by Brett Whiteley in 1988, turned the spotlight onto the fraught issue of problematic paintings, a term that covers everything from fakes to works that have been incorrectly catalogued, to ones that don't have supporting provenance. It was a reminder that one of the biggest bugbears of those managing the estates of well-known artists never seems to go away.

The first of these paintings to come to light was *Orange Lavender Bay*, bought by Sydney prestige car seller Steven Nasteski for $1.1 million in December 2009. Nasteski bought it via Melbourne dealer John Playfoot, who was acting as an agent for fellow Melbourne art dealer Peter Gant, who was acting as an agent for ... This is how it can work on the secondary art market; various dealers try to sell a high-value painting, the successful seller as well as those down the line taking a cut of

the ultimate sale price. The purchaser doesn't always know who or even how many dealers are involved, or indeed who the ultimate vendor is—the identity of the latter is often kept secret. *Orange Lavender Bay* had been shown to other collectors before Nasteski bought it, but none was prepared to pay what was then a higher asking price.

A good-looking, fast-talking man in his late thirties, Nasteski entered the Australian art market with a splash in the mid to late 2000s, buying up big at a number of commercial galleries and through private purchases. Some works he would keep, others he would on-sell relatively quickly. In the late 2000s his purchases became a crucial source of income for a number of galleries doing it tough during the downturn. Nasteski is particularly keen on Whiteley, and has bought some of the artist's paintings directly from Wendy. Those works, he assured her, he would not resell. *Orange Lavender Bay* was not a painting he intended to keep for long, however, and soon after buying it he took it to auction house Deutscher and Hackett with a view to selling it. Initially excited, Deutscher and Hackett considered putting it on the cover of its April 2010 auction catalogue. However, directors Chris Deutscher and Damian Hackett became uncomfortable with the painting as soon as they started looking into its history. Conversations with Brett Lichtenstein, who had been Whiteley's framer, and with Whiteley's art dealer Stuart Purves, raised some alarms. The painting's supporting documents included a catalogue for a 1989 exhibition at Gant's Melbourne gallery, which was said to have featured *Orange Lavender Bay*. They had this catalogue forensically tested; it was found unlikely to have been published in the stated year. Nasteski then had the painting forensically tested, the results of which cast further doubts

on its authenticity. He lodged a complaint with Victoria Police, but dropped it when Playfoot, who had signed the sales invoice, agreed to repay him his $1.1 million in instalments. Playfoot now has the painting in a warehouse and is trying to recover his money from Gant, who is bankrupt. Two other Whiteley paintings featured in that same 1989 catalogue, and mentioned along with *Orange Lavender Bay* on a consignment note purportedly written by Whiteley's studio manager Christian Quintas, subsequently came under suspicion: *Big Blue Lavender Bay*, for which Sydney investment banker Andrew Pridham had paid $2.5 million in 2007, and *Lavender Bay Through the Window*, which Gant had reportedly given to a Melbourne restaurateur to pay off some debts.

It is in part because of cases like this that Wendy is vigilant with copyright, requiring auctioneers send to her for copyright approval images of all works they intend to publish in their sale catalogues. But when works are sold privately, as happened when Nasteski bought *Orange Lavender Bay*, there is often no catalogue or other advertisement for the sale. Thus there is no need for copyright to be cleared. It is perhaps no coincidence that all three paintings were dated 1988, one of the years in which Whiteley and Wendy were separated, and thus one in which Wendy could not categorically say, 'I was there. I know he did not paint that.' The woman who was there at the time, Whiteley's then girlfriend Janice Spencer, is no longer alive so—rather conveniently—she cannot be consulted either. One of the questions Wendy most dislikes is whether she would know if they were done by Whiteley, given that she was not with him in 1988. 'I know what's a Whiteley and what's not,' she says sharply. 'Whatever people think about Brett and his line, some

days he had a bad hair day … I know what Brett looks like, I know what a line looks like, I know the way he painted those Lavender Bays.'

It's easy to understand Wendy's frustration; she has been dealing with problematic paintings on and off for years now. In the 1990s 'innuendos', or imitations of works by Whiteley and other artists, were being sold to Sydney eastern suburbs collectors by the Paddington dealer Germaine Curvers. The works were actually painted by William Blundell, who admitted to having created hundreds of them and claimed that Curvers knew they were copies done for decorative purposes only. Curvers was dead by the time Blundell made this claim but earlier, when Curvers was alive, Wendy confronted her about the paintings. Curvers, Wendy recalls, retorted that as the ex-wife she did not know everything Brett had painted. 'The woman had balls, I'll give her that,' Wendy says. 'She looked like Zsa Zsa Gabor's mother, covered in gold, and the Hungarian housewife hairdo. Tough as nails. She just said: "You don't know everything that Brett did." And I said, "That's true, Germaine, in many fields, but I do know what he didn't do, and that's the point of this discussion. He didn't do any of these things that you've been schlepping around the neighbourhood for the last however many years."' The contents of Curvers' estate, including many of these innuendos, were put up for public auction following the dealer's death. Along with Purves, Wendy attended the auction and told the crowd not to buy any of the 'Whiteleys' because they were not real. Just to be sure, she bought them herself, then destroyed them. 'I have a bag full of shredded fakes, which I thought I'd put in the [Brett Whiteley] Studio as an art object, tie a bow around the top.' Wendy's anger on this subject helps convince

dealers and auction house executives to run Whiteley images by her before consigning them for sale, or risk her wrath. She might not be foolproof, but she's as good a counter as exists to the underlying problem with Whiteley's oeuvre, which is that he sold artworks directly to a range of people, as well as selling through galleries. Known as a 'leaky oeuvre', this makes it much more difficult to definitively say what he did and did not paint, because gallery records tell only a partial story.

That questionable artworks are rarely destroyed is one of many problems that stop anything meaningful being done about fakes. It leaves open the risk that they will one day be recirculated, selling to the most gullible bidder. If there is one sector in which insider knowledge is valuable—about which dealers are reputable and which are sharks, which artists have problematic oeuvres and which are relatively watertight, which items have been around the market and/or have question marks hanging over them—then the art sector is it. It was an extremely rare case, then, when the Victorian Supreme Court ordered that three artworks attributed to the artists Charles Blackman and Robert Dickerson be destroyed because they were not by those artists. Justice Peter Vickery found in 2010 that the Carlton dealer who had sold the artworks—Peter Gant—had breached the Fair Trading Act by doing so, although he did not make a finding on whether Gant knew the works in question were fake. Of great help in the case was the fact that Dickerson, despite being eighty-five at the time and frail, went to court and stated categorically that he did not do the artwork in question.

Robyn Sloggett, director of Melbourne University's Centre for Cultural Materials Conservation, does not like the term 'fake';

the legal hurdles that need to be jumped to prove that a work is a fake are onerous. Coupled with the laws of defamation, they make bandying about the f-words—'fake', 'fraud' and 'forgery'—perilous. Hence Sloggett uses the more cautious phrase, 'cannot be ascribed to the artist's oeuvre', which encompasses everything from works about which there are some doubts or inconsistencies, including innocent errors in naming, dating and cataloguing, to those it seems pretty certain were not done by the artist in question. Not surprisingly, talk about fakes is higher during boom times, and falls away when the market is flat. The reason it is more of a problem for estates than for living artists is simple: the artist is no longer around to state unequivocally that he or she did not create that work. It is not just the actuality of fakes that plague artists' estates, though. The spectre of fakes is just as damaging in a sector that is easily spooked, and which runs on sentiment. The mere suggestion of a painting being 'not quite right' is enough to dissuade informed collectors and thus destroy a work's chances of fetching a good price. Works can be both fairly and unfairly tainted. And yet to prove that a painting is 'wrong' is extremely difficult. Works that fall in the middle ground—those that are suspect, but not provably so—often end up in no-man's-land. On some occasions a work is sold off quietly to an unwary buyer who is oblivious to the doubts surrounding it. At other times the vendor retains it, seething that its monetary value has been destroyed by rumour and innuendo.

The word of the artist's partner or family member counts for something in the fight against fakes, and is one of the main reasons they ask to approve copyright for images of works going up for sale. A blank space in an auction catalogue is a

red flag, suggesting at the very least that more questions should be asked. But family members are not invincible. Lyn Williams mistook a problematic Fred Williams painting for a real one in 1988, no doubt one of the reasons she has been so thorough in building an online database of all the artist's oil paintings. Art auction executives and dealers are fond of pointing out that family members of artists do not always know everything that was created, and that sometimes an expert in the artist's oeuvre will be a better judge. Family members are equally keen to point out that supposed art experts are fallible. Both are true. A handful of reputable auction executives saw *Orange Lavender Bay* without raising concerns about it before Deutscher and Hackett became suspicious.

One of the few prosecutions for art fraud in Australia was of Melbourne couple Ivan and Pamela Liberto, who in 2007 were found guilty of six charges of obtaining a financial advantage by deception after selling works they had themselves painted as those of the famous Indigenous artist Rover Thomas. The well-dressed, elderly couple from the upmarket Melbourne suburb of Toorak fooled executives from three auction houses before the then head of Aboriginal art at Sotheby's, Tim Klingender, got suspicious and called in the police. The prosecution succeeded in part because the Libertos were caught red-handed—partly finished paintings were found in their Toorak apartment. Victorian County Court judge Roland Williams sentenced them to three years' jail, of which at least nine months was to be spent in custody.[2]

Over the past two decades Sloggett's Centre for Cultural Materials Conservation has developed a burgeoning commercial sideline assessing problematic paintings. As Sloggett explains, it

is a matter of building a case that would hold up in a court of law, and that's no easy thing. She and her team subject paintings to a barrage of tests, ranging from chemical analysis of the paint used to the measuring of brushstrokes, and consider questions based on art history, such as whether the work fits into an artist's oeuvre, whether the frame is of the kind that was used at that time, whether the provenance or ownership trail holds up, and so on. Since 1991 the department has constructed detailed databases on many Australian artists, spanning paints, brushes, series and so on, against which it measures new works that are brought in for analysis. It's not always easy to give a definitive answer, and yet that is often what clients are looking for. 'You have to make it hard for yourself,' Sloggett says. 'When a work comes in someone has usually raised questions about it, but the market raises questions for a whole lot of reasons—to discredit someone, or because they don't particularly want a work to go to auction, or they don't want to deal with a particular person. Our job is to put up competing views and test them. So we say, "This isn't by Arthur Streeton; he preferred three types of brushes and this one seems to have used fifteen types of brushes." But how do you know he wasn't experimenting? Good question. So we'll test that.' Sloggett is particularly interested in the effect art fraud has on artists and their family members. 'It's dealt with legally as an issue about property, but actually it's about identity, particularly if you're talking about Aboriginal artists. If they're seen to have given the wrong story out, one they had no rights to, then it's a crime in Aboriginal law, often with consequences. So a fake work can have really serious repercussions. And for all artists there is the issue of how they respond to it. "I feel so debased I don't feel like painting"—that is not an uncommon reaction.'

Oliver Streeton has spent a lot of time photographing and documenting the work of his grandfather Arthur Streeton, to help establish authenticity. An amiable man in his early seventies, Oliver talks freely about the things he looks for that might suggest a painting is wrong. They include many tiny clues, such as whether a painting depicts a place he knows his grandfather visited that year; whether the gum trees are of the kind that were found in that area; or whether the apartment block in a picture actually existed in the year it was supposedly done. Rather than having the job bestowed upon him, Oliver took on the role of guardian of the Streeton legacy of his own volition. Arthur Streeton died when Oliver was two years old, and thus he never knew the grandfather to whose work he has dedicated a large part of his life. 'Maybe I felt it was a sort of duty or something,' Oliver says over coffee in a café near his home in Toorak, Melbourne. 'Also, the question of authenticity kept coming up.' There are times when he is not always keen to be thanked in the subsequent catalogue entry. 'Sometimes they will say "thanks to Oliver Streeton", but I've tried to avoid that, because they will on occasion thank me when I haven't actually helped, or when they have got the title wrong and I think, Please don't, that's not what I would have said. My name has in the past been used deceptively when I have expressed doubt, but there it is, in print, appearing to endorse the entry.'

After years of looking at Streetons, Oliver is fairly confident about his eye, although like most in his position, he has got it wrong. He concedes that he did not pick two problematic Streetons when Melbourne dealer Lauraine Diggins showed them to him in 1998. Geoffrey Smith, then a curator at the NGV and working on a show on Streeton, raised the alarm with

Diggins after viewing the show. Diggins took the paintings to Sloggett, and after some to-ing and fro-ing asked her to subject them to the full suite of tests, including dissolving some paint to test its age. Sloggett's resulting report raised enough questions for Diggins to take the matter to police and refund the purchase price for the Streeton that had sold. The dealer also wrote to everyone who received her catalogues explaining what had happened, and included a sticker for the recipients to place in the offending catalogue, which advised that Lauraine Diggins Fine Art did not guarantee the authenticity of the disputed works. Constrained by legal advice at the time, neither Sloggett not Diggins called them fakes. 'My catalogues are held in libraries and various public institutions Australia-wide and internationally, and I did not want the provenance of these paintings to continue as sound,' Diggins explains.

It is clearly still a sensitive issue for the dealer, who is frustrated at what she says is a lack of certainty offered by forensic authenticity reports. Sloggett points to the need for evidence that will stand up in court as the reason why her reports do not definitively declare works fake. Diggins and Oliver Streeton say they learned valuable lessons from the experience, in Oliver's case to look at problematic paintings against ones he knows are real. When he did this with Sloggett as part of the testing, he could immediately see the difference.

While the report from Sloggett was enough to convince Diggins to refund the purchasers' money, the police at the time did not take action against the source of the paintings. The difficulty of proving that a painting is a fake is one of many reasons why there never seems to be much progress in the field. Others include that the police require a complaint to investigate,

and do not have squads dedicated to and trained in art fraud. (Victoria Police dropped its investigation into *Orange Lavender Bay* after Nasteski withdrew his complaint.) Nor is there a national register of suspect paintings. Publicity is one of the best means of ensuring that a fake painting does not get resold, but collectors and dealers are often loath to admit that they were duped, and would rather deal with the matter quietly.

Above and beyond the word of either family members or art experts, the best protection against fakes is a catalogue raisonné, preferably one produced in the artist's lifetime. An exhaustive, scholarly list of all the work done by a particular artist, this will sometimes cover the entirety of their work, while in other cases it will be just a specific area—for example, oil paintings or prints. The vast majority of catalogues raisonnés are for artists in Europe and the United States. Surprisingly few Australian artists have one, reflecting the cost and work involved in producing them, and the tiny market for Australian art. As a publishing exercise they are mostly uncommercial, but as protection against fakes they are gold. Yet there are not enough of them. Even an artist as well collected as Arthur Streeton does not have one, although the NGV is working with Oliver on an archive of all available research on Streeton. There is only a partial one for Brett Whiteley, encompassing his work up to 1967—contained in Kathie Sutherland's 2010 book—but it is in the later years that most of the problems for Whiteley's oeuvre arise. Fred Williams does not have a complete catalogue raisonné either, although Lyn's electronic database would be pretty comprehensive on his oil paintings. Contemporary painters who show through reputable commercial galleries are likely to be in a better position than their predecessors because good records are now kept, with

every artwork photographed and catalogued by the gallery. It helps, too, if an artist has stayed with the one gallery for most of their career.

John Brack worked with art historian Sasha Grishin on a catalogue raisonné of all his oil paintings, which was published back in 1990, long before the Brack market seriously took off. Brack's methodical ways made the job easier than it might have been for some artists. He had noted each work in a record book, including when a piece was completed, and destroyed the working sketches. It is no coincidence that Helen Brack has had fewer problems with fakes than some of her estate counterparts. Grishin believes catalogues raisonnés should be compiled for more Australian artists, particularly Indigenous artists such as Rover Thomas and Emily Kame Kngwarreye, for whom many problematic paintings have come to market. 'If there's a first wives club, there should be an artists' widows club, and among the rules should be to get yourself a catalogue raisonné,' says Grishin.

One of the greatest gifts Ben Gascoigne gave to his children was the database he began creating of his wife Rosalie Gascoigne's work. In electronic form, the catalogue comprises 650-odd works created by Gascoigne between 1975 and her death in 1999. Says the couple's son, Martin: 'Thanks to his science training Dad knew how to keep good records. He took photos and started working on a catalogue, with the title, dimensions, material, where each work was exhibited and so on.' For his own part, Ben quipped, 'it meant that I was now accepted in art-going circles not so much as Rosalie's Prince Philip–type husband, [but] more as her archivist and photographer.'[3] Ben's work ensured that the artist's children had a comprehensive

record of their mother's achievement (useful also for curators planning major exhibitions), and his systematic approach meant that they could act with confidence when asked to authenticate works purported to be by Gascoigne. While there are many copycats, Martin says he has only come across a handful of works purporting to be by his mother that might not be. The database is a good start from which to develop a full catalogue raisonné, a task Martin has been working on. 'Eventually, some time before the anniversary of Rosalie's 100th birthday in 2017, I would like to see the catalogue raisonné published,' he says, adding that it 'raises a whole heap of practical issues' about whether to do a traditional hard-cover book or something electronic. The complete catalogue raisonné for New Zealand artist Colin McCahon has been published online, its upkeep funded by copyright fees and overseen by a trust set up by members of the McCahon family and two public museums. But perhaps one of the best examples of the benefit of a catalogue raisonné can be seen in the case of Indigenous artist Paddy Bedford, whose story touches on many other issues, and thus deserves a full telling.

Peter Seidel, a partner at Melbourne law firm Arnold Bloch Leibler, talks about the day he took the East Kimberley artist Paddy Bedford to meet a group of Federal Court judges. Seidel had handled the legal work for Bedford and the art centre he painted for, Jirrawun Arts, on a pro bono basis since the early 2000s. Bedford's paintings were selling well, to influential members of Melbourne's legal fraternity among others. Bedford was one of eight Indigenous Australian artists

chosen to create paintings that were rendered onto the walls, ceilings and pillars of France's Musée du quai Branly, which opened in June 2006, and in December that year Sydney's Museum of Contemporary Art opened a solo show of his work. A senior law man within his community, it was Bedford's talent with a paintbrush that caused him to be feted in Melbourne that day by some of the best legal minds in the country. There were about fifteen judges in the Federal Court judges' chambers, none of them a woman, but it didn't stop the wheelchair-bound Bedford from beginning his speech with 'Hello ladies and gentlemen'. The microphone let out a few of those high-pitched squeals that microphones emit when the speaker gets too close. The artist went on: 'I'm Paddy Bedford. I know blackfella law, I know whitefella law. I am the law.' Seidel had to use all of his willpower to stifle the giggles. 'He said it so authoritatively, it was just brilliant,' the lawyer says. 'You can just imagine the judges thinking, Hang on mate, we're the law.' The judges were sitting around a horseshoe-shaped table, and when the meet-and-greet ended Bedford was wheeled around to say goodbye. Shaking his hand was not an option. 'He high-fived every single one of them,' says Seidel with a laugh. 'He was so conscious of being a rock star. That was him, he was a total character.'

Seidel has many other stories about Bedford, one of numerous Indigenous people he has represented as Arnold Bloch Leibler's partner in charge of pro bono and public interest work. If the judges' meeting is among the funniest of those stories, the most moving is the trip the lawyer made to Kununurra in far northern Western Australia to say goodbye to the artist, who died in July 2007, aged in his mid eighties. 'I arrived in Kununurra at about 9 pm. I was completely exhausted and said I'd go to bed and

see Paddy in the morning. "No, you won't," I was told, "You're going to see him now." I walked into his room and he was there, fully dressed, waiting for me. That was Paddy, an incredibly dignified gentleman.'

Bedford's estate is not handled by his wife (who died before him), nor by his children, but rather by two white people, namely Seidel and his co-executor, Kununurra linguist Frances Kofod. This is typical of the estates of many Indigenous people living in remote communities. The executor of the estates of Rover Thomas and Queenie McKenzie is Kevin Kelly, owner for seventeen years of Red Rock Art Gallery in Kununurra; Emily Kame Kngwarreye's estate is handled by the Public Trustee of the Northern Territory; and the estate of Ginger Riley Munduwalawala is handled by Beverly Knight, owner of Melbourne's Alcaston Gallery. Family members may be beneficiaries, but they don't tend to drive the decision making or reputation building in the way that, for example, Lyn Williams, Wendy Whiteley and Barbara Tucker do. Artists' estates are a white construct that many in remote Indigenous Australia are not interested in. Kofod says in addition to this, in Bedford's case his children did not live where he painted and had not been involved in his artistic career. Bedford's estate is different from many others in that it was set up from the start with best practice in mind. It's almost as if someone saw what Lyn Williams had done and decided to transport the best of it into Indigenous Australia. Says Kofod: 'It was to counteract what had happened with other artists, whose works were purchased at cut-price rates then sold at vastly inflated prices at auction, with neither the artists nor their families benefiting.' Most crucially, Bedford has a catalogue raisonné, which gives collectors of his work a certainty

that many other artists, black or white, lack. It's likely thanks to this that Bedford's prices have remained relatively stable at a time when the overall market, particularly that for Aboriginal art, has fallen sharply.

In the decade before he died, Bedford was talked about as being the next Rover Thomas—another from the hot, harsh, north-west of Australia and one of the country's most famous Indigenous artists. Thomas died in 1998, coincidentally the year that Bedford, then in his mid seventies, started painting in earnest. Bedford was the Rover Thomas you bought when you couldn't afford a Rover Thomas; or, to put it another way, the chance to get in with an artist of similar ilk before his prices really shot up. Not that Bedford came cheap after the first few years—while his paintings were selling for less than $10 000 in 2000, by the time he died, in mid 2007, the largest ones were selling for $60 000. Bedford painted many of his works on the verandah of Kofod's Kununurra home. She says he had wonderful hand–eye coordination and a sensibility that set him apart from other artists. That final decade was a contrast to the previous seven of Bedford's life. A Gija man, he was born on the Kimberley station Bedford Downs and named after its white owner, Paddy Quilty. He was sent to a leprosarium in Derby in his teenage years, despite not having leprosy, returning to Bedford Downs in the late 1950s, where he spent years toiling as a stockman for rations. When equal pay was introduced in 1969 he and other black workers were forced off the land, after which he went to work on the roads, before injury eventually forced him onto welfare.[4] Then, at an age when most men have retired, he started painting, a move that took him out of the Kimberley and onto the national and international stage.

Jirrawun Arts, the centre for which Bedford painted, rode the final decade of the three-decade-long Indigenous art boom to a meteoric high, combining blue-chip 'whitefella' contacts and compelling artist stories to sell the kind of minimalist paintings that collectors love. Bedford was first among equals in its stable of artists, which also included Freddie Timms, Goody Barrett, Rammey Ramsey, Rusty Peters, Peggy Patrick and Phyllis Thomas. The MCA's 2006 survey of Bedford's work proved enormously popular, attracting 80 048 visitors during a Sydney run that was extended for two months due to its popularity, and touring to Perth, Brisbane, and Bendigo in Victoria. Although frail, Bedford attended the exhibition's opening in Sydney but he died before it finished its tour of the country. Despite the public lauding, he was troubled at the time of his death due to fighting between some of the art centre's key people, among other things about who had responsibility for him. Nobody knew it at the time, but it was the beginning of the end for Jirrawun, which within the next few years would become mired in debt and unhappiness. By 2010 Jirrawun had stopped producing art and had begun selling off its assets, starting with its gleaming white studio, which had only been built in 2005–06, and ending with the slow dispersal of its stockpile of paintings.

Unlike many Indigenous people living in remote communities, Bedford had a written will when he died. Seidel had drafted wills for many of the Jirrawun artists in 2003–04, after their income reached a level where they were susceptible to humbugging, or being pestered for money by friends and relatives. Bedford's will made Seidel and Kofod co-executors of his estate. It dictated that half of the proceeds of his estate go to Jirrawun Arts, at that stage a charitable organisation that produced and

sold art, with the balance to be split between about half-a-dozen other beneficiaries, one of which was an education trust. In choosing these beneficiaries Bedford highlighted his desire to turn his artistic success into something of lasting good for the highly disadvantaged community in which he lived. The Paddy Bedford Education Trust was set up to run for twenty-one years, with the interest from its capital to be spent on the schooling needs of a handful of named beneficiaries, about twenty to thirty individuals, mostly relatives of Bedford. It is administered by Arnold Bloch Leibler, with Seidel and Kofod making the strategic decisions about where this money should be spent, and another lawyer from the firm executing their decisions. 'Paddy had real pride in the fact that after his death he would be contributing to the wellbeing of a lot of potentially very disadvantaged kids. It's probably educating about ten children, paying for things like tutorial lessons, the cost of a mentor if the child is boarding in Perth, air fares, school uniforms, computers,' says Seidel. 'It's pretty basic. There's governance there, but we don't want to create something too bureaucratic. We say to the families involved, "It's up to you. Tell us what you need, give us the requests and receipts and we go from there."'

Bedford's estate was strategically constructed almost from the moment he found success. This was partly because he was already in his seventies when he started painting, and thus death, and what to do when it came, was never far from anyone's mind. Critically important, too, were his advisors, first among them the co-founder, chief executive and guiding force of Jirrawun Arts, former Melbourne gallery owner Tony Oliver. If Jirrawun was more man-made construct than organic movement, then the maker was Oliver. Seidel, who began his relationship with

Indigenous Australia in the mid 1990s representing Victoria's Yorta Yorta people in their historic native title claim, was also an important player in establishing how Bedford's estate would be managed, bringing the best of Arnold Bloch Leibler's brain-power to the Jirrawun cause. 'Our firm works for high-net-worth individuals, that's our client base, so I tapped into our estates experts in building Paddy's will,' he says. 'He was becoming a high net worth individual, and Jirrawun was becoming for us the model pro bono public-interest law client.' Some might say the Bedford estate is too clever by half, and that the subsequent demise of Jirrawun highlights the folly of overlaying white struc-tures onto black Australia for an ideological end. Others would argue that the winding down of Jirrawun simply reflects the downturn across the entire art market after the global financial crisis, and the importance of individual managers to the success or failure of remote Aboriginal art centres. Wherever the truth lies, Bedford's estate had two other unusual things going for it, namely the published catalogue raisonné produced for the MCA exhibition, and the 150-odd works left in the estate, a virtually unheard of number for an artist from remote Australia with less than ten years' painting under his belt, who had sold well during his lifetime. Bedford painted about 630 paintings all up, highly productive for a man in his late seventies and early eighties. Some question the high number of works left in Bedford's estate after he died. In this most rumour-fuelled corner of the art sector, it was the innuendo attached to such questioning that led to Seidel's involvement. Seidel says:

> Someone was overheard saying these paintings are too
> good for Paddy Bedford, they must have been painted by

Tony Oliver. Tony was obviously very offended by that, as was Paddy. When you unpick it, it's such an arrogant thing to say, that it's too good for this artist. So Tony asked on behalf of Paddy whether it defamed him and Paddy. I remember the conversation: Paddy got on the phone and in Kimberley Kriol he spoke very passionately, and very strongly, about the offence it was causing him, and I heard that loud and clear. So I wrote a couple of letters on behalf of them, and the relationship started from there.

Bedford started putting works aside for the estate as soon as his will was drafted. By way of contrast, Kevin Kelly says there was very little work or money left in Rover Thomas's estate when he died, and about fifty works in that of Queenie McKenzie. This was much more the norm for the estates of successful elderly Aboriginal artists. Melbourne Gallery owner William Mora held Bedford's first solo show at his Richmond gallery in 1998, and has been put in charge of the slow dispersal of works from the artist's estate. The son of Georges Mora and his artist wife Mirka, he is one of only a handful of second-generation Australian gallery owners. He went out on his own in the late 1980s rather than work for Tolarno Galleries, which his father established in 1967 and ran until his death in 1992 (it was subsequently sold to its current owner, Jan Minchin, who worked for Georges before buying the gallery upon his death). 'Most successful Aboriginal artists never have an estate because they sell everything they paint,' Mora says. 'This estate was set up so that once a painting went into it, it couldn't come out while Paddy was alive. They put a little sticker on it and that was it. You couldn't buy it, it had to go to the estate.'

Bedford's story is intricately entwined with that of Jirrawun Arts, which was founded in 1998 by Oliver and Freddie Timms, after a 1996 meeting in which Timms asked Oliver for help because he felt ripped off by a Melbourne gallery that paid him a few hundred dollars for a month's worth of paintings. Oliver knew the art world and how it worked, having run his own gallery in the Melbourne suburb of Fitzroy through much of the 1980s, where he had shown American artists such as Andy Warhol, Roy Lichtenstein and Philip Guston among others. Oliver's ambition upon arriving in Kununurra was to create an art centre that dealt with its artists, and their commercial galleries, as it would with non-Indigenous painters. Not welfare; commerce. Not dependence; autonomy. Thus consignment agreements were written in which the artists retained owner-ship of their work until it was sold through a gallery. (Many Indigenous art centres sell their work outright to galleries, which then price it as they see fit.) With Arnold Bloch Leibler's pro bono support running into hundreds of thousands of dollars by this time, Jirrawun became a company limited by guarantee, a structure that allowed it to accept tax-deductible donations. The money that came in from the sale of paintings was used to pay the artists regular stipends, regardless of whether their individual works had sold or not. This practice later caused big problems, but in 2007 Jirrawun was one of two art centres singled out for praise by a Senate committee that looked into the Indigenous arts and craft sector, not least because it was surviving without government funding.

Under Oliver's tutelage Bedford painted not only his cockatoo, emu and bush turkey Dreamings, but also the killing of some Aboriginal men by station owner Quilty in retaliation

for the theft of a bullock that took place not long before he was born.[5] Oliver curated an exhibition about this and other colonial killings on Gija country, *Blood on the Spinifex*, which showed at Melbourne University's Ian Potter Museum of Art in 2002. The next year the AGNSW held a show focusing on East Kimberley artists. Staged in Australia's two biggest cities, these exhibitions lent kudos to a group that was already proving popular with collectors.

People rarely buy art purely on the basis of marks on canvas, even less so when it costs a lot of money, and Jirrawun had a second-to-none list of supporters from whom new collectors could draw confidence about their taste and ethics. Early collectors included Colin and Elizabeth Laverty, a Sydney couple with one of the biggest private collections of Indigenous art, as well as members of Melbourne's legal community. Word of mouth spread through the connection with Arnold Bloch Leibler, where Jirrawun paintings lined the boardroom walls. As Mora notes, 'It doesn't hurt to have one of your paintings hanging behind [ABL senior partner] Mark Leibler when people are in there discussing their multi-million-dollar tax issue.' Another could sometimes be seen behind Ron Merkel QC, as he discussed asylum-seeker issues on the evening news. Jirrawun's patron was former governor-general and High Court judge Sir William Deane, who developed a close relationship with Bedford and gave a eulogy at his memorial service. New South Wales Governor Marie Bashir was also a supporter. The board was peppered with high-flying business people, Qantas and Rio Tinto sponsored various shows, and respected Indigenous affairs academic Marcia Langton sat on the board for some time. With that list of supporters it's not surprising Jirrawun found a way to exhibit in Parliament House,

Canberra, in 2005, and in 2008 at the prestigious Australian Club in Melbourne, where Mora hung Bedford alongside works by Fred Williams in a show titled *Masters of the Australian Landscape*.

Jirrawun Arts sold through top contemporary art galleries: Mora in Melbourne, Chapman Galleries in Canberra, Short Street Gallery in Broome, and Watters Gallery, Martin Browne Fine Art, Grantpirrie and Sherman Galleries in Sydney. Grantpirrie took its artists to the US art fair Art Miami in 2002, and Mora brought them to the Melbourne Art Fair in 2006. But by the mid 2000s, at the height of the art boom, Oliver had another idea: what if Jirrawun sold direct from the Kimberley via the internet and to fly-in, fly-out visitors? Among other things it would save itself the gallery fee, which in most cases is about 40 per cent of a picture's sale price. A bank loan was obtained to build an $800 000 architect-designed studio on a property near Wyndham in far north Western Australia. An air-conditioned, hangar-like space, it would serve as an impressive gallery and painting space. During its heyday Jirrawun put some of its newfound wealth into police efforts to reduce crime, and into a health advocacy spin-off, Jirrawun Health. The dream was always about more than just selling pictures. 'The idea was not just to have something beautiful and worthy of the artists, and of international studio standard, but also to place the bulk of our economy in country, so we no longer have to give commissions to galleries,' Oliver told Nicolas Rothwell of *The Australian* in 2007. 'Aboriginal people will run their own space up here and dealers in the south won't have control of the product. To be truthful, if we're going to sacrifice work for galleries, we think it's better to do that in Europe or Asia, where we're building an international market.'[6]

That Bedford ended up as one of the few Australian artists with a catalogue raisonné is no accident. The curator of the MCA's exhibition, Russell Storer, says that the gallery got sponsorship from Argyle Diamonds to produce the catalogue, and that Jirrawun's operational methods made it relatively easy. Good records were kept of every work done, and their release onto the market was managed slowly and carefully. Even the size of the paintings was restricted. Bedford did 300-odd gouaches on 51 cm by 76 cm boards, about sixty paintings on custom boards measuring 80 cm by 100 cm, and more than 260 paintings on Belgian linen, mostly 150 cm by 180 cm or 122 cm by 135 cm. There wouldn't be too many artists whose oeuvre is so neatly contained. 'Jirrawun had very thorough records, including photos, and Paddy painted over such a short, intense period, that it was really quite a simple, straightforward thing to do,' recalls Storer. Mora sees the catalogue raisonné as a great advantage in wooing collectors, because in an area of the art market that is beset by fakes it provides certainty. If it's in the MCA's book, it's okay. If it's not, well, at the very least, dig further. The reputations of Rover Thomas and Emily Kame Kngwarreye have been damaged by fakes, made easier to get away with because they painted for a range of different people. Bedford did paint outside of Jirrawun for one stint, when he went with a friend to Derby for a few weeks. The estate does not recognise the paintings done during this time: 'We don't say [they're] fake—that's none of our business. Auction houses want approval from the estate that it's a Paddy Bedford work,' Seidel says. 'We say this doesn't appear in any of the records, so we can't authenticate it.' There are more of these works out there than Seidel and Kofod think Bedford would have done in

just a few weeks, allowing for the possibility that some of them may be fakes.

With about 150 works left in Bedford's estate, including prints, the issue after Bedford's death became how to sell them, through whom and over what time frame. As the estate's sole agent since 2008, Mora plans to release the remaining works onto the market over a period of five to ten years, with international collectors the focus of his selling efforts. 'Western Europe has about 400 million people, Australia has 20 million,' says Mora in explanation of the strategy. 'At this stage he's in all the major public and private Australian collections. Given his prices and the size of the Australian market, it seemed obvious that we had to look overseas.' Mora showed Bedford at the inaugural Cornice Art Fair in Venice in 2007, and in 2010 a five-painting commercial show was held in Geneva. Locally he sold close to $500 000 worth of paintings from Bedford's estate through an exhibition at his Melbourne gallery in 2009, *Bury My Heart at Bow River*, including one for $230 000.[7]

Mora planned to hold a second commercial show at his gallery in 2011, but opted instead for a stand-alone auction by Bonhams, which was in the throes of re-establishing itself in Australia as a fully owned subsidiary of the UK-based international group. The auction, held on 21 November 2011, featured twenty-six paintings from the Bedford estate, most of which had never been on the market. Bonhams toured highlights of the auction to New York and London, as well as Sydney and Melbourne. The market for Indigenous art in 2011 was anything but strong, and a number of Bedfords had passed in at auction in the previous few years. The paintings in the Bonhams auction were priced from $40 000 to $60 000, $80 000 to $120 000, and $150 000 to

$180 000, depending on size and style, with the gouaches at $7500 to $10 000. Twenty of the twenty-six sold on the night, eight of them to international buyers, grossing $1.1 million against a low estimate of $1.5 million. While under expectations, it was a good result in a year that was generally terrible for Aboriginal art sales. Mora sees the next challenge as getting some Bedford works into international public museums and more private international collections. He is open to doing this via strategic gift; he has watched with interest how Lyn Williams has done that. 'You're instantly in a museum. If private collectors follow the lead of institutions, then it's a good place to be,' he says. 'And often these institutions rely on gifting, as they don't have the funds to buy, particularly the really expensive works.'

Playing out in the background as Mora, Seidel and Kofod worked to promote Bedford in Australia and internationally has been the demise of Jirrawun, the art centre that was so dear to Bedford's heart. Getting to the bottom of what went wrong, and who is to blame, is an almost impossible task. Kofod is highly critical of many decisions made with regard to its management once Oliver left, but does not want to go into detail. Seidel has thrown his hands up at trying to work out exactly what has happened. 'I feel very sad about Jirrawun. The more I know about Jirrawun the less I know,' he says. What everyone does seem to agree on is that the beginning of the end of Jirrawun came when Oliver, burnt out and devastated by Bedford's death, left the Kimberley for Vietnam. That was in 2007. In an unfortunate piece of timing, Oliver's departure coincided with the global financial downturn, which had a shocking effect on art sales, most particularly Indigenous ones. According to chairman Ian Smith, sales through Jirrawun fell from $2.1 million in 2005

before the financial crisis to about $500 000 in 2009.[8] If the idea of selling direct through the internet worked during the boom, that was certainly no longer the case. By early 2010, faced with the risk of insolvency, the board decided that there was no option but to wind the company down. Chairman Smith—a heavyweight Adelaide-based corporate advisor and husband of former Australian Democrats leader Natasha Stott Despoja— explained that not only had sales slumped, but there was no new generation of artists coming through, a problem faced by many remote Aboriginal art centres. In 2010 the Jirrawun board began selling assets to pay off its debts. The new studio was sold for $475 000, just over half what it cost to build, and Sydney art dealers Michael Reid and Wally Caruana were charged with slowly selling the 200-plus paintings remaining in the company's hands, estimated to be worth more than $1 million. Smith, a man practised in the art of public relations, reiterated that the company was winding down—in business terms it would remain a seller of Aboriginal art, but would no longer be a pro-ducer—rather than winding up. This was not merely a matter of semantics. Jirrawun is beneficiary of 50 per cent of Bedford's estate, and the money coming in from the sale of Bedford paint-ings was a crucial source of the income needed to pay down the art centre's debts. Kofod was uneasy about this, particularly in 2011 when Warmun, where Bedford had spent much of his life, was devastated by floods and in dire need of funds.

But it was Bedford's written will. Says Smith: 'Respecting what Old Man wanted, that was his will. That sort of thing crosses white fella and black fella. Would anyone want their will if they knew how things would turn out? That's an issue irrespec-tive of an Indigenous climate.' And from Seidel: 'When Paddy

was alive Jirrawun was the jewel in the crown … and as executors you have to channel the views of the artist when the artist was alive. Jirrawun was big to Paddy, so it's not my role to play into the politics and say, "Hmm, it's not what he thought it was." The fact is though, Paddy well knew Jirrawun would not last forever, and he directed that as soon as it ceases to exist the executors are duty bound to look for alternative charities doing similar work to Jirrawun. That day has now come.' Jirrawin the company is being wound up, with the remaining cash and paintings to be gifted to the art cente in Warmun. 'We've been to hell and back with this, but we managed to sell the paintings without a fire sale, which is no small feat in the current climate,' says Smith.

The Bedford case is a powerful example, not only of the value of a catalogue raisonné, but also the other things that go into making an artist's reputation: influential friends, a charismatic dealer/manager with vision, and good records right from the start. But as the demise of Jirrawun shows, not everything can be controlled. The market is a force all of its own.

Chapter 5

Boom Times

The problem with art is the people who buy it.

PETER CAREY[1]

People were chatting, downing the free wine on offer and collecting blue bidding paddles from the glamorous young woman at the front desk. It was 11 April 2006, and a who's who of the Melbourne art scene was jammed into Sotheby's High Street headquarters in Armadale for its Australian art sale. Among those present was someone not usually seen at auctions: Gerard Vaughan, then director of the NGV. Public gallery directors tend to shy away from auctions, fearful that their attendance may encourage collectors to bid against them on the basis that if an august institution wants a work, it must be good. Institutional purchases at auction are thus typically made over the telephone and announced later.

But this night was different. In *The Age* newspaper that morning Vaughan had flagged his intention to bid for Lot 18, John Brack's 1954 painting *The Bar*. It would make the perfect companion piece to Brack's 1955 existential ode to the drudgery of salary-man life, *Collins St, 5p.m.*, one of the NGV's most popular

pictures, which it had purchased the year it was painted. To have another painting by the same artist, this one depicting the 'six o'clock swill' at the pub the workers were heading towards as they trudged down Collins Street, would double the drawcard. Vaughan had raised $2.8 million from private donors to bid for the painting, which seemed plenty even if, in a rising market, the price was to go above the auction house's $1.5 to $2 million estimate for the work. He even had the gallery's publicist on stand-by. It wasn't nearly enough. Five bidders battled it out for *The Bar*, which ended up selling for $3.1 million, including the auction-house fee. The buyer was Tasmanian gambler turned art collector David Walsh, who in the process set a new record price for an Australian artwork at auction.

It was a red-letter night for a number of reasons, chief among them that this was the first of a string of top prices paid for post–World War II paintings at auction. That record run raised the value of the estates of Brett Whiteley, John Brack, Sidney Nolan and Fred Williams because it re-rated all the work left in them. It also increased the power of the women in charge of those estates because they had what every auction house chief now desperately wanted: valuable paintings. It's worth looking a bit more closely at the boom to see how and why it unfolded.

Previously the highest price paid for an Australian painting at auction had been for a work by Heidelberg School artist Frederick McCubbin. His 1893 *Bush Idyll* sold for $2.3 million in 1998 at Christie's Sydney. Other paintings had sold for similar prices privately—as opposed to at public auction—but they were mostly colonial or Australian impressionist works. In 1995 the NGA paid $3.5 million for Arthur Streeton's 1889 work *Golden Summer, Eaglemont*, and the National Portrait Gallery

bought John Webber's 1782 picture of Captain James Cook for $5.3 million in 2000. From 2006 to 2010, three more Australian paintings would break the $3 million barrier at auction—by Brack, Whiteley and Nolan. Other works by these artists also sold for more than $2 million in 2006 and 2007, the heady years just before the global financial crisis reversed the art market's stunning decade-plus run of growth. That growth spurt had begun in earnest in 1996 with Andrew Lloyd Webber's $1.98 million purchase at Christie's Melbourne of a colonial painting, Eugene von Guerard's 1856 *View of Geelong*. One of a number of canny art collectors who disposed of big-ticket pictures at the height of the boom, the musicals maestro was to sell it privately to the Geelong Gallery in 2006 for $3.9 million.

Sotheby's then managing director Mark Fraser had Walsh in mind when he secured *The Bar* for auction, and took the Tasmanian to see it the day he collected it from the vendor. Buying the painting was the first time Walsh had stuck his head above the parapet. His identity was known only to Fraser and one other Sotheby's executive; back then he did not even come up on a Google search. His Museum of Old and New Art, MONA, on the outskirts of Hobart, was still five years away from opening, but his cover as an anonymous collector was blown as a result of that history-making purchase. The subsequent publicity Walsh received was timely for the Australian Taxation Office, which had been observing the tax-free millions he and his gambling partners had made over many years using complicated algorithm-based betting systems, and wanted a slice of it. The tax office subsequently pursued Walsh and his associates for what it saw as unpaid tax for years, eventually settling its dispute in 2012 in a confidential deal.

Walsh was responsible for many of the records set in the 2000s. Wendy Whiteley sold the large diptych *Naked Blue Studio*, 1981, to him privately for $3.4 million in 2005, although it took years for Walsh to confirm that he was the buyer. 'I denied owning that many times. It turns out I was mistaken,' he said just ahead of MONA's January 2011 opening.[2] The man is odd, but he does have a good sense of humour. In 2005, when Mary Nolan told Sotheby's Fraser she wanted to sell *Snake*— the 1620-panel, 46-metre-long 1970–72 painting—Fraser knew exactly to whom he should take it. Mary had been offering it to public institutions on and off for more than a decade, including to the National Museum of Australia, which got close to buying it in the late 1990s when its new home was being built on Acton Peninsula in Canberra. But none of these galleries had a wall big enough to hang it on, nor the $2.7 million asking price. Neither was a problem for Walsh: he had the money, he could build the wall. It took him less than a day to decide that yes, he must have it. *Snake* is now one of MONA's centrepiece artworks.

Walsh was not the only private collector chasing *The Bar*— there were four underbidders, including Rodney Menzies, a man who made a fortune in contract cleaning and who was then majority owner of rival auction house Deutscher-Menzies (he is now 100 per cent owner and, reflecting the fact, the firm is now called Menzies Art Brands). The sale and its successors were a salient reminder of just how much money some Australians had made during the good times. The stamp of approval from Melbourne's top public institution also probably egged some of these collectors on, and it's unlikely that a state gallery director will telegraph his buying intentions quite so openly again.

Sitting quietly in the crowd the night *The Bar* created auction history was Helen Brack. When asked after it was hammered down what she thought of the result, she said that it was 'a shame it hasn't gone to a public institution', but that 'on the other hand', the NGV already had one.[3] Privately, her opinion was much sharper. She was appalled: not that the gallery missed out, but that a painting—any painting—could sell for such a monstrous amount of money. The previous record for a Brack at auction was only $528750, paid in 2003 for the 1984 painting *Beginning*. It's hard to imagine an artist who would be less impressed with his paintings becoming baubles for the rich than John Brack. He was so aghast when a company offered him $1 million for his 1980–83 magnus opus *The Battle* that he took it home and turned it against the wall. It was a decade later that he finally let it go, giving it to the NGA in a half-sale, half-donation arrangement. In a tribute given after he died, Helen said of her late husband that he was 'measured, scrupulous and deliberating', a man 'impatient with lightweight values, with sentimentality and with all the disguises that obscure'.[4] The same could be said of her.

Helen's disquiet would grow in 2007, when another of Brack's paintings, this one a 1969 ballroom-dancing work titled *The Old Time*, broke *The Bar*'s record, selling at Sotheby's for $3.4 million. It was bought by Marc and Eva Besen, founders of the Sussan Group and TarraWarra. The Besens had been early collectors of post-1950s paintings, and Helen Brack did not know it was they who bought *The Old Time* when she spoke shortly after the auction:

> All I can think is that it's terrible that there is so much money going around that people can spend like that.

It's converting pictures into something that has nothing to do with the content of them. I'm all for people getting a fair wage, and if a picture took a month to paint, then the artist should get a month's wage. But this cancels the intrinsic value of the picture, which becomes not the issue. It's the reputation that's being bought and sold, and [that] has nothing to do with what the object actually is.[5]

Brack and Whiteley jostled for the mantle of top-priced Australian artist at auction between 2006 and 2007. In the May 2007 sale at which Brack's *The Old Time* made $3.4 million, the picture everyone had expected to set a new record was Whiteley's *Opera House*, 1971–82, one of a swag of paintings being sold off that night by Qantas. It made $2.9 million. Sensing the frenzied interest in these two artists, Rod Menzies went so far as to buy a Whiteley outright in order to consign it to auction, paying fashion designer Sally Browne about $2 million for the 1985 painting *Olgas for Ernest Giles* so he could include it in his June 2007 sale. The strategy appeared to work, with Melbourne art dealer John Playfoot successfully bidding $3.5 million for it in Menzies' midyear sale on behalf of a client.

If anyone was in doubt that collector interest had shifted away from the colonial and Australian impressionist art that was favoured by 1980s magnates like Robert Holmes à Court and Alan Bond, and towards artists such as Brack, Whiteley, Nolan, Tucker, Williams and Boyd, 2006 and 2007 laid such doubts to rest. Trophy pictures account for a tiny percentage of the annual turnover in art, and a record sale depends on the right rare picture coming onto the open market. Such sales tend to drag the

rest of the market up with them, with other works by those artists, and sometimes by others in their milieu, benefiting by association. A look at the statistics regarding such sales highlights who was in demand and when. According to the Australian Art Sales Digest, eighty-six paintings have sold for more than $1 million at auction in Australia. Looking more closely at the artists who made most of these high prices, Brett Whiteley accounts for eighteen of the $1 million–plus sales, Russell Drysdale for eleven, Fred Williams nine, John Brack eight, Arthur Boyd five and Sidney Nolan four. The sole exception to this group of artists is McCubbin, who accounts for seven of the sales in excess of $1 million. That most of these sales took place from 2006 onwards is also borne out by the statistics. Twenty-two of the $1 million–plus paintings, or more than a quarter, sold in 2007 alone, with sixty-four of them (nearly three-quarters) selling in the years from 2006 to 2012. The Australian fine art auction market exceeded $100 million for the first time in 2006, hitting $175.6 million in 2007.[6] Part of the reason for all of this is that the best of the Australian impressionist and colonial works were by then in public institutions, and it was thus unlikely that they would come back onto the market. But collector interest had also shifted as a new generation of buyers came through.

The run of record sales smoked more Brack, Whiteley and Nolan paintings off lounge-room walls and onto the market. This was fuelled not only by the excess money and interest in them, but also by an expansion of the art auction sector. Where once there was a cosy duopoly at the top of the fine art market, with international juggernauts Sotheby's and Christie's battling it out for market supremacy (and on the tier below them Leonard Joel in Melbourne and Lawsons in Sydney), by the late 2000s

there were half-a-dozen auction houses competing for stock. One such auction house was Deutscher-Menzies, which had arrived on the scene in 1998 and had been set up by Menzies in partnership with art dealer Chris Deutscher. Expanding into fast-developing markets in Asia and the Middle East, being beaten in Australia by Sotheby's and Deutscher-Menzies, and keenly aware that its entire Australian turnover could be achieved by the sale of one impressionist painting in London or New York, Christie's decided to stop holding auctions in Australia at the end of 2006. That triggered a raft of others to fill the gap. Leonard Joel set up a short-lived upmarket spinoff, Joel Fine Art; Bonhams and Goodman signalled a move upmarket by hiring former NGV curator Geoffrey Smith; Paul Sumner ramped up his Mossgreen Auctions; and in late 2006 Deutscher and another Deutscher-Menzies executive, Damian Hackett, left Menzies to set up their own firm, Deutscher and Hackett, backed by Melbourne businessman and art collector Ian Hicks. There were now six auction houses focused squarely on the top end. Given that they make most of their money via a 20–23 per cent fee imposed on the hammer price (called a buyer's premium), that was the place to be when $1 million–plus pictures were running hot. All were looking for stock for their auctions; all filled their sales with works by the artists they knew were in demand. Art catalogues thus became drearily predictable, dominated by Boyd, Nolan, Brack, Whiteley, Williams, Blackman and Tucker.

But the record-setting for these artists actually began in the mid 1980s, with Holmes à Court's 1985 purchase of Arthur Boyd's *Melbourne Burning*. The Perth entrepreneur set a new record for an Australian painting at auction when he paid $313500 for the apocalyptic 1946–47 painting at Sotheby's.

The colonials and Australian impressionists still led the market back then, but interest in post–World War II art was growing, just as in the 2000s the supremacy of the Australian modernists dovetailed with the rise of contemporary and Aboriginal art. (In 2006 the Holmes à Court family sold *Melbourne Burning* to David Walsh, who is said to have paid up to $3 million for it.) Nolan's grand, nine-painting mural *Riverbend II*, 1965–66, became the first painting by this mid-twentieth-century group of artists to break the $1 million barrier when Rupert Murdoch paid £450 300 (A$1.022 million) for it at Christie's London in 1993. Janet Holmes à Court upped the ante in 1999 when she sold Whiteley's 1977 painting *The Jacaranda Tree* at Christie's Sydney for $1.9 million. This was six times the previous auction record of $332 500, paid in 1997 for Whiteley's 1976 painting *The Pond at Bundanon*. Despite winning the Wynne Prize the year it was painted, *The Jacaranda Tree* had been bought by Holmes à Court's late husband in 1982 for just $115 000, when interest was so scarce that it was initially passed in.

Denis Savill is a rambunctious Sydney art dealer who has built his reputation selling modernist works to aspirational Australians around the country. A New Zealander who was a real estate agent and auctioneer in the late 1960s and early 1970s before turning to art, he is one of the biggest buyers on the secondary art market. Savill thinks nothing of buying a painting at auction and then retailing it with a hefty premium on his purchase price through his Paddington gallery (or, until it closed in 2007, his Melbourne outlet in Toorak Road, South Yarra). When the market was strong collectors didn't seem to mind, because the kind who bought through Savill were cash rich and time poor—they wanted quality works by name artists, and he

was the man to supply them. When Savill started dealing in art in the early 1980s he traded mostly in Australian impressionists, such as Streeton, Roberts and McCubbin. But he picked up on the growing interest in mid-twentieth-century artists. In 1988 he hung a big banner out the front of his refurbished gallery advertising a new exhibition, *Four Australian Modern Masters: Arthur Boyd, Sidney Nolan, Brett Whiteley and Fred Williams.* 'The other dealers whinged about it; they thought it was too in your face, too obvious,' he says. According to Savill, these artists began to gain traction in the recession of the early 1990s. 'In the 80s the traditional paintings were way out in front, so an average Streeton would sell for four times a good Arthur Boyd,' he says. 'That ran right through to 1989. I started thinking you could get more bang for your buck if you believed in Boyd, Nolan, Blackman. It was obvious they were underrated. Fred Williams was inexpensive then, too.'

Over the decades Savill became the go-to man for Boyds, just as commercial dealers Rex Irwin in Sydney and Philip Bacon in Brisbane became the dealers for Fred Williams from the 1990s onwards. Chris Deutscher was most associated with Brack through the late 1990s and 2000s. Lauraine Diggins and then Geoffrey Smith were the people to ask if you were after a good Tucker. In Savill's words:

> It's all about branding—it took me a while to work that out. I don't sell many John Olsens anymore because everyone thinks of [John's gallery-owner son] Tim Olsen as the one who sells them, but I'm known as the man to go to for Arthur Boyds. I felt an affinity with Arthur and admired his talent, style and diversity

of subject matter, from religious pictures and wild Nebuchadnezzar paintings to Victorian landscapes, the bride series and Shoalhaven works. In that respect I chose Arthur, he didn't choose me.

By the time he died, aged seventy-eight in April 1999, Boyd and his wife Yvonne had gifted their rural New South Wales property Bundanon to the federal government for the public's use (1993). He had had become the first artist to be named Australian of the Year (1995), the first depicted on an Australia Post stamp (1999), the only artist to represent Australia twice at the Venice Biennale, and he had received honours in the United Kingdom as well as Australia. His good friend Barry Humphries had referred to him as the 'Donald Bradman of the art world'.[7] His work was held by all of the major institutions and top private collections, and in 1993 a retrospective had opened at the AGNSW before touring to Victoria, Tasmania and Western Australia. There was no chance of his profile slipping under the radar, but it didn't hurt to have a dealer as loud and commercial as Savill pushing him, either. Savill bought his Boyds from private collectors here and offshore, in London in particular, and at auction. Later he got a direct line to Boyd himself, whom he visited at the artist's homes in London, Suffolk and Tuscany to secure stock, following the lead of earlier dealers such as Barry Stern and Andrew Ivani. 'I was Johnny-Come-Lately in many ways. Those guys had been getting Arthur for so little money, I was staggered. I was mostly buying at auction, paying market price. I wish to God I'd started earlier with Arthur, but you don't know your way around town when you start.' Savill was shocked when Boyd died; his supply dried up overnight, and he

had to return to buying his paintings on the secondary market. Yvonne was not selling works from the estate; most of what was left had been donated to the nation along with Bundanon. 'I never thought Arthur was going to die, I just couldn't believe it,' says Savill.

That Boyd's prices have remained high reflects in part promotion by Savill, who regularly supported him at auction by either buying works outright or underbidding them, as well as showing them in his own galleries. Boyd has certainly become an auction staple. Since the 1970s more than 4000 Boyd artworks have come up for sale at auction. This compares with more than 1200 Williams, more than 2000 Whiteleys and more than 600 Bracks. Nolan beats them all, however, with more than 5000 of his works traded at auction in the same timeframe.[8] Not that it is ever that simple; part of Brack's allure is the scarcity of his oil paintings relative to those of his contemporaries.

Alongside the interest in the likes of Boyd, Whiteley and Brack through the 1990s and 2000s, there was a growing interest in contemporary art, bought by a mostly younger clientele than those chasing the earlier generation of artists. Australian Aboriginal art in particular was highly sought after, the only sector of the Australian art market with international as well as local interest. Tolarno Galleries' Jan Minchin says the end of the boom in the 1980s was when she really noticed a change in contemporary art's place in society. 'There seemed to be an explosion of artists and galleries in 1989,' Minchin says. 'I was working at the NGV at the time, and part of our job was to answer enquiries. Someone rang and asked if I knew anything about a particular artist. Up until that time I thought I could probably list every artist working in this country. I really did

think that. But I had to admit that I had never heard of this artist. And that's when I realised it had really shifted up a notch.' The early 1990s downturn hit the art sector hard, with many galleries going to the wall, but by the middle of the decade it was on again. By the 2000s, contemporary art exhibitions were regularly selling out, with new works fetching tens of thousands of dollars. For those in high demand, waiting lists at their primary galleries became the norm. Australian dealers and collectors became regular attendees at art fairs and biennales, both in Australia and offshore, and galleries such as Sydney's MCA and Queensland's Gallery of Modern Art found new audiences. There were more art galleries, magazines and people calling themselves artists than ever before. The auction houses also got in on the act. Sotheby's ran stand-alone contemporary art sales from 1991, and in 1997 these morphed into Aboriginal art sales—the auction house was keen to ride the movement begun by Geoffrey Bardon at Papunya in the early 1970s, which had expanded into remote communities across the country. Christie's ran stand-alone contemporary art sales for a short time, too, and like Menzies, it also held stand-alone Aboriginal art sales.

All this meant that Howard Arkley, Bronwyn Oliver, Rosalie Gascoigne and Paddy Bedford sold well in their lifetimes—not at the start, but for more of their prime working years than the generations before them. Arkley and Gascoigne both died in 1999, having enjoyed many years in which demand for their work outstripped supply. That their careers were relatively short but highly successful meant there were not big stockpiles of work left in their estates. The same was true for Oliver, who died in 2006 when contemporary art was at its peak on the primary market. Her labour-intensive sculptures took months to complete, and

in her final few years there was nearly always a waiting list for her work, a lot of which was made on commission. So while the growth of the market pushed up prices for all successful artists, it was more lucrative for the estates of the mid-twentieth-century artists because there was more work left in them, and it was generally selling at a higher price point.

The explosion of interest in art in the 2000s reflected not only buyer taste, but also the fact that investors were turning their gaze towards it. The market was not simply people who wanted paintings for their homes any more; it was now also people who wanted to buy paintings in the same way as they bought shares, with an eye to capital growth. In investor parlance, the Australian modernists were the new blue chip, with contemporary art—and Aboriginal art in particular—on a par with more speculative stocks. Some people were buying art through their self-managed superannuation funds. Others were 'flipping' work—that is, buying it and selling it only a year or two later for a profit. Accountant Tom Lowenstein observes:

> Forty years ago, when I started my involvement with the arts, people bought art at both commercial galleries and auction houses because they loved it. Over the years, art became recognised as a good investment— even the tax office accepted this. It also became socially desirable and sexy. This added the investor to the market. Collectors saw their work going dramatically up in price, and the auction houses promoted this way of looking at art. This resulted in another new type of buyer entering the market, the speculator. They were not interested in art; they bought, promoted and sold it

as a commodity. I think it was their activities that led to unrealistic price increases for a select group of artists, prices that could not be sustained.

The 2006–07 boom was also characterised by some aggressive market tactics. Menzies brought new buyers into the art market, many from the horse-racing world, where he also had interests. He was determined to beat the colonisers, Sotheby's and Christie's, and used the business acumen he had picked up studying for an MBA in the US to do things differently. Those auction houses used guarantees to secure trophy paintings for their sales in New York and London, but did it very rarely in Australia. Guarantees give vendors certainty that they will get paid whether someone successfully bids for their painting at auction or not. The auction house guarantees to pay the vendor a set price if the work does not sell.

With his own powerful cheque book, Menzies was able to use guarantees to secure trophy paintings for his sales. Sometimes he would do this as part of a syndicate he had put together. He also on occasion sold in his own auction rooms paintings in which he had a full or partial interest. It was not always clear when he was a full or partial buyer, and he felt this information was commercially confidential and that he was not legally required to disclose it. It is thus not known how many sales to guarantors feature in the record auction totals for 2006 and 2007, because Menzies did not separate them out from sales to fully independent buyers.

Some rival auctioneers complained to the Australian Competition and Consumer Commission, arguing that these practices lacked transparency. The ACCC looked into Menzies practices, but made no adverse findings against him. Menzies changed the disclosure statements at the back of his catalogues, stating

that he or the company might own in whole or in part works included in its sales, and that some works were guaranteed, and putting the onus on potential buyers to ask Menzies staff which works fell into these categories. In March 2010 the ACCC suspended its inquiries on the basis that Menzies continued this enhanced disclosure.[9]

Not that Menzies was the only auction house scrutinised for an alleged lack of transparency. All allowed dummy bids up to the reserve price; all calculated their clearance rates slightly differently yet compared them with those of their rivals. There was talk at the time about setting up an industry code of conduct and uniform way of calculating clearance rates. None of it eventuated.

Melbourne property developer Lustig and Moar also played an odd part in the record-setting prices. The private property group was represented by Brian Kino, a small, wiry, eccentric kind of a man who often turned up to auctions in colourful T-shirts and jeans. Between bids for top-end paintings he could be found outside having a calming cigarette. Kino bought more than half-a-dozen paintings for Lustig and Moar during the mid to late 2000s, almost all at record prices, and very conspicuously so. Whiteley, Nolan, Olsen, Tucker—the big names were what they wanted. Kino said at the time that Lustig and Moar's plan was to build a collection of 'the best' Australian paintings, which might eventually be put on public display, then sold off in a stand-alone sale. Neither of these things happened. Within a few years Lustig and Moar had sold many of these paintings at prices drastically below their auction records. Among those scooping up the bargains were Aussie Home Loans founder John Symond and Sydney prestige car seller Steven Nasteski. No explanation was given for the collecting about-face.

Symond and Nasteski were able to scoop up bargains because, thanks to the global financial crisis of 2008, the seemingly inexorable rise of the market had come to a screeching halt. Over the following five years auction clearance rates plummeted. During the boom anything under 70 per cent was considered decidedly average; after the financial crisis anything above 50 per cent was good. Total reported fine art sales at auction fell from a record high of $175.6 million in 2007 (which admittedly included many of those unusual sales) to $95.2 million in 2012.[10] A spate of commercial galleries closed in 2011 and 2012, others merged, and others still reduced the number of artists they represented. At auction, a brand-name artist was not enough to spark a bidding duel any more; it now had to be the exact work, done in the best period, in pristine condition and with rock-solid provenance. Vendors still expected 2006 and 2007 prices, and many had to be hit with a work being passed in before the penny dropped that the game had changed.

Brack's *The Bar* came back onto the market in this down time. Ahead of the January 2011 opening of MONA, Walsh's interest had moved away from Australian mid-twentieth-century art and towards international contemporary art. He needed cash to buy Belgian artist Wim Delvoye's *Cloaca Professional*, 2010—a machine that is fed food at one end and produces faeces at the other—and in 2009 decided to sell *The Bar* to free up money. He gave the NGV first right to buy it for $3.2 million. Walsh's right-hand man in art matters was by now Mark Fraser, who had been managing director at Sotheby's during the heady boom years and, in remarkably good timing, left in 2007 to help Walsh build his museum and the collection that was to go in it. As Walsh's contact at Sotheby's, it had been Fraser who had steered him into

those record-setting purchases—of *The Bar*, Nolan'swith *Snake* and Whiteley's *Naked Blue Studio*. A canny operator, Fraser was careful to position the sale of *The Bar* as a museum-to-museum transaction, lest his boss be criticised for getting bored with the painting within a few short years. He got Walsh a remarkably good deal, given the overall market was now in decline, although he was quick to point out that Walsh had spent a considerable amount restoring and reframing the picture, in consultation with Helen Brack and the NGV, and that the Tasmanian's profit on the sale would be less than $30 000. Walsh was lucky that the director at the NGV was the same man who had lost the painting at auction in 2006. Gerard Vaughan could not afford to let it go a second time. Helped by a $2 million loan from the Victorian Government, it took him only twelve months to raise the purchase price from a group of collectors who, like him, were emotionally invested in ensuring it did not go elsewhere again. Could the NGV have negotiated with Walsh for a better deal, given the state of the art market by then? Arguably yes. But Vaughan had history to consider, saying at the time: 'It's a big ask in this climate, but we have no option but to do it. Posterity would not forgive us for missing it twice.'

As for Helen Brack, her dismay at the high prices now being paid for Brack's paintings was countered by the fact that it raised the value of all works left in the Brack estate. She did not like what art had come to signify, yet inevitably benefited from the market's re-rating of Brack when she needed to sell. She did not drop her prices to meet the market when it cooled, sticking to what she thought a work was worth, but nor did she try to ride the boom, selling only occasionally and discreetly. Both say something of her smarts.

Chapter 6

The Gold Standard

The death of a friend, yes. The death of a relative, yes.
But above all, the death of an artist. That is different in a
particular way from the death of others, because while he
lives, he is his work, and when he dies, he stays behind.

JOHN BRACK[1]

Lyn Williams is the gold standard for how to handle an artist's estate. So says former NGV director Patrick McCaughey. 'Chair of the artists' widows in my time' is how art dealer Stuart Purves describes her. Observes Paul Sumner, owner of Mossgreen Auctions: 'She's never been greedy for income. Our business is supply and demand. Lyn Williams knows that and has controlled the supply. As a result Fred has probably had the most consistent price growth of any artist, without an actual boom.'

This being the visual arts, a hot-bed of nastiness if ever there was one, not everyone is laudatory. 'She's extremely controlling,' says more than one art expert. Another calls her 'Lyn Millions', referencing the fact that the best of her husband's paintings can now sell for more than $1 million, many others for hundreds of thousands of dollars. When Melbourne art dealer Lauraine Diggins is asked whether Lyn finds the handling of the estate a

burden, she says she doubts it: 'I don't think there's any love-hate with Lyn. It's given her a life, a job.' McCaughey goes a step further: 'It's been the making of her.'

Lyn did not want to participate in this book. She felt that she had said all there was to say about her role as guardian of Fred's estate in various newspaper and magazine interviews she had given over the three decades since his death, including with me for a 2009 magazine article. Fred was a very private person, she says, and so is she. She eventually agreed, no doubt on the basis that if the book is going to happen anyway, the information in it should be correct. 'It just becomes something, takes on a life of its own,' she says. 'I will always be more Fred's widow than anything else I do, in a public sense I guess.' Lyn told a journalist in 1991 that she thought it 'important not to live all of my life as Fred's widow'.[2] This concern seems to have dissipated over the years; in 2000 she told another journalist that she was less worried about lacking her own separate identity than she had been in the immediate aftermath of Fred's death. 'I didn't want to be too immersed in it. It was just too hard; it's like living your life in the past altogether,' she said. 'It's different now, and I realise I probably know a lot about the work. It's not an emotional thing like it used to be.'[3] When asked if it is annoying now, her answer suggests that she's so far from worrying about it that she's forgotten she ever did. 'I don't think about it too much like that,' she says, going on to explain what she has tried to do with the estate, and why:

It's the last, I keep saying ten, but it's probably more like fifteen years that I've tried to concentrate on tidying up the estate. It would be good to have it in

the kind of order that it's not too burdensome for our [three] daughters, because eventually someone will have to take it on. These things always tend to stay in the family, and for good reason, because there will be more attention paid to the spirit of the artist. I would like to get to the point where all the main decisions have been made, and hopefully most of the important works have found a place, whether they're in public institutions by gift, or whether they've been sold.

All of this suggests a woman who knew what to do from the start, but as Lyn explains it, that was far from the case. Rather, she grew into the job, gaining confidence as the years went on. There was tenacity, intelligence and caution involved in her slow, strategic sell-down of the works left in the estate, of which there were about 1200, ranging from oil paintings to gouaches, etchings, drawings and prints. But there was also serendipity. For reasons to do with life, not strategy, Lyn did not start selling works from the estate in any serious fashion until the early 1990s, years after Fred's 1982 death and, as luck would have it, as prices for Australia's post–World War II artists were on the rise.

'In a funny way we've had parallel art lives, Lyn Williams and I, because we've been in a rising economy with rising art interests,' observes Stuart Purves, who was left with a lot of Australian modernist stock from his parents' day. 'What we've had to do is steer the boat in a current that is running the same way as we are. That can be quite complicated actually, so you have to get it right. I don't know if you've ever steered a boat in a stream that's going the same way as you are, but the tail can flip out, so it's not just a smooth course.'

With so many paintings to dispose of, and three daughters to support financially as well as emotionally, Lyn could not take the option of walking away from the art world. She needed to remain engaged in a way that Helen Brack and Yvonne Boyd did not. John Brack created only about 360 oil paintings, and lived a relatively long life, dying when he was seventy-eight. There were paintings, drawings and prints left in his studio, and while Helen has sold pieces, she has been left a different task from Lyn by virtue of the artist she married, the point at which her husband died, and the amount of work left. 'I see it as my job to encourage a proper understanding of what John was doing, but I don't do marketing,' says Helen. 'John had a very small output, so it's not as important. Whereas if you have a huge amount of things, it's a good idea to get rid of them. For an artist who never throws anything out, that's a huge issue.' That Helen sees her job as better educating the public about her late husband's work—such that, for example, when people look at *The Bar* and *Collins St, 5p.m.* they see multiple meanings beyond the obvious depiction of Menzies-era Melbourne—reflects not only the complexities of his work and the lack of thousands of paintings to sell, but also her own nature. At NGV openings Helen will be the one looking intently at the paintings, not lingering over champagne in the foyer. She has been hosting occasional art appreciation courses for the Council of Adult Education since 1967, and still gets frustrated at how little people really consider what they are looking at:

> I'm always surprised that there is such ignorance about John's work. People don't look, they don't look closely at the work, they just glance at it, then when you point

something out they say, 'Oh, so it is.' I'm very bad because I get disgusted. I think, Oh for God's sake. It's intriguing when you do show people things in the work, and they do see what you're saying. It's exciting for me, actually, but it shouldn't really be up to me to tell them this.

Like Williams, Arthur Boyd and Brett Whiteley were enormously prolific. But the existence of public properties like Bundanon and the Brett Whiteley Studio meant they were not really in the selling game either. That it was different for Lyn reflects the amount of work she had to disperse. Fred's famous quote, 'I wasn't in a hurry—and I am still not',[4] could just as easily have been said about his widow, who appears to have dispersed nothing in haste or without careful consideration. Crucial to the success of the enterprise has been the quality of Williams' work. The slow and steady sell-down might not have worked for a less significant artist, nor one who was less established at the time of his death. 'She has certainly been, of all of them, the most thorough with documentation, recording media where she can, being as meticulous as possible with framing and reframing, and stretching and varnishing works. And she hasn't flooded the market,' Ron Radford told me at the media preview for the 2011 retrospective. 'But apart from that, I don't think you can artificially build up an artist. For a short time, maybe, but remember he's been dead for thirty years. You can't control a reputation for thirty, forty years.'

Williams was considered 'top shelf' well before he died. By the early 1970s he was an eminent enough artist to be given roles on government boards. In 1972 he was appointed to the

Commonwealth Art Advisory Board, the precursor to the NGA's acquisitions committee, and was later appointed to the Canberra gallery's governing council (the gallery opened in 1982). From 1973 he was a member of the inaugural visual arts board of the Australia Council and in 1976 he was made an Officer of the Order of the British Empire (OBE). The likes of News Corp's Rupert Murdoch, Sussan Corporation founders Marc and Eva Besen, and long-time BHP director Gordon Darling were buying his work, and in the late 1970s Sir Roderick Carnegie, head of the mining company then called CRA, took him to the Pilbara in Western Australia. Completed between 1979 and 1981, the paintings from this trip became Williams' last series.

Fred Williams was diagnosed with cancer in November 1981, aged fifty-five. Lyn has at times wondered whether the chemicals Williams used in his etchings contributed to his sickness. These were the days before high awareness of the dangers of such materials.

> Well, we don't know. He wasn't a smoker, but he always had asthma, which he developed when he lived in England, so the lungs always seemed to be the faulty area. If anything went wrong with him, it seemed to be there. Fred was careless with the acids and so on. I strongly objected to them being around the house, given there were children. Certainly, with the new building we'd bought [to turn into his studio] there was going to be a proper area with a fume cupboard and acid bath. I was quite determined that it be set up properly this time, simply because I knew how dangerous it was.

The wider public did not learn about Williams' death, in April 1982, until a few days after his funeral. Some people in the art world believe that Williams had the choice of whether to start a new series of artworks or tidy up the ones that were left, and that he chose to do the latter, one of the reasons his estate is in such good order. But it seems that there was less of this than art-world folklore suggests. 'He only got to work through the drawings, really, and go through the gouaches, and sign things,' Lyn says. 'I sorted the gouaches because I knew the series, the things that had been done on various trips. But he really only had a few weeks that he was able to do very much in the studio. He was just too sick, and he couldn't stand the smell of the turps and the paint, because his lungs were very raw.'

Lyn wanted her husband to appoint someone as artistic executor of the estate, but he resisted. It was the first of a number of wise choices made about his estate. If an art dealer had been co-executor, which is often the case, they may have had an incentive to push for sales earlier, or had any number of differences of opinion with his widow. 'He said he didn't think it was a good idea [to have a co-executor], because our children were still teenagers, and dependants, and that I needed the freedom to do things when I wanted to, and that it could tie things up if I had to consult someone else,' she says. 'And he said: "You'll still be able to seek advice." With hindsight it was the right decision, and it certainly gave me more confidence with what I was doing.'

Lyn was in her mid forties when widowed. She and Williams had been astute with property, buying a beach shack and a couple of houses over the years, which she had renovated and rented out. Williams had earmarked some works for her to sell, which she did, but Lyn decided to wait a year before doing

much more. Not being in dire need of funds allowed her to stick to two guiding principles—to follow as closely as possible what Williams might have done with his own artworks, and to try not to make decisions on the basis of money.

Lyn says:

> I had enough of a backstop. I knew there were people who would buy pictures, and that I could sell them. But I wanted to analyse what was in the estate first. It was easier to dispose of things we didn't need. We had outgrown the holiday shack in Western Port, so I sold that.

The delay was extended by the death of Williams' dealer, Rudy Komon, within six months of the artist. 'When Rudy died at the same time, that made it so difficult,' Lyn says. 'That's when I thought, What do I do now?' There were two other people around, however, to whom she could go for informal advice over the years. James Mollison, a former director of the NGV and NGA, and Patrick McCaughey, also a former NGV director, both of whom have written comprehensive books on Williams. Mollison also staged a large Williams retrospective at the NGA in 1987. 'Lyn has had two of the most significant and influential figures in Australian art supporting her—giving her advice, but also giving Fred the stamp of curatorial excellence,' says Lauraine Diggins. 'They wrote about Fred as really no other Australian artist has been written about. What two heads of public galleries have written about Arthur Boyd or Sidney Nolan? It's a really significant thing.'

Of perhaps more importance were the dealers through whom Lyn chose to sell, primarily Rex Irwin in Sydney and Philip

Bacon in Brisbane. Both would be best described as blue-chip; both tend to focus on painters, printmakers and sculptors. Lyn has stayed with these two dealers for twenty years, giving the estate a consistency that many others who have chopped and changed commercial galleries lack. Working with Bacon and Irwin she has curated exhibitions around themes—bushfires, waterfalls, small pictures. Since the early 1990s these have been held every two to three years, neither flooding the market nor starving it, with prices rising steadily rather than in big jumps. Of this Lyn says:

> I really aimed to do exhibitions that gave a bit more insight into aspects of Fred's work that he hadn't shown. We haven't tried to get someone pushing the barrow to shove prices up. Where they are is pretty high, on the whole, anyway … I try to follow the current market. I don't see the point of selling works that other people can buy and re-sell in a year or two, making a huge profit. But everyone does expect artists to sell them cheaply. When I say cheaply, I mean they see it like buying property, that they will eventually make a capital gain. The art world is far more commercial than it ever used to be.

Bacon jokes that when Lyn asked in the early 1990s if he would be interested in selling works from the estate, he virtually crash tackled her to the ground in his rush to say yes. One of the more respected dealers in the country—all the more impressive given that his gallery is in Brisbane rather than the art capitals of Sydney and Melbourne—Bacon represents many of the nation's

big-name painters, including Jeffrey Smart, William Robinson, Gary Shead and Philip Wolfhagen. He shares with Irwin the contemporary bestsellers Cressida Campbell and Nicholas Harding, and when he took on the Gold Coast–raised artist Michael Zavros, it was a sign that the artist was on the up and up. When Zavros won the inaugural Bulgari Art Award in 2012, Bacon squired Ros Packer to the celebratory dinner at the AGNSW. He has sat on the boards of Opera Australia, the National Gallery of Australia and the Queensland Art Gallery, and has donated generously to all of them. In short, there's a cachet to representing Fred Williams, but it goes both ways; being in Bacon's stable also confirms status and collectability. If provenance is the art world's in-built caste system, it extends beyond those who own an artist's work to everyone associated with it.

Williams came to Irwin via another Sydney dealer, Vivienne Sharpe, who wanted to stage a Williams show in Sydney in the late 1980s. Without her own gallery, Sharpe suggested they do it together at Irwin's. Sharpe was the instigator but it was Irwin who won out, forging a close relationship with Lyn, or 'Mrs Williams', as he switches to calling her midway through our interview. Born in India to British parents, and arriving in Australia when he was twenty-one, Irwin opened his gallery in the top of a converted tobacco bond building in Sydney's prestigious Queen Street, Woollahra, in 1976. He sometimes wears kilts to art fair openings, and is referred to as Rex Irwin Esq. in Opera Australia programs, where he features in the small print as 'OA's long-time patron of star baritone Teddy Tahu Rhodes'. But he's not quite as snooty as all that suggests; unlike many art dealers, who like to pretend they're in a sector more rarified than retail, Irwin freely calls himself a shopkeeper.

In 2013, after a few very tough years for the art market, he merged his business with that of Tim Olsen, whose gallery was just around the corner in Jersey Road. The newly merged gallery, Olsen Irwin, is housed in Olsen's premises.

The Irwin gallery website had listed 'the estate of Fred Williams' as one of its represented artists, but Irwin is at pains to downplay his role. 'No, no, no, I don't handle the estate. I work with Mrs Williams from time to time with projects from the estate,' he says. Obsequiousness is common among art dealers, who operate small businesses in a tiny pool in which the loss of a big artist or collector can have dire consequences. But Irwin has a genuine respect for 'Mrs Williams', whom he says has done a great amount to build her husband's reputation. 'She has pursued with enormous generosity and energy his reputation. He left his reputation in her hands, but she could have sat on it and done nothing,' he says. 'I think Mrs Williams' exhibitions are her work. She hasn't painted them, but she has made these shows through her hard work and her knowledge and her scholarship. They are a team, as they were during his lifetime.'

Of how the shows tend to come about, Irwin says:

Whenever we've done exhibitions we have tried to do ones that actually could have been done by Fred. I might come up with a wild idea and Lyn will then focus on it. She does most of the work by looking up things, thinking of things. Then when I go down to see her and talk about it, we think about where that might go, how many things we need. I might throw in: 'Do we have something of that?' It's a very minor collaboration, but it's been exciting.

Irwin says that when he started selling Williams' works it was to 'quite established collectors who had bought a picture from Rudy and thought maybe they should have another'. He continues: 'Rudy [Komon] was a bit of a tyrant and probably decided some people could have a picture and some couldn't, and perhaps one or two of those who couldn't were then able to buy from me.' Since then, he says, the Williams market has broadened to include a much wider range of people. Lyn has not had a dealer in Melbourne, showing in the early years through Lauraine Diggins and then in 2013, for the first time in many years, with Bill Nuttall's Niagara Galleries. Her reason for not having regular exhibitions in her hometown says a lot about the size and nature of the Australian art world. 'I've never quite sorted out Melbourne,' she says. 'There are too many dealers here that I know or like.'

The Williams name has stayed in the limelight not just through commercial gallery sales from the estate. Collectors also regularly buy and sell his work at auction, where more than 1200 pieces have traded since the early 1970s, nine of which have fetched more than $1 million.[5] Yet he hasn't been as traded at auction as Arthur Boyd or Brett Whiteley, for example. And, unlike Brack, Whiteley and Nolan, Williams has not broken the $2 million barrier, his top auction price being $1.9 million.[6] Perhaps the right record-setting Williams has not come up for auction. Perhaps his collectors are simply more conservative than those who chased Whiteley and Brack in 2006 and 2007, some of whom were traders looking for a quick profit. Whatever the reason, that his market has grown consistently rather than suffered big peaks and troughs has been an advantage. Irwin observes: 'I go to Maroubra to swim, and if I'm sitting ... at

Maroubra and somebody asks how business is, they'll say: "Sold a Whiteley this week, mate?" They wouldn't say: "Sold a Fred Williams this week?"'

The rise and fall of William Dobell's market

since the artist's death offers a fascinating contrast to that of Fred Williams. Born in 1899, nearly three decades ahead of Williams, Dobell was, like Williams, a star in his lifetime, collected by the best families and top public institutions, lauded by critics and the general public alike. But unlike Williams, whose estate has been sold off slowly, the bulk of the works left in Dobell's studio were dispersed in a couple of big auctions in the years just after his death, aged seventy, in 1970. Unlike Williams, this life-long bachelor had neither a wife nor children to help fuel public interest in his work in the decades following his demise.

Today Dobell's paintings are held by all of the top institutions, and his status as a significant Australian artist is assured. But he is no longer an artist *du jour*. His works don't come up on the secondary market that often, and while his painting of a nearly finished Sydney Opera House on a misty morning sold in 2007 for $816 000, more than double its low estimate and a record for the artist, he is not sought after in the same way that Williams, Brack and Whiteley are today. Nor have his paintings achieved the $1 million–plus price tags those modernists enjoyed over the past decade; *Opera House, Sydney Harbour*, 1968, is, in fact, the only Dobell to have sold for more than $500 000. Although half the size, it is a more evocative painting of the great white building at Bennelong Point than the pop depiction by

Whiteley that made $2.9 million in 2007. This lack of market activity for Dobell reflects a love of his best paintings by those who own them—private collectors who won't part with them and public institutions that rarely deaccession. But might it also reflect a relative lack of demand? Vendors tend to come out of the woodwork when ridiculous prices are being offered for artists in their collections.

Dobell has also slipped from the wider public consciousness. Attendances at the AGNSW's 1997–98 Dobell show, *The Painter's Progress*, illustrate the point. Exploring the link between Dobell's extensive drawing oeuvre and his paintings, the show received good media coverage, toured the country and was critically praised in some quarters. But it averaged only 403 visitors a day in Sydney. The gallery's Whiteley show just two years prior had averaged 1445 visitors a day. As art historian Sasha Grishin noted at the time, Dobell was now being judged as an artist, not a celebrity.[7] There are no doubt many reasons for this, chief among them the general shift in public taste away from more traditional painting and the dark palette favoured by Dobell. He has also been gone for twelve years more than Williams, twenty-two more than Whiteley and twenty-nine more than Brack. Perhaps they will follow the same trajectory. But it is also possible that his lower profile today has something to do with the quick sell-off of the works left in his estate at the time of his death, which meant that there were less of them coming onto the market—and keeping his name out there—in subsequent years. And might the lack of a living, breathing, familial promoter, with all the love and one-eyed belief in his brilliance that a wife typically holds, also have something to do with Dobell's lower profile? Dobell lived alone for much of

his life. In his later decades he lived with his sister Alice, who took on many of the roles of the artist's wife, caring for him and looking after the household affairs, leaving him free to paint. But Alice died before her famous brother.

What Dobell had instead was a foundation made up of businessmen, into which his entire estate went, the proceeds to be spent for the benefit and promotion of art in New South Wales. The three men who comprised the Sir William Dobell Art Foundation—Franco Belgiorno-Nettis, of Transfield fame and a founder of the Sydney Biennale; Charles Lloyd Jones, of the David Jones retail family and an AGNSW trustee; and Sydney accountant Tony Clune, executor of the Dobell estate and son of Frank Clune, author, gallery owner and one of Dobell's best friends—ran it for more than thirty years, and were replaced as they died by other members of their families. The foundation has done many great things, including buying the Oxford Street building in central Sydney in which the Australian Centre for Photography resides and selling it to the centre through a low-interest loan. It also funded the creation of John Olsen's 1972–73 mural *Salute to Five Bells* for the Sydney Opera House, bought a Bert Flugelman sculpture for the City of Sydney, and was heavily involved in the setting up of ArtExpress, which displays the work of final-year school students in the AGNSW and windows of Sydney's David Jones department store. It has funded lectures and art prizes, most notably the Dobell Prize for Drawing, an acquisitive award administered by the AGNSW, which after twenty years came to an end in 2012, to be replaced with a biennial exhibition starting in 2014. In 1990 it gifted 1000 drawings to the AGNSW, which formed the basis of the *Painter's Progress* exhibition. But this has all been done with minimal fuss

and no trumpet blowing. The foundation has no website, does not publish annual accounts and does not seek a media profile for what it does, says secretary William Neill, a partner at Sydney chartered accounting firm Frank Clune and Son, which handles the foundation's books and administration. 'There is a feeling among a couple of people that we should promote what we have done more, but I'm not one of them,' Neill says. 'I'm in favour of not publicising things. Part of that is self-interest—if we did, we'd be inundated with grant applications, and most of them would be for things we can't afford to do. The people we can help know about us. The trustees don't want credit or the interest in themselves. They would rather it went to Sir William.'

It is worth being reminded just what a big name Dobell was in his day. When the AGNSW held a survey of his work in 1964 there were queues, traffic jams and the hasty reprinting of catalogues.[8] Dobell and Russell Drysdale were to collectors in the 1960s and 1970s what John Brack and Brett Whiteley were in the 2000s. In 1972 art critic Robert Hughes warned that prices for 'local heroes' such as Dobell, Drysdale and Boyd were at 'incredible levels' given their lack of international profile. Dobell's notoriety was in part thanks to a 1944 court case in which he and the AGNSW trustees were sued over the artist's 1943 Archibald Prize–winning portrait of fellow artist Joshua Smith. The complainants, two of the losing artists in that year's prize, argued that it was a caricature, not a portrait. The case turned Dobell and Smith into household names, all but destroying them and ruining their friendship in the process. Dobell won the case, but was so mentally and physically debilitated by the experience that he retreated to Wangi Wangi, a small town on the shores of Lake Macquarie in regional New South Wales,

where he mostly lived until his death. Dobell won the Archibald Prize again in 1948, this time with a portrait of his friend and artist Margaret Olley. He also painted society folk, such as cosmetics queen Helena Rubinstein, writer Dame Mary Gilmore and Brisbane art collectors Sir Leon and Lady Trout. His portrait of Gilmore adorns the $10 note. He won three Archibalds in total, plus a Wynne landscape prize, being the first artist to win both in one year. In the early 1960s he was commissioned to paint four portraits, including one of then prime minister Robert Menzies for the cover of *Time* magazine. His work was hung in the David Jones gallery for Queen Elizabeth's 1954 visit to Australia, and the Duke of Edinburgh commissioned him to paint two works for Windsor Castle. The British knighted him in 1966, and in 1984 Australia named a federal electorate after him.

That Dobell was popular with collectors in his lifetime is highlighted by the 1962 Lawsons auction of the collection of Sydney cosmetics entrepreneur Norman Schureck, which realised more than £81 858 against a presale estimate of about £30 000. Thirty-six of the 292 lots in the sale were by Dobell, and he was the highest-selling artist in the auction. 'The Dobell prices were incongruous, especially for a living artist,' writes art market analyst Shireen Huda in her book *Pedigree and Panache*, pointing out that a newspaper article at the time said they bore no relation to the general market value of paintings either in Australia or Europe. Schureck had paid between £500 and £600 for the Dobell paintings, and they fetched more than £50 000 at the auction, representing an 8000 per cent return in less than twenty-five years.[9] Works by Nolan, Drysdale and Leonard French had also risen in status, but not to the extent of Dobell. The artist himself

was not impressed, noting sagely that 'people have more money than bloody sense'.[10]

The Sir William Dobell Art Foundation sold off most of the 100 paintings and hundreds of sketches and gouaches left in Dobell's studio through two public auctions held within a few years of the artist's death. The first sale, of only nine paintings and six drawings, was held by Christie's in 1971. The second, much bigger sale marked the arrival of Sotheby's in Australia two years later. Held at the new Sydney Opera House, it was touted as the largest art auction ever held in Australia, and Sotheby's third single-artist sale anywhere in the world. Befitting its importance to the auction house as well as the Dobell Foundation, the works were exhibited prior to the sale in New York, Los Angeles and London, as well as in Melbourne and Sydney. Wooed by extensive publicity, the auction attracted the crème of Sydney society, and as a result many first-time art buyers helped push prices beyond expectations. The sale realised $381 650 for the foundation, way above the $130 000 the works were valued at in 1970 and a nice premium on the $200 000 expected from the sale. Was it the right strategy? Huda writes in *Pedigree and Panache* that the dramatic increase in prices caused havoc with the original valuations and that Dobell's market suffered afterwards as a result. 'Work has almost certainly been purchased at over-inflated prices and a mini-depression occurred in the following year.' She notes that the remnants of the studio were not a true reflection of Dobell's oeuvre and ability, and thus 'perhaps not the most appropriate collection to introduce his work to the international market'.[11]

When asked if, with hindsight, selling off most of the remnants of Dobell's studio in two big sales was an error, given

the growth of the market in subsequent decades, Neill says no. 'I don't think it was a mistake. You have to look after art, have somewhere to store it, and there are costs associated with that.' He adds that the people involved were giving their time pro bono. Warren Brash, former personal assistant to Charles Lloyd Jones, points out that the foundation needed money to fulfil Dobell's wishes and that the sale of paintings was the obvious way to get it. Andrew Sayers, art historian and director of the National Museum of Australia, says it's hard to be definitive about the big sale versus drip feed:

> Would Dobell's reputation be any different now if there
> was still a body of work being slowly released? I'm not
> sure that would be the case. Shifts in taste have meant
> that people like Dobell and Donald Friend don't have
> the status they seemed to have when they were alive.
> Dobell engaged with the people of a particular moment
> in time, and once they disappear, their court disappears
> too. There's a universalism in Fred Williams and
> Arthur Streeton that Dobell doesn't necessarily have.

Holding a single-owner sale from the estate of a well-known artist certainly whips up excitement in a way that the slow release won't. After Hans Heysen died in 1968, the Art Gallery of South Australia received all his unfinished works, as per his will, of which there were nearly 2000. The remaining finished works were auctioned in a stand-alone sale at Leonard Joel in Melbourne in 1970. People crammed into the Malvern Town Hall for that sale, the crush so dire that the caretaker had to lock the doors to stop more people coming in.[12] Heysen's grandson

Chris says they had little choice but to auction it all off at once, as money had to be raised for death duties and to distribute among Heysen's children. 'Sometimes if you have this spectacular thing, and it's all from the estate, it builds up a lot of hype around the auction,' he says. 'I was about twenty-seven at the time and the town hall was packed out. It was amazing.'

How to manage sales is only one aspect of estate concerns. Lyn Williams has spent her own time and money creating an electronic database of Fred Williams' oil paintings, employing people to help with the task, and since 1991 has had a Melbourne warehouse where she stores and reframes work. 'Nobody has organised an artist's work in Australia more systematically than she has organised it,' says McCaughey. 'Suddenly the work had this ordered, structured look to it, and she in turn could create exhibitions from what was simply left in the estate. These were tremendously imaginative and creative steps.' Rex Irwin says the work has taken years. 'If you got a PhD student to do it, it could last four years or something, and they wouldn't have the knowledge or the insights that Lyn has. She's spent a lifetime doing it, and I think she feels very responsible for it.'

In an effort to promote better understanding of Williams' work, Lyn has also given curators and scholars access to her husband's leather-bound diaries in which he wrote daily from 1963 until his death.

Lyn has sat on the boards of the NGV and NGA, and for six years chaired the Australian Centre for Contemporary Art.

While she didn't join these boards for profile, her presence on them has not hurt. Some question what an artist's widow can bring to a public gallery board, but the answer is obvious: an artist's perspective, albeit one step removed; a contact book that spans artists, collectors and dealers; and the possibility of donations down the track. Lyn's invitation to join the NGV council in 1983, the year after her husband's death and during McCaughey's tenure, sprang out of her role with various bodies associated with the gallery. 'It was good for me at the time; it gave me something new to focus on,' she says. As with most of these things, she was worried about how it might appear and said yes reluctantly. In any event, she stayed until 1994, near the end of Mollison's tenure. She also served on the NGA council of trustees, from 1997 until 2004, during the directorship of Irishman Brian Kennedy. 'Like everybody, I thought that the boards had a great deal to do with acquisitions. But it often comes down to whether the café is making or losing money. There's a lot of that and very little of the other,' she says.

Lyn has also been assiduous in donating works to public institutions, and has avoided the path of those who set up galleries in honour of their late loved ones. 'I think it's more important to get key works into major museums than to set up shrines, because after a while people get tired of them, and you get the question of who's going to fund them and how are you going to do it?' she says. 'I think to be well represented in major museums is much more important.' More than 1000 works from Williams' print oeuvre have been given to the NGV to help it build the definitive collection of Williams prints, and works have been gifted to international museums, including the Tate and the British Museum in London, and the Museum of

Modern Art in New York, to help build international awareness of the artist. Her donations have not been confined to the visual arts, though; for example, Lyn made a sizeable donation to the Melbourne Recital Centre when it opened in 2009, and lent six Williams lithographs to hang in a function space that is now called the Williams Room. In 2011 that loan was converted into a gift. It is something of a surprise to learn that Fred Williams was not in favour of artists donating their work to institutions; nor, initially, was his widow. 'Fred felt that if galleries can sit back and wait for artists to donate work, that they're not taking the initiative in collecting, and he felt they should be,' she says. 'But I think the world has changed, and it could well be that he would have changed his mind on that as time went on. It's a different world now, knowing that galleries can get recurrent operational funding from government but that they have to find their own money for acquisitions.'

It was William S. Lieberman—the powerful, long-time chairman of twentieth-century art at the Metropolitan Museum of Art in New York, and before that a curator at the Museum of Modern Art—who helped change Lyn's mind about the merit of donations. In 1977 Fred Williams had been the first Australian artist to have a solo show at the Museum of Modern Art, curated by Lieberman. Following that 1977 show a handful of New York dealers expressed interest in exhibiting his work. 'At that time Rudy was very possessive, he wanted to be the go-between,' Lyn says. 'He was offering ludicrous shared commissions, and they weren't interested. Certainly Fred was looking at taking up some of those offers overseas.' Lyn stayed in contact with Lieberman after her husband's death. 'He said: "We want the work at the Met, I want the work, and I think you should donate it."'

Lyn donated seventy etchings and nine drawings, gouaches and watercolours to the British Museum in 2003, which consequently held a solo show of work from that gift, *Fred Williams: An Australian Vision*. Patrick McCaughey groans at the title: 'I couldn't believe the banality of it, what a clunker. The only thing that would have been worse is *An Antipodean Vision*.' He probably wouldn't have approved of the name for the British Museum's next show on Australian prints, either—*Out of Australia*. That 2011 exhibition, which featured sixty artists working from the 1940s onwards, was sparked by the success of the 2003 Williams show. It was put together by Stephen Coppel, an Australian who had worked at the NGA during Mollison's tenure.

Lyn has also donated five paintings to the Tate. She says:

> Generally I have only followed offers, I haven't initiated. [Tate director] Nick Serota wanted to extend the collection of Fred's work; they had already bought four etchings and a painting in the 1990s. We got the works together and he said he would have to find a donor. I couldn't bear the thought of him going around asking people for money. He probably would have come to Australia looking for money, and it wasn't a very good time, so I donated them.

She has also had some selling shows offshore, at Marlborough Fine Art in London in 1995, Nevill Keating Pictures in London in 2003, and at Peter Goulds' LA Louver in Los Angeles in 2005. The link with Goulds is a reminder of the role contacts play in the art world. Goulds asked to sit next to Lyn Williams at a 2001 dinner for the opening of the NGA's exhibition on British artist

Leon Kossoff, whom he represents. Over dinner Lyn invited Goulds to Melbourne to look at Williams' work. He had come across Williams a few decades prior, and eagerly accepted her invitation. The one-day visit turned into two and by the end of it Goulds had proposed staging a show in Los Angeles of Williams' later oil paintings. Goulds took Williams to the Basel Art Fair in 2004, then held a solo show in Los Angeles in 2005, featuring seventeen paintings done between 1975 and 1981, all of which were priced between $200 000 and $500 000. Fourteen sold, says Goulds, five to Australians, of whom two were living in their home country. He is keen to do another Williams show but is worried that if he waits much longer the interest he built up in 2005 will have dissipated. He was at the Canberra opening of the 2011 Williams retrospective, and his comments about the speeches and the chatter at the post-opening dinner are a reminder of how essentially parochial the Australian art scene is. 'I was struck by how much talk there was about Fred being an Australian artist, not an international one. I thought that was rather limiting,' Goulds says over the phone from Los Angeles. 'At the end of the day you can barely remember Picasso was Spanish. It isn't what comes first to mind, although when you think about it of course you see the Spanish influence every-where. But what comes to mind is that he's an international artist, and his influence is transcendent.'

Despite being held in a number of prestigious international collections, Fred Williams is not a big name offshore. A substantial international presence is the one thing that has eluded him in death, in part, ironically, because of his success at home. His paintings look very highly priced to Europeans or Americans who have not heard of him, and yet if the prices were dropped

internationally in order to gain a following, canny Australian operators would find ways to buy and then resell back in Australia for a profit. At the time of the Marlborough show the gallery expressed interest in handling the estate, but Lyn declined. 'I couldn't see how it could be managed from England; it didn't seem practical,' she says. 'I think it's too late to do anything serious overseas. I think you have to be living and working to really make it happen.'

Three decades after Fred Williams' death, the dispersal of works from his estate is still continuing. Philip Bacon says that it's not a 'magic pudding', even though at times it might look like one. 'Her [Lyn's] view is they should be seen by the widest number of people, which is why she's been so assiduous about placing them in museums, but also the commercial sphere,' he says. 'With Lyn it has always been about his legacy, and his well-deserved artistic reputation. A lot of estates would sell off the worst ones first, or the best. She's never been interested in playing that game.'

When asked whether handling her late husband's estate has been a burden or a joy, Lyn sidesteps the question: 'It's been very interesting. I've got to do things that a lot of people don't. There are aspects of it that you do worry about and think about a lot, but overall it's been very interesting.' As for what her daughters will do when it's their turn, she is not too fussed. 'They can sort it out. Fred told me what he thought I should do, but he left it to me to organise, to have the freedom to do it as I saw fit.'

The standing of Fred Williams today, first and foremost, reflects his talent as an artist. But what his wife has done, consciously or not, is ensure that the people who count in art legacy terms—public gallery directors, curators, blue-chip collectors—are

reminded of that talent on a semi-regular basis. This has been not only through carefully planned and executed exhibitions and donations, but also because of her particularity about how things are done, and her presence as an active art-world participant. She would no doubt hate it being described this way, but everything about Williams appears to align with the artist's brand, from the people and institutions associated with him to the quality of his commercial and public shows, to the boards Lyn has been involved with, to her diligence in documenting his paintings. Nothing appears to have been accidental, or rushed, or done for quick cash, nor without a view to how it fits with his overall standing as one of Australia's premiere artists.

Controlling? Yes. But to brilliant effect.

Chapter 7

Contemporary
by Nature

I think Australian art will be picked up internationally more progressively now. Polish art is red hot in LA at the moment, South American art is popular, Chinese and Indian art is everywhere. Australian Indigenous art has a following overseas. Non-Indigenous art from Australia and New Zealand are about the only ones that have not yet really gone global.

CHRIS DEUTSCHER[1]

The way in which Andrew Klippel is handling the work left behind by his father, sculptor Robert Klippel, marks a different approach from that of Lyn Williams, one in which the market to crack is nothing less than the world.

Andrew is a next-generation contrast to Lyn in that his strategy reflects his own career in contemporary music, and his age group—he is in his mid forties. As someone who divides his time between Los Angeles and Sydney, it was logical for him to think in terms of the broader, global market. If Australian musicians can cut it in the United States and Europe, why shouldn't Australian visual artists?

Robert Klippel's career spanned six decades before his death in 2001, aged eighty-one. Born in 1920, by the late 1940s and early 1950s he was living in Paris and London, and then in the United States for some of the 1960s. But after returning to Australia permanently in 1967, Klippel spent the bulk of his working life at his home in Birchgrove, Sydney. His abstract sculptures are made from materials ranging from wood and bronze to plastic and paper, some assembled from found objects such as typewriter parts, industrial objects and large wooden machine pattern parts. Klippel also painted and drew, but it is his sculptural assemblages for which he is most renowned. Life was financially tough for Klippel until he hit his sixties, although he did have his supporters. One was Sydney business-man Richard Crebbin, a big collector of Australian art through the 1960s and 1970s, and chair of the NGA in the six years leading up to its opening. Klippel put his only son through one of Sydney's most prestigious boys' schools, Cranbrook, by sell-ing more than 1000 works, mostly drawings, to the NGA in 1976. Crebbin convinced Klippel to show with Watters Gallery in Sydney, and a sell-out 1979 exhibition at that gallery proved a turning point commercially, after which the sculptor no longer needed to teach. He was fifty-nine. Transfield Holdings founder Franco Belgiorno-Nettis and Sydney solicitor William Burge were also big collectors of Klippel's work. Says Andrew of his father:

> He'd learned to live on fairly small amounts, and he maintained that for the rest of his life, regardless of how much he made. Abstract sculpture in Australia is a very marginal activity at best, especially back

then. But he just didn't care. He liked the isolation Australia offered. And he felt it gave him more time to just do his work. He wasn't expecting to do well out of it at all.

When Robert Klippel died he left behind his partner of the previous twenty-eight years, fellow artist Rosemary Madigan, and Andrew, his son from his former wife Cynthia. Andrew says there was never any doubt that he would be put in charge of the estate, which had been a tangential topic of conversation, on and off, for more than a decade:

> Without me even knowing it, he was always talking to me about the estate. He wanted me to have my own career. He said there was a lot involved with the estate, but I never really understood how much there was until I took it on. He would have liked to put all his work on a barge and float it out into the harbour. He said it's going to be a nightmare—he didn't want to burden me with it, but I said that's fine, I want to do it.

His determination to get his father's work known and collected internationally is palpable. After the anxiety of some artists' widows, the ease with which he talks about his strategy is refreshing. Perhaps he has less to lose. His father is no less an artist than painter contemporaries like Fred Williams, Sidney Nolan and John Brack, and certainly no less revered by curators. But in terms of handling the estate, and helping to build the

market for his father's work, Andrew is at the bottom of the mountain, just about to begin his ascent. It has taken him until now, with a lot of trial and error, to find the right path.

Andrew began learning the piano when he was about five. His parents had already split by this time and Andrew spent weekends in Birchgrove with his father. From the age of thirteen he developed an interest in jazz, and it was his father who took him to his weekend lessons. For the first few years after finishing secondary school Andrew worked as his father's studio assistant, while developing his songwriting skills. 'It never really occurred to me to follow Dad into art. It would have been too close to what he did and that would have been quite a difficult situation,' he says. 'I focused on music.' A composer and producer of pop and other contemporary music, Andrew had brief success as lead singer of the band Euphoria in the early 1990s, which enjoyed a gold album and a hit with the dance track *Love You Right*. Later that decade, with financial backing from an old Cranbrook School friend, James Packer, he set up independent record label Engine Room Music, through which he helped launch the careers of Human Nature, The Vines and Holly Valance. 'With the record label, the model was to take things out of Australia and contextualise them,' he explains. 'At that point the music business was only set up to deal with acts being successful in Australia. What I wanted to do was sign artists to major labels in America or England before they had established themselves here.' By the time his father passed away, Andrew's music career was in full swing; The Vines were making it big in the United States, and he had two songs in the UK Top 10. His strategy for ensuring that the big music labels

put their money behind a signing is one he hopes to transfer to the visual arts:

> The way I did business in music was I knew the stuff was good and I'd create a bidding war. My only insurance was that they'd paid so much for it they had to make it work, so I backed them into a corner. That's the only way. Otherwise you're from Australia, it's too much of a hassle, and when they see the costs involved in taking people back and forth they'll go: 'Oh stuff it.' But if they already have all their money on the line, they're more likely to go: 'Oh we have to do this.' While I'm aware that Dad is firmly established here, the same kind of thought process has gone into his estate.

In the decade after his father's death Andrew chopped and changed Australian dealers, trying out Bill Nuttall's Niagara Galleries in Melbourne, Philip Bacon Galleries in Brisbane and Anna Schwartz, who has galleries in Melbourne and Sydney. He had some success and some disappointments selling work, but really wanted to go international, and these local galleries were primarily focused on the Australian market, and their living artists. He then approached Sotheby's, hoping that because auction houses have a broader client base than small commercial galleries, they might have more success. 'The theory was that an auction house can perhaps do more for a sculptor than an art gallery, because it seemed to me there was more publicity and excitement around auctions, which were more of an event than exhibition openings,' he says. He had seen his

father's work get re-rated in the saleroom, where Klippel had been the star performer at Christie's 2006 auction of work from the estate of William Burge. Twenty-six Klippel sculptures found new homes at the Burge sale, mostly at prices vastly above their estimates. A new auction record for Klippel was set at that sale, $558 580, which still stands today. The sculptor's work was also hotly sought after in the 2009 auction of work from the estate of surrealist painter James Gleeson. Buoyed by these results, Andrew consigned about a dozen sculptures from his father's estate to Sotheby's for sale in 2010. More Klippels from other sources were added, such that the auction featured twenty Klippels all up. Only seven sold. 'It was an amateurish move on my behalf, to be honest,' Andrew says of his decision to consign so many to the one sale. 'What I learned was there is only a very small market at any given time for Dad's work. The market can only absorb so much, and it's not a lot per year.' He also learned that the auction room is good for some things, but that putting the entire estate in the hands of an auction house was probably not good for the brand. 'The theory was wrong. What it ends up doing is cheapening your position.'

In 2012 Andrew got the international break he had long craved, securing his father's representation with Galerie Gmurzynska in Zurich, Switzerland. A prestigious gallery that introduced the Russian avant-garde to Western Europe and which represents mostly modernist European and US artists working up to 1980, Gmurzynska sells from the estates of Pablo Picasso, Yves Klein and David Smith, among others. It was through his music contacts that Andrew made the connection. As he tells it—laughing at how it must sound—he had a friend who knew the hair stylist of the singer Beyonce, who knew the

daughter of gallery co-owner Krystyna Gmurzynska. 'Before I knew it they wanted to meet me in New York. So I flew over there to have lunch with the Gmurzynska family and [co-owner] Mathias Rastorfer,' he says. He was impressed with the approach of the gallery, which has four art historians on its payroll. That kind of staffing is unheard of in Australia, where even the most prestigious galleries are small businesses with staff numbers you could count on one hand. 'They did their due diligence on me and the estate and Dad's work,' Andrew says. 'When I arrived at the restaurant, they had every catalogue and book on Dad right there at the table.'

Klippel is the first Australian artist to enter Gmurzynska's stable, and Rastorfer sounds serious when he outlines his three-year strategy to make Klippel known, collected and respected internationally, from a virtual standing start. Rastorfer explains his approach over the phone from Europe:

> One of the biggest temptations is to sell the four or five most important works straight away, because that's the easiest thing to do. But then the estate is left with the lesser-known work and often doesn't know what to do with it. It's about placement in museum collections, in significant private collections, and with opinion makers, not just about selling. If we show him in the context of his better-known peers, the rest will follow.

It's just as well Robert Klippel is not around to see it. In September 1957, fourteen of his sculptures were smashed against a New Jersey wharf, many beyond repair. The then struggling artist was living in New York, and had shipped the works there

from Sydney. According to his son, he never got over it. 'If he thought of his work travelling, he'd be totally stressed out,' Andrew says with a laugh. 'It probably wouldn't happen if he was around, to be honest. He'd just get in the way and stop it.'

If Andrew's global push comes off—and it's a big if—Klippel will become one of the few Australian artists of his generation to crack the European market in the twenty-first century. Australian artists such as Russell Drysdale, Sidney Nolan, Albert Tucker and Brett Whiteley had great success in London in the 1950s and 1960s, but their profiles in Europe are not great today. Contemporary artists such as Tracey Moffatt, Bill Henson, Shaun Gladwell and Ricky Swallow have good reputations off-shore, but you only have to look at the hundreds of stands at international art fairs from Basel and Miami to Singapore and Hong Kong to see that Australian artists mostly appear on the stands of Australian gallery owners. Among the commoditised artists who are ubiquitous at such events—Damien Hirst, Anish Kapoor, Gerhard Richter and Tracey Emin—there are none from these shores. 'Successful exhibitions of Australians abroad are the exceptions that prove the rule,' Patrick McCaughey wrote in 2011. 'The rule is that Australian art looks indifferent when shown overseas and is treated accordingly.'[2] Nobody expects Klippel to become ubiquitous, but Andrew is pleased that Gmurzynska has already shown his father's work at fairs in Miami, Basel, New York, London, Paris and Hong Kong.

Andrew's international push is a gamble, but it is also a necessity. Lyn Williams had such a ready-made market for Fred Williams' work within Australia that the international sphere, while alluring, kept being subsumed by demands at home, for both his work and her time. It's a different story for an abstract

sculptor like Klippel, for whom the home market is narrow. Klippels sell for tens and in some cases hundreds of thousands of dollars, but even so, there are only so many people who want one. For an artist of his stature—AGNSW curator Deborah Edwards called his 'the greatest body of work produced by an Australian sculptor'[3]—there is a ceiling. 'Dad's work is on a really high level academically, but commercially it's difficult in this country,' Andrew says. 'It's difficult to reconcile those two things in a small market, which is why it's essential for him to get a shot overseas.' Klippel's work might be more suited to the international market anyway. His influences were cubism, surrealism and constructivism, Picasso and French sculptor Henri Gaudier-Brzeska. Strangely enough for a man who didn't live outside Australia again after the late 1960s, his work fits in better in Europe and North America than it does here. As Andrew observes:

> With most successful Australian artists, their work is geographically based one way or another. It has something to do with the land, or the sea, or the colours of the landscape. But Dad's isn't. A lot of people say he was a surrealist, but I'd say he was more of a constructivist in reality. So I've been looking to contextualise him into the constructivist movement, as a missing brick in the wall. He didn't talk a huge amount about being influenced by other artists. He was more influenced by shapes, and things that happened in nature, but in a very micro way.

Just as Lyn Williams had people quietly advising her, so has Andrew. One of the key advisors to both has been that

puppet-master behind so many Australian artists' careers, James Mollison. As inaugural director of the NGA, Mollison was an early supporter of Klippel. He extended the same courtesy to the artist's son. 'He was my secret consultant, he is a truly international thinker,' says Andrew. This is the director who bought Jackson Pollock's 1952 work *Blue Poles* for the NGA, weathering scorn at the time but ultimately having his foresight vindicated. The late Ann Lewis also helped Andrew, most crucially in developing contacts in the international art world. Lewis was director from 1964 to 1983 of Sydney's Gallery A, which supported modern artists, including those, like Klippel, who worked in the unfashionable area of abstract art. Lewis had serious clout, sitting for a time on the international councils of the Museum of Modern Art in New York and the Tate Britain, and closer to home chairing the Australia Council's visual arts board and being the Australian commissioner for two Venice Biennales. The wife of John Lewis, chairman of construction business Concrete Constructions, she was godmother to Andrew's friend James Packer and a good friend of Janet Holmes à Court.

Lewis's harbourfront home in Sydney's Rose Bay had art everywhere, including a John Olsen mural she had commissioned in 1964 for her dining room ceiling. After being diagnosed with pancreatic cancer in 2008, she donated many works to the Museum of Contemporary Art in Sydney and the Newcastle Art Gallery in regional New South Wales. After her death in May 2011 her house sold for $15 million and most of her remaining collection was sold off by Mossgreen Auctions. Before all of that, in 2005, Lewis met up with Andrew in London, where she introduced him to Nicholas Serota, head of the Tate Britain, and Neil MacGregor of the British Museum. She also gave him

introductions to top curators at the Museum of Modern Art in New York, the Getty in Los Angeles (whose boss then, Michael Brand, now runs the AGNSW) and American curator Robert Storr, artistic director of the 2007 Venice Biennale. Andrew says: 'She always told me to be patient. It's not like the music business; it takes time.'

Gmurzynska is planning an exhibition and a couple of publications on Klippel for some time in the next few years, with the idea that it will add to the 2002 catalogue raisonné by Deborah Edwards. Rastorfer makes it clear that this is a serious project for his gallery:

> We have a solid reputation for scientific research, and for promoting interesting, important historic figures who have created something authentic but have not had the exposure they should have had. We found him very interesting due to his connection with the constructivists, his Polish origins, his time in America. The more you go into Klippel, the more modernist links you find. We will introduce his work in the context of those peers, taking him out of the Australian context and putting him into an international one. We want to show where he fits in worldwide.

If Gmurzynska gets it right, prices for Klippel's work will rise, probably over the course of a decade or more, rather than in sudden spikes. The money will obviously be of benefit, but Andrew seems genuine when he says that it is more about honouring his father, putting him in the international context he deserves, than about making money. And that will take time. 'With music

you can get something within nine or ten months, and within another ten months it could all be over. This is a long play.'

Bronwyn Oliver was born thirty-nine years after Klippel, Rosalie Gascoigne three years before, but both are considered contemporary sculptors by virtue of the pieces they created and the decades in which they worked, primarily the 1980s and 1990s. The job for those managing their estates is very different from that of Andrew Klippel for one very simple reason: they both sold so well in the latter parts of their careers that there is very little left to disperse.

Bronwyn Oliver had a very strict daily routine, which became even stricter in the last few years of her life. The Sydney artist would wake at 5 am every day to set out on an hour-long run from her home in Haberfield. Her daily jog would take her around Iron Cove, along the water's edge through Five Dock, Drummoyne, across the Iron Cove Bridge and back through Rozelle and Lilyfield. When she arrived home she would make herself an elaborate fruit breakfast, and by 9 am she would be in the self-contained studio at the back of the house she shared with her partner of twenty-two years, wine writer Huon Hooke. If she felt tired—and she often did—she would take a mid-morning nap under the kitchen table or on the studio floor, or wherever else she felt like lying down. It was rarely a bed. She would go back into the house from the studio for an hour-long lunch break, typically cooking up a vegetarian extravaganza, before returning to work for the rest of the afternoon. Bronno, as Huon called her, would come inside again at 6 pm for dinner at 7 pm

and return to the studio an hour and a half later, always working through until the end of Phillip Adams' *Late Night Live* on ABC Radio National. Like many of the most successful artists, Oliver was obsessive about her creations, and she had an incredible work ethic. She was also highly organised, a lover of routine as well as effort. Huon recalls:

> On the dot of 11 Phillip Adams would be finishing his program, there'd be the ABC time signal and sure enough you'd hear this bang as the oxyacetylene torch went out, she turned off the lights and shut the door. Bronwyn used to say if you're not living on the edge, you're taking up too much room. I doubt she truly believed that, but I think her discipline had a positive effect on my discipline. I probably wouldn't have got as much work done as I did during those years if it wasn't for her. Now I'm much more laid back, I'm always cursing that I'm not getting stuff done.

For eighteen years Oliver taught art to children aged between four and five at Sydney's Cranbrook School, but from 2003 she was able to survive solely off the sale of her sculptures, which in the mid 2000s were selling for between $25 000 and $40 000, and in the case of her bigger pieces often for more than $100 000 (and $350 000 in the case of the 380 kilogram *Vine*, 2005, which spirals down a four-floor atrium at the Sydney Hilton and was commissioned as part of the hotel's $200 million redevelopment in 2003–05). She had a ready-made client base in the Cranbrook parents and the collectors who frequented her Sydney gallery, Roslyn Oxley9 Gallery. Owned by Roslyn Oxley, daughter of

the founder of Waltons department stores, and her husband Tony, a member of the Bushells Tea family, the gallery is tucked down the end of a Paddington laneway and doesn't get much passing traffic, but to those in the know it's one of the best in the business for contemporary art. Back in 1984, when Oliver, then a newly minted art graduate, wrote to Oxley asking her to come and see her sculptures, Oxley's gallery had only been running for a couple of years. Oliver was then living above a restaurant in Surry Hills and making sculptures out of paper. She would move onto cane and fibreglass with paper before settling on metal, mostly copper, in the late 1980s. 'When an artist is quite young, you have to look at the integrity of the personality, because the work tends to be fairly underdeveloped—their sense of urgency to become and stay an artist, their intention, that sort of thing,' Oxley says. 'We get a lot of requests to come and look at an artist's work and mostly I say, "We'll see." But there was something special about Bronwyn. She was really together and bright, and quite chirpy.'

Getting taken on by Oxley was a fortuitous break in a career marked by many such moments. Oliver, who grew up in Gum Flat, in regional New South Wales, enrolled in painting at Alexander Mackie College but due to a computer glitch ended up in the sculpture stream, where she chose to stay. Upon graduating, she won a 1981 New South Wales Government travelling art scholarship that took her to London to study at the Chelsea School of Art, where for a time she shared a house with British–Indian sculptor Anish Kapoor. It was the first of a number of scholarships awarded to her, including an artist-in-residence at Cheltenham College in the United Kingdom and three others that took her to France, among them the prestigious

Möet & Chandon Travelling Art Fellowship in 1994. In 1993 she had been included in the Queensland Art Gallery's inaugural Asia Pacific Triennial, and a decade later, in 2003, she featured in the inaugural Beijing Biennale. In the summer of 2005–06 the McClelland Sculpture Park and Gallery in Victoria held a survey of her work. 'She never lost sight of the fact that Roslyn was the person who gave her career the big kick that got her established,' says Huon. 'Bronwyn didn't sell for years. She sold to people like my mother and my aunt. Beryl Whiteley [Brett's mother] actually bought some of her early paper works.' Oliver held a solo show at Oxley's almost every year, only occasionally every two or three, from 1986 on. She also showed with Christine Abrahams Gallery in Melbourne from 1987. 'It was really unusual for an artist to show every single year in one city,' says Oxley. 'It was fantastic because it cemented her as productive. People started to get to know and follow her work.' The early shows, featuring work made of paper, cane and fibreglass, did not sell well, but when Oliver moved into working with copper wire, and then copper sheet, things started to take off.

By the mid 2000s she was a regular on the most-collectable lists put out by art magazines, and her work was included in the NGA, most state galleries, some corporate collections and many collectors' homes. She also created works for numerous public spaces, including Sydney's Botanic Gardens and Quay restaurant, Brisbane's Queen Street Mall and Adelaide's Hyatt Hotel.

Oliver had always been quirky; Oxley laughs as she talks about how the artist would never reverse a car, always getting out to let someone else do it. She talks with fondness about how the two couples, Oliver and Hooke and Oxley and her husband Tony, would go bushwalking in the Blue Mountains,

Oliver rushing ahead to take photographs of the rest of them as well as of tree roots, seed pods and other items that might provide inspiration for her work. The Oxleys hold an annual Christmas party at their 1841 Gothic Revival home Carthona, situated on Sydney Harbour at the tip of Darling Point. It is the kind of party people desperately want an invitation to. 'They'd come, Bronwyn would eat two prawns and then they'd leave,' says Oxley, not unkindly. Oliver was not and never aspired to be part of the Sydney art scene. She always stood outside it, and it was one of the things Huon admired about her:

> I write about wine, and you see an awful lot of it in the wine world as well as the art world: people whose wine is ramped, their prices go up, they get talked about and collected, and it really isn't justified; it's about a personality or a particular knack for self-promotion. When I want to profile someone in the wine world, I'm particularly impressed by people who don't resort to artificial means to achieve their profile or fame, and if I see that, it's a turn-off. Bronwyn wasn't like that at all. Whatever recognition she got was thoroughly earned; it wasn't manufactured or manipulated. Yes, she had Roslyn, which is a pretty good start, and I guess if you were negative or cranky you might try to push the line that Roslyn ramped her career. But the way I see it, Roslyn just gave a person of great talent the opportunity.

Oliver's creations are extremely labour intensive, and it would often take her four to eight weeks just to finish one piece.

She would sometimes call on Tony Oxley's engineering background to help her nut out a problem—for the sculpture that sits outside the Orange Regional Gallery it was how to pump water upwards, for another it might be how best to attach a spherical sculpture to the ground without losing its shape. But mostly she would work it out herself. She would talk to Roslyn most days, and the two of them would often visit a collector's house to look at a space and decide what kind of creation could be made for it. When one of her big works was being fabricated at Crawford's Casting, Oliver would drive over there daily to check on its progress, sometimes taking homemade biscuits or lunch for the staff. Despite her own regimented diet, she loved to cook for others.

But aside from this sort of contact, Oliver lived a fairly solitary existence, which might help explain why, when Huon left the relationship and the couple's home in late May 2006, Oliver fell to pieces. To his mind the relationship break-up had been a while coming. 'I just wanted to be somewhere else,' Huon says by way of explanation. 'We certainly didn't love each other any more. The relationship had died as far as I was concerned. I suspect she might have admitted that to herself, although she never said so.' Five weeks after she and Huon split, on 11 July 2006, Oliver took her own life. She was forty-seven.

Huon never thought he would be able to live in the couple's Haberfield home again, but did eventually move back in there a few years later. There are a number of Oliver's sculptures in the house, some on the walls, some on plinths, but they do not dominate. Oliver was a contemporary artist working during one of the longest booms the Australian art market has enjoyed. In the latter years of her career she sold almost everything she created and made about half of her works on commission, and

Oxley had a waiting list for her uncommissioned pieces. Dying eighteen months before the start of the global financial crisis, Oliver was not around to see the market shift from demand to supply overload. Huon had many headaches after Oliver died, but what to do with a big stash of artworks left behind was not one of them. Mostly what he had to do was get over the guilt, the hurt and the shock of what happened. He had a lot of counselling, which helped, but for a long time he was distracted, operating on very low energy levels, dividing everything in his life into pre and post that event. 'For the first year after Bronwyn died, my overwhelming feeling was that this is a postscript, my life from here on in is a postscript. It sounds very negative doesn't it, but that's how I felt for a long time.' He adds, almost as if it's the first time he thought it, 'It doesn't feel like that very much any more, actually.'

In conversations with Oxley and others after Oliver's death, Huon began to realise that he was not the only one who had noticed incremental changes in her personality over the years. Oxley says her friend had become quite difficult and impatient, and completely obsessed with her diet. In her early years teaching at Cranbrook she had put on weight, thanks to morning and afternoon teas, and once she lost that weight, she was determined to keep it off, hence the long morning runs. 'She became more reclusive, obsessive, anxious. Her career was going extremely well, but the more well it went, the more worried about [work] she became,' says Huon. 'She'd always be reminding people that her career could fall over at any time, that people might abandon her.'

Oliver worked with copper virtually every day for eighteen years. She never wore a face mask or respirator, nor did

she wear gloves when handling copper wire and phosphorus copper brazing rods. She often kept the doors and windows shut when brazing because she felt the cold. Huon says that when he visited her in the studio he could sometimes see little black filaments in the air. Ironically, Oliver had moved from fibreglass to copper because she was worried about the detrimental health effects of the toxic fumes produced by fibreglass. As it turned out, she should have been equally worried about working with copper. Following Oliver's death Oxley's daughter Leyla Oxley, a naturopath, suggested that they send some of Oliver's hair to a laboratory for heavy-metal testing. The results were revelatory. It contained nearly eight times the normal, or healthy, level of copper. Aside from being harmful for internal organs, such as kidneys and liver, an excess of copper in the system can play havoc with the brain, the glands and the nervous system, and has been linked to depression, anxiety, bipolar disorder and schizophrenia, among other things. The artist's diet probably exacerbated the problem because red meat, which she no longer ate, is one of the best sources of zinc, an element crucial to balancing the amount of copper in the system. 'The doctor who analysed her hair said she was very sick, and would have had a major health issue very soon, if she did not have one already,' Huon says. 'How much the copper poisoning contributed to her state of mind, and her death, is a matter of conjecture, but the guy who did the analysis was in no doubt at all that she was in a very bad state.'

It wasn't much comfort to those who wanted Oliver to still be alive, but it did help to make some sense of what had happened. It was also a wake-up call about the health risks artists can take in the name of creativity. Huon wrote to the then dean of the

University of New South Wales' College of Fine Arts, Professor Ian Howard, the head of Crawford's Casting, Alan Crawford, and some other sculptors to warn them of the finding. In the letter of September 2006 he said:

> The technician at the laboratory said there was no doubt that Bronwyn had major copper toxicity and that if she was not already suffering from serious liver and kidney problems, she was about to. But the most interesting thing is that copper toxicity is bad news for mental health: it is related to anxiety disorders and depression, and that fits with Bronwyn's personality, especially in recent years. There are many other symptoms which tally too, such as problems with pre-menstrual tension ... fibroids and endometriosis, skin rashes and eczema. The balancing element for copper is zinc, and Bronwyn was only in the reference range for zinc—she needed more in her system to metabolise the copper. She had given up red meat two or three years ago, and red meat is the best source of zinc.

Huon agrees that he might be reading too much into it, that he might be looking for reasons other than the couple's break-up to explain Oliver's decision to take her own life, but his gut feeling tells him otherwise. 'Copper poisoning could explain why Bronwyn became so depressed; why she could not go on living, when she had so much to live for.' Oxley agrees with him. 'Well, she worked with copper for a long time, and she worked without a mask on. She went through thousands of audiobooks, she'd listen to books all day, sitting in there with all the fumes

going,' she says. 'I guess her personality became exaggerated probably two or three years before she died.' Professor Howard says that training colleges such as COFA are very aware today of occupational health and safety concerns, but when Oliver was a student that was not so much the case:

> We have more data sheets and reading to be done by students before they commence projects than you could believe, and there can be a culture clash here because art students want to be free and creative; they don't come from scientific, methodical backgrounds. That's a gap we often have to bridge, but nowadays we are absolutely hot on this, because we recognise the dangers. Were we aware of this in the mid 80s? No, and nor was the rest of the industry. Even now, internationally, the standards can vary enormously. If you went to a studio in China you'd be shocked, and within Australia standards vary widely from artist to artist.

Huon also had some other dramas to contend with in the wake of Oliver's death. The couple had written wills when they bought their first home, effectively leaving everything to each other, but about eighteen months before Oliver died she re-drafted her will, leaving her half of the Haberfield house to the Cat Protection Society. The couple had three cats, and as Huon explains, 'animals were pretty important to her; she was more inclined to support animal causes than human causes'. But due to a drafting technicality the will wasn't valid. This meant that, in effect, Oliver died intestate. Huon wanted to abide by her intentions, so he made an offer of a payout to the Cat Protection

Society, which was accepted. Oliver was estranged from her bio-logical family, so the estate eventually came to Huon on account of their long-term de facto relationship. 'The family were really upset. They thought I was trying to grab everything. They didn't necessarily want it, but misunderstandings happen when legal letters go back and forth,' Huon says. 'I was very upset that I did that to them, it wasn't my intention. It was a bit of collateral damage, I guess.'

Huon's job of handling Oliver's legacy is different from that of most of the other people interviewed for this book, and it stands in interesting counterpoint to them. There are many reasons for this: because he is male, because he had his own, entirely separate career, because Oliver didn't leave hundreds or even dozens of works to deal with, and because, unlike many artists, Oliver was highly organised. She left notes saying who the handful of leftover works should go to, a note about returning a library book, all of her tax files, and instructions for the man who made the crates that would be required to take her pieces to Oxley's gallery, where her next show was due to open within a month. On her computer she also left the database she had always kept, listing the details of every work, with a picture of each. 'She had a fairly good idea of her own significance; she wasn't overly egotistical or self-aggrandising, not at all, but I think quietly she had a pretty accurate idea of her position in the art world. The tragedy is she could have gone on to do so much more.' Oliver was also a good editor, throwing away works that she felt were not up to scratch, sometimes to Huon's horror:

> She was pretty pragmatic about stuff like that. She
> didn't really want people to see things that she didn't

think were successful. It must be strange—something you've built up with your own hands over a period of weeks, and presumably built a relationship with of some sort, then you get a saw out and chop it into pieces small enough to fit into a wheelie bin. Some of them I'd think: You're right, that one probably didn't work. But there were a couple of pieces that were more doodles than sculptures that I rescued from the bin when we were living in Leichardt. I had one on the wall in my office for years.

Oliver held only eleven solo shows at Roslyn Oxley9 Gallery, together with some at Christine Abrahams Gallery in Melbourne. Along with her commissioned works, Huon estimates that there are about 305 works in her oeuvre, along with some small maquettes or models that he has. They all sold through Oxley or Abrahams, so the ouevre is watertight, making the issue of fakes non-existent, at least to date. If all artists worked the way Oliver did, with assiduous record keeping and selling only through the one or two long-time dealers, they would make it a lot easier for those handling their legacies. Although Oliver wasn't doing it for this reason, the upshot is that it protects her work and thus her reputation. Wendy Whiteley and Alison Burton, by contrast, have a much harder job due to the fact that neither Brett Whiteley nor Howard Arkley were great record keepers, and both sold through unofficial avenues to support their drug habits. Oliver had the added protection of creating work that would be very difficult to copy. 'There are plenty of people who—how shall I put it in polite terms—have done work that is heavily influenced by Bronwyn. But to do it in that kind of detail, and

that kind of intricacy—if I was being a bit rude, I'd say no sane person would do it,' Huon says. 'The amount of time, effort and intensity to produce those works is not normal. It's not within most people's idea of what's reasonable.'

Oliver's July 2006 show at Roslyn Oxley9 was a sad event, staged in memory and honour of someone who should have been there, and featuring some of the most exquisite works she had produced. Art dealers typically try to pre-sell works before a show opens, and in the pre–financial crisis 2000s, with an artist like Oliver, this was not hard. Before Oliver's death a prominent Sydney art dealer had already secured four of the sixteen works in that show, which, priced at about $48 000, now looked like bargains. Three other works were given as gifts to friends and family. The rest Huon and Oxley decided not to sell for a while, despite fielding numerous offers for them. 'Maybe that was a little unnecessary but at the time I thought: Hang on, I have to look after this stuff. This is the last there is,' he says. 'You don't want it disappearing into someone's garage.' Oxley did eventually price Oliver's final works, at about $120 000, more than double what they would have sold for had she not died. The NGA bought one piece, as did a private collector, but the other seven remained unsold. Huon wondered if perhaps the prices were too high, but like Oliver he deferred to Oxley on the matter. Oxley is sanguine about it. Given how few of Oliver's works were left, and that by 2007 her pieces were already fetching upwards of $100 000 on the secondary market, she says that it doesn't really matter if they take a long time to sell. Simple supply and demand means they will sell, and the most important job is to ensure they go to a good collection. Oliver had made two models for larger pieces that a Sydney couple were

considering commissioning, with the large works to be made at Crawford's and installed in the couple's home. As they were undecided about whether to proceed with the commission at the time of Oliver's death, the issue became whether the pieces could be fabricated posthumously. Huon is not comfortable with the idea. Oxley consulted a few people and was told it would be okay. In the end the couple did not go ahead with the commission. It's an interesting issue for sculpture—one that is slightly different in Oliver's case because she handmade her works in editions of one, so they are usually more akin to one-off paintings than limited-edition sculptures cast from a mould.

Oliver's work did not appear on the secondary market very often before she died—only ten times, in fact—and they were mostly priced at a few thousand dollars. Some didn't sell. After she died the number of her works on the secondary market, and the prices they fetched, jumped markedly. Eight pieces sold for more than $100 000, six of them selling in 2010, when the overall market had cooled. The run began in May 2007 when a 2001 work, *Tendril*, fetched $162 000 at auction, much higher than its $60 000 to $80 000 estimate. A few months later a 2004 work, *Skein*, sold for $192 000, also significantly above its $100 000 to $140 000 estimate. By 2010 auction houses had recalibrated their prices for Oliver pieces, and when in April 2010 a large 2003 sculpture, *Tracery*, came up for sale at Deutscher-Menzies, it had an ambitious $350 000 to $500 000 estimate. It didn't quite meet these expectations, being knocked down for $300 000, but that was still nearly double the previous highest price fetched at auction. It was bought by Luca Belgiorno-Nettis, joint managing director of Transfield Corporation and chairman of the Sydney Biennale. He paid $360 000 once the auction house fee was

included. In November 2010 a piece made in 2002, *Calyx*, made $234 000, and in December another 2003 work, *Shell*, sold for $240 000. Huon is happy to see Oliver's work on the secondary market, although he says that he will probably eventually donate to public collections the thirteen-odd works he has left. They include four large framed works on paper, several maquettes 'and bits and pieces, many of which are just fragments but beautiful things in their own right'. His view:

> If they're in private homes, they're going to be on display but probably only seen by a limited number of people. If they're in public collections the chances of them being seen by a large number of people is higher, but they're probably going to spend a large amount of time in a storeroom. How do you decide which is the better place for them to be? Maybe being traded, sold to someone who wants them, is a better future for them than sitting in a dungeon somewhere.

Cranbrook School has honoured its much-loved former teacher. It owns a 1993 Oliver sculpture, *Surge*, which the artist donated in 1994, and each year since 2007 its senior school has awarded the Bronwyn Oliver Prize, for 'the most sophisticated and resolved sculpture that does justice to the memory of Bronwyn Oliver'. Huon hasn't thrown anything of Oliver's out and says he feels no great rush to sort through her files. He has had tentative discussions with an archivist at the AGNSW about whether the gallery might consider holding Oliver's papers, pictures, drawings, diaries, letters, records and so on, and they have expressed interest. But for Huon there is no need for speed.

He would like a retrospective of Oliver's work to be staged, preferably at the AGNSW, and a book to be published, which art writer Hannah Fink has begun work on. He would love to bring out three early fibreglass works, which were executed in the 1980s and are in long-term storage at Oliver's parents' home in Inverell, northern New South Wales. The book and retrospective, Oxley says, need to go hand in hand, as one tends to promote the other. Oxley believes a time lapse after death is not a bad thing, particularly after a suicide. 'I don't think there is any rush. The work is still going to be there, and I think the appreciation probably grows,' she says.

Holding back on selling those final works from the 2006 show was a good idea. In 2011, when COFA was trying to raise money for its $60 million redevelopment, Dean Ian Howard considered to whom he would like to offer naming rights of the new galleries and studios. The federal government had committed $48 million, and the University of New South Wales, the school's owner, would tip some more in, but the expectation was that COFA would raise the rest. Gene and Brian Sherman, of Sherman Galleries, gave more than $1 million, and in return a postgraduate floor on the main studio building was named after their friend Nick Waterlow, former curator of the college's Ivan Dougherty Gallery who had died in 2009. Howard decided that Bronwyn Oliver, who had briefly taught at COFA, would be a perfect name to have in the sculpture studio. (He had his own link to Oliver, having taught her at Saturday morning art classes in Inverell, when she was ten and he was a fresh art/teaching graduate, and he had taught her again at Alexander Mackie College, renamed COFA in 1990.) Oliver was more interested in process than intellectualising her work, and the

college's sculpture studio had one of the best tool rooms around. 'Bronwyn was interested in the materiality of sculpture, the techniques, tools, materials making form,' says Howard. 'COFA has always had a strong woodwork and metalwork workshop, and a fabulous tool room.' He decided to approach Huon, but was nervous about doing so. In return for naming the sculpture studio after Oliver he would have to ask for $250 000. 'It didn't feel right asking him—I really worried about it, but within seconds of my pressing the send button I heard back from Huon, who said this is a fantastic idea, yes we must make it happen.' Huon sold some works from the estate to pay the $250 000; the sculpture studio has now re-opened as part of the redeveloped COFA, and is named the Bronwyn Oliver Sculpture Studio.

Huon's working life was not intricately tied up with that of Oliver, and he doesn't have a lot of spare time to devote to polishing her legacy. 'It is not something I've spent any time on really. I have a busy enough life of my own. It's a bit out of control but isn't everyone's life out of control?' Nevertheless, like the others, he is keen to ensure her name lives on. 'One hopes she won't be forgotten—that's the big hope. I don't care if she isn't raised up as one of the greatest ever, that's a bit unrealistic, but it's terrible if people forget. Plenty of good artists have not been remembered well enough by history.'

Roslyn Oxley has also been involved with the Rosalie Gascoigne estate, having been the artist's dealer since 1989. The artist died relatively suddenly in 1999, and thus had no time to guide her family on how to deal with the contents of

her studio, let alone designate an artistic executor. The family left the studio alone for some years, feeling in no rush and wanting to preserve Gascoigne's spirit within it. But the Canberra bush-fires of 2003, which came to within two streets of the Gascoigne family home, got them started. Given the nature of Gascoigne's materials and working methods, assessing what was finished, what was only partly finished, and what was a study or sketch was one of the first tricky jobs for husband Ben and children Martin, Toss and Hester. There were between thirty and forty pieces left in the studio, including one that was laid out but not yet glued down. Martin explains the process of sorting through 'many shades of grey':

> It's a judgement and it wasn't easy. You think about it, you look at whether it had a signature on it, but then she often didn't sign things until signing day, when she'd sign all the works for a particular show at once. And there were a couple of things that seemed to be finished but didn't yet have titles.

Gascoigne had donated works to galleries before her death and the family followed suit afterwards, particularly the larger, significant works that are too unwieldy for most private homes and that they felt really did belong in public collections. 'It's about finding good homes for good works and, in so doing, helping to encourage appreciation of the artist,' says Martin. After some consideration they decided to give the letters, papers and other correspondence of both Gascoigne and Ben to the National Library of Australia. 'We could have given Mum's papers to the National Gallery of Australia, and they were quite

keen to have them, and given Dad's to the Australian National University or the Australian Academy of Science, but there is quite a bit of overlap between them, and in the end we thought it important that they be kept together,' Martin says.

The ten panels for the work *Earth*, 1999, were in the studio when Gascoigne died, but they had never been exhibited. Martin says it was not clear how they should be hung, and that his mother would have liked to see them in a gallery space before deciding what to do. The dark brown, maroon and green-hued panels are vastly different from many of her earlier works, whose yellow and white tones seem to radiate life. The family decided the best thing to do with the panels was to show them, to get a sense of how they might hang together and be received. *Earth* thus appeared in the Drill Hall exhibition of Gascoigne's work in Canberra in 2000, and then again in a commercial show at Oxley's gallery in 2004. As the last work of a Canberra-based artist, the obvious place for it was the NGA. Director Ron Radford was a family friend; he had spoken at Gascoigne's funeral, and Hester then worked at the gallery as his personal assistant. There was some pressure to sell the piece, but the family did not want the panels broken up and scattered around the country. 'Mum had always been close to the gallery here. She'd given them a number of important works for one reason or another. We knew Ron and he was enthusiastic,' Martin says. 'It seemed the obvious place, he was very keen, so that's where it went.'

Public gallery directors typically hate attaching dollar values to acquisitions, none more so than Ron Radford, who almost rolls his eyes whenever the issue of price is raised. However with *Earth*, perhaps to encourage other donors, he announced that the work had been valued at more than $2 million. Since

they had donated it under the federal government's cultural gifts scheme, the family didn't mind. Says Martin: 'While there's a considerable tax benefit for *Earth*, there's no way Dad got the full value of that. But at least you're getting a proper valuation. It's important, it sets a benchmark. You don't want things to be undervalued. It's a reputation thing, and it can affect the market, too.'

Gascoigne has done extremely well on the secondary market in the decade since her death, with most of the 151 of her works that have appeared at auction coming up through the 2000s. Her highest auction price while alive was $17 760, but within three years of her death Gascoigne's work had broken through $100 000. Within another two years her prices had topped $200 000, and in August 2007, within weeks of that $200 000 sale, they had breached $300 000. Quality aside, collectors were responding to the knowledge that the source was now finite.

Nor has there been a lack of exhibitions since Gascoigne died. Her work has featured in many group shows over the past thirteen years, as well as numerous solo ones. There was the Drill Hall exhibition of work from the studio, and her appearance in the Sydney Biennale in 2000; a showing of the large installation piece *Plein air* at Gow Langsford commercial gallery in Sydney in 2003; a survey at New Zealand's Wellington City Gallery in 2004; the Oxley estate show in 2004; and, most significantly, a retrospective held at the NGV in 2008–09. The latter was a success, attracting an estimated 94 450 visitors between late 2008 and early 2009, a high figure for a solo show on an Australian artist, albeit for an exhibition with free entry. The family put some of its own money into the catalogues for the Drill Hall and NGV shows, and waived copyright fees, as often happens. 'It's

about more than the work, it's a reputation thing,' says Martin. 'That's why the catalogue is so important, and why we put a lot of time into it.' Ben wrote an essay for the Drill Hall catalogue, Martin for the NGV publication. Martin says his essay gave him an opportunity to 'pull together the work I'd been doing on Mum'. He speaks in his essay about the artists who had interested his mother, including Colin McCahon, Ken Whisson, Pablo Picasso and Michael Taylor. 'I wasn't writing art appreciation of her, because it's for others to make those judgements, but what I could talk about was her relationship with artists, who she looked at and why, what she got from them, what she wrote about,' he says. 'We are fortunate in that we have good family records.'

The existence of good records from Gascoigne's galleries as well as from the family has probably helped protect her oeuvre from fakes thus far. Copycats are more of a family bugbear, of which there are numerous examples, some more blatant than others. 'I just try to keep track of them so I know the environment and what's out there, so that if anything were to come onto the market later as a "Rosalie Gascoigne" I'd be aware of it.'

Would Gascoigne have been flattered or irritated by the imitators? The latter, says Martin. 'It's disrespectful—she hated that kind of thing. But there's very little you can do.'

Chapter 8

Copyright Wars

I would never authenticate a work—I don't have the expertise. It's not where I go, it's not what I'm about.

ALISON BURTON[1]

Howard Arkley is another contemporary artist who sold so well in his 25-year career that while there were many works left in his estate when he died, they were not the most valuable ones. The majority were earlier works; paintings from the 1970s and hundreds of works on paper, many also from that decade. It was paintings from the later period—the suburban homes, apartment blocks, freeways and chimneystacks, done from the mid to late 1980s onwards—that collectors were, and still are, most interested in.

After his death, Arkley's widow Alison Burton had plenty else to contend with, however, from friction with Arkley's mother that spilled into the public arena, to a rampant auction market in the years immediately following Arkley's death, complicated by the appearance of works that Arkley might have sold out the back door to support his drug habit, but that might have been fakes. In granting copyright approval only for works with clear

provenance, which means mostly those sold through Arkley's representative galleries, and in charging a high copyright fee, Alison earned herself the ire of auction house executives and dealers, who felt this damaged the Arkley market and damned many works that, while not sold through official channels, were nevertheless by the artist's hand. Having endured worse than the displeasure of a few grumpy men, Alison stuck to her guns. But all this white noise came at a cost: 'I always felt that I didn't get to grieve for the relationship I had with Howard. In that early part it was always contaminated by the things that were going on outside of my relationship with him. I found that really, really distressing, that I couldn't grieve properly.'

Copyright is a powerful asset. Automatically part of an artist's estate, and able to be sold or gifted, in Australia it exists for seventy years after the artist's death, meaning that with some exceptions, those who want to reproduce an artist's work within that timeframe need permission from the copyright holder. Many artists' estates give it away for educational purposes but charge for commercial use, making limited-edition prints, mugs, catalogues and books potential revenue sources. Its most potent use is when it is withheld, and the most celebrated cases of this have involved books on artists, and paintings coming up for sale.

Arkley represented Australia at the 1999 Venice Biennale, the world's most prestigious contemporary art event. Alison joined him on the trip, during which they celebrated not only Arkley's career but also their decade-long life together. His colourful, spray-painted pictures of Australian suburbia had been warmly received at the biennale, and that reception was repeated in Los Angeles a few weeks later, at his first international selling show. As soon as the LA show finished the couple hired a convertible

and drove across the Mojave Desert to Las Vegas, where they married in a midnight service attended by friend and fellow artist Callum Morton. The bride wore a black dress and sandals, the groom a black suit and trademark red tie. They celebrated in their hotel room afterwards with champagne and bread-and-butter pudding. Marriage wasn't an impromptu decision—they had talked about it on and off for years—but they told few people before the actual event. Jan Minchin, Arkley's Melbourne art dealer and director of Tolarno Galleries, vividly recalls the mood of the month. 'I remember sitting in Venice with Howard, having a glass of wine and saying, "What's next Howard?" He looked at me with a twinkle in his eye and said, "I know what I'm going to do, and you will find it mighty hard to sell." I still remember the twinkle in his eye; I thought it was brilliant.'

The newlyweds arrived home on 19 July to a typically bleak Melbourne winter. Artists are often hit by post-opening blues, the downer that follows an opening and all the hard work that goes with it. Arkley's return was complicated by another factor, too: his long-term heroin addiction. The artist had made a big effort to be clean for this important trip overseas, to the extent that he was quite sick in Venice from withdrawal. Alone in his Oakleigh studio two nights after arriving home, he took heroin again. Alison thought Arkley was going out for a drink with a friend, so didn't fuss too much about where he was. But as night turned into early morning she began to worry, eventually going to the studio to look for him. There, at about 6 am on 22 July 1999, she found the shambolic, charismatic, complex artist, her husband of a week, dead from an overdose.

John Brack, Albert Tucker and Rosalie Gascoigne died that year, too. Those artists, however, had lived long, full lives.

Arkley was just forty-eight. 'Obviously Howard wasn't using drugs when he was in Venice, and he came back and was vulnerable, on a whole range of levels,' Alison says. 'The emotional stuff, his history of addiction, put him at risk for a start. Then coming back from all that success and the high of it, into usual life, in a city that was cold and miserable. I can't be sure of the accuracy of this, but I was told that there was a lot of very high-strength heroin on the streets at the time, and his tolerance would have been zero.'

Where Lyn Williams opted in, becoming the uber-widow par excellence, Alison opted out after Arkley's death, rarely attending exhibition openings and keeping up with only a few of his old friends. She handed the management of his estate to her art dealer and friend Kalli Rolfe, who had been associate director of Tolarno Galleries when it represented Arkley. Operating from her home rather than a dedicated gallery space, Rolfe represents half-a-dozen artists, including Howard Arkley, Alison Burton, Juan Davila and the estate of Melbourne photographer Athol Shmith. Alison says these decisions were very deliberate, and made for reasons of self-preservation:

> Left in this position you do have a certain responsibility. It's almost as if their career continues, and that in itself is difficult, to be looking after someone else's legacy. I did it myself for a short while, but I found it overwhelming and consuming, and not what I wanted to do with my life. I think for me it would have been suffocating. I want to have a memory of Howard that is different to just being focused on keeping the legacy straight.

181

Handing over the day-to-day estate management allowed Alison to get on with her own art practice, and she exhibited every few years through the 2000s with Rolfe. She also worked with the Jesuit Social Services at the Artful Dodgers Studio, an arts-based program for young adults who were marginalised due to a range of factors including alcohol and drug abuse, retiring in mid 2011. 'Howard was always really supportive of me having my own practice, always encouraging me to do my own work, and I have,' she says. 'I think his support and encouragement is the thing I've hung onto. He instilled in me that art was something I should do and keep at. It's been very good, very healing in some ways, to do my own work.'

Alison is sitting on a cream sofa in the modest Melbourne home she shares with her sister, Shirley Law, and brother-in-law, John Gregory, an art academic and author of the 2006 monograph on Arkley, *Carnival in Suburbia*. There are a few Arkley pictures on the walls, but not the blanket coverage that some artist's widows give to their husbands. Arkley's death and its aftermath damaged Alison, and she has built a tight-knit, protective group around herself. But there are things she wants to say, to set the record straight. Among them, she wants to clarify the background to her cracked relationship with Arkley's mother, Gwen Lewis, which was highly public and coloured her decision to withdraw from the art world.

The trouble between Alison and Lewis began before Arkley's funeral, but intensified around the time of a 2006 Arkley retrospective at the NGV. Arkley's 1996 will appointed Alison executor and sole beneficiary of the estate; it was witnessed by Alison's sister and brother-in-law. Lewis publicly questioned whether Arkley knew what he was signing, asking why he would have

left out his mother, then in her seventies, and his two much-loved nieces, whose tertiary education he had said he would fund.[2] Burton was appalled by the implication that her partner of ten years might have been coerced into signing something he didn't understand. She says she had drawn up her own will at the same time as Arkley, and that the pair of wills 'reflected our intention to take care of each other and our commitment to the relationship'. Arkley's will was granted probate, she says, and that should have been the end of the story, pointing out that as his wife she would have ended up with the estate either way:

> After his death there was a notion of this disorganised, unruly person who would never have left a will, or would not have had the insight to have his life organised in some way. But that was absolute rubbish. He knew his work, he knew what he was doing, he was organised and methodical about his work. He wasn't a fool, and he was portrayed as a buffoon too often. He did have this persona in public, as the riotous Howard, and he did make people laugh, and he was silly and fun. But he also had a very serious aspect to his career.

For years Arkley had stored nearly two dozen works at his mother's house, many of them earlier pieces that hadn't sold. When probate was granted, Alison, as executor, requested them back. Lewis was devastated, and said so publicly. Alison now puts her side of the story, pointing out that the only people at the house when the pictures were retrieved were Gregory, as her representative, and a solicitor for Lewis:

The way it's been presented in the media is that the place was stormed and the works were taken. After Howard's will was granted probate, Mrs Lewis refused to give the works to me. She refused. So instead of taking any action, I decided to wait for twelve months after probate was granted in the hope that the situation would improve. It didn't, so at the end of the twelve months my solicitor made contact with hers, and an arrangement was made for the work to be picked up from her house. My sister was not there, as has been reported on occasion; I wasn't there; and Gwen wasn't there. It had to be done by appointment, and a time was set and a date was set ... It was a legal matter. The work was taken and put into storage.

Did she consider leaving at least one painting for Lewis, who had lost a son when she lost a husband? Alison says carefully: 'Had circumstances been different, the allocation of those works might have been different. The allocation would have been different.'

In stepping away from the art scene, and remaining mostly silent about the issues that arose publicly about the estate, Alison created an empty space. Lewis, dealing with her own grief and wanting to retain a link with her son's world, was happy to fill it. Thus it was Lewis who funded an art prize in her son's name and warmly presented the winner's cheque; Lewis who attended exhibition openings and who cooperated with Edwina Preston on her 2002 biography of Arkley, *Not Just a Suburban Boy*; and Lewis to whom the media subsequently went for comment on matters Arkley. She died in May 2011. Alison had not

seen her since Arkley's funeral.[3] This dispute was not the only issue Alison faced regarding Arkley's estate. There was also a rampant art market, in which weird things were happening.

Arkley was already established and selling well when he met Alison. He had moved from abstraction towards more figurative work through the 1980s, exhibiting his first house painting, *Suburban Exterior*, 1983, at Tolarno Galleries the year it was painted, and his first full show of house exteriors in 1988. But it was during his decade with Alison that his career really went into overdrive. He painted his house interiors, his shadow factory series, freeway and head paintings, and the mural *Fabricated Rooms*, 1997–99, which was first shown at the AGNSW and then in Venice, with some additional panels. Just before leaving for Italy in 1999 he completed a portrait of musician Nick Cave for the then fledgling National Portrait Gallery, its first ever commission.

One of the few contemporary artists who had morphed into a semi-public figure, at least in Melbourne, Arkley was popular with collectors through the 1990s, in particular with architects, designers and property developers. Collectors of his work included property developer Michael Buxton, architect Corbett Lyon, and Melbourne gallery owner Robert Gould, together with his then partner Geoffrey Smith, then a curator at the NGV. Lyon bought the seventeen-panel *Fabricated Rooms*, installing it, wrap-around style, in the dining room of his house-museum in Melbourne's Kew. A building that doubles as his family home and an art museum, it opens to the public by appointment. A number of people also bought paintings directly from Arkley, bypassing his galleries, typically when the artist needed money for drugs. In the years before he died, Arkley's large paintings

were selling for between \$25 000 and \$90 000 at Tolarno. His top price at auction was only \$11 500, although his secondary market prices through dealers were probably higher. In the year after his death, however, his auction prices went into overdrive, with the Arkley record being broken three times in four months at auction. *Dining in a Glow*, 1993, fetched \$178 500 in May 2000 at Deutscher-Menzies. In August that year Christie's sold *Roomarama*, also painted in 1993, for \$178 876, and a week later the 1989 painting *Shadow Factories* went for \$366 888 at Deutscher-Menzies, well over its high estimate of \$300 000.

The market was abuzz with talk that Arkley's prices were being artificially inflated, with dealers bidding works up to put a floor under the price of their own Arkley stock. Like many of the opaque practices of the art world, it was impossible to prove. All that can be said with any certainty is that 2000 was a decidedly good year for Arkley at auction. Fewer than three dozen of his artworks had been traded at auction before the artist died, but in 2000 more than a dozen went under the hammer. His market fell sharply the following year, and then peaked and troughed as the decade progressed, jumping wildly again in 2007 when the *Shadow Factories* record was finally broken by a 1988 painting, *Family Home*, which sold at Joel Fine Art for \$401 442. The highs and lows of the market were very specific; the paintings selling for more than \$100 000 were almost all of homes, freeways and apartment blocks. All painted from the mid to late 1980s onwards, they had mostly sold up to fifteen years prior for between \$6000 and \$25 000. Jason Smith was a curator of contemporary art at the NGV at the time, and went on to curate the gallery's 2006 Arkley retrospective. Sitting through one of those auctions in 2000 he found the specificity of collectors,

who seemed to want a house and only a house, perplexing. 'There was a spectacular work from his *Succulents* series—it had diamond dust on it, and nobody wanted it,' says Smith, who is now director of Melbourne's Heide Museum of Modern Art. 'Houses were going for upwards of $100 000 and this Succulent went for something like $8000. I turned to the person next to me and said, "People don't know what they're looking at."'

The estate did own some of these later works, which Rolfe sold privately on behalf of Burton over the course of the decade, thus Alison benefited from the secondary market frenzy, as prices paid at auction are a guide to what dealers can charge privately. It was nevertheless upsetting. 'I found it pretty distasteful. It was enlightening, I guess, as to how greedy people can be, and how badly behaved people can be. I did find it distressing, but my interest was much more in trying to keep control of copyright.'

Copyright became an issue because of the different categories of Arkleys on the market after his death. There were essentially three types of paintings. The first was those with impeccable provenance sold through his representative galleries—Tolarno Galleries in Melbourne, Roslyn Oxley9 Gallery in Sydney, Bellas Gallery in Brisbane and, for that one offshore show, Karen Lovegrove in Los Angeles. The second category was those Arkley sold direct from his studio when he needed drug money. Those in the third category were fakes. There was no problem with the first type being traded, because gallery records clearly established their bona fides. The issue for the market became distinguishing between the second and third types. The job was made more difficult by the fact that Arkley often painted different versions of essentially the same scene. Neither fakes nor backdoor pictures will have the sale records or receipts that the

market relies upon to establish provenance, and because Arkley was secretive about his drug use, Alison hadn't necessarily seen those that went out the back door. How many of the backdoor paintings Arkley sold is not known. Some in the art market talk about him selling through a 'Greek landlord' who has rather conveniently, according to art market myth, returned to Greece. Others talk about a couple of local dealers buying works from Arkley for cash. Alison, Rolfe and Minchin all say that they have never heard of the Greek landlord. Gregory attempts to untangle this quagmire in *Carnival in Suburbia*, but like everyone he is hamstrung by the law of defamation: 'Arkley's well-documented heroin habit surely led him into some murky situations at times. Anecdotal evidence suggests that at least some works dating from his last decade or so were produced in a hurry, for cash, no questions asked, perhaps even under some duress.' He goes on to say that 'these factors open a window of opportunity for unscrupulous operators, especially after his death', noting that the appearance of a number of previously unrecorded 'Arkleys' since the artist's death 'gives rise to concerns, indicating the need for scrupulous attention to provenance'.

Alison and Rolfe's job has been made easier since the publication of Gregory's book, which is accompanied by an online database of all of Arkley's authorised works (arkleyworks.com), which the academic is constantly updating. Rolfe explains her logic with regard to Arkley: 'If the work has a record and a provenance and it's in the [Gregory] archive, permission is given,' she says. 'If we don't have a record of the work, we don't give permission, and there are various reasons for that. And we don't give reasons.' In short, this is because giving reasons would mean entering a legal minefield. If collectors are concerned

about the authenticity of a work, Rolfe points them in the direction of Melbourne University's Centre for Cultural Materials Conservation, which analyses artworks for a fee and reports to the owners on the likelihood of a work being problematic.

Rolfe continues:

> The situation is that neither I nor the estate verifies or authenticates Howard Arkley works. I've had requests to come and look at works, including works that are not recorded. Of course Howard did many works that are not recorded. We accept that, there is absolutely no doubt. But I'm not in the position, I'm not actually qualified to say whether a work is authentic or not, and I would never put myself in that position.

She concedes that it makes for a tricky situation. When asked bluntly whether she thinks there are Arkley fakes out there, she responds: 'Look, I can't really say there are Arkley fakes because, as I say, I'm not qualified. The only thing we have the power to do is to use the power of copyright. And that's what we do.'

It is because of this stance that Rolfe and Alison are unpopular with art dealers and auction executives, who say it casts a pall over many legitimate works just because they were not initially sold through galleries, and uses copyright to make what seems like a moral judgement about how those works were acquired. Adding fuel to the fire, the Arkley estate was among the first to charge for use of Arkley images in auction catalogues, and it charges more than many other estates. When it refuses copyright, the work appears without an image, putting it at a disadvantage in relation to other paintings being sold in the same auction.

Yet the estate won't say whether this is because it believes the work is problematic. 'I've tried to find out from them whether not granting copyright means they think a work is a fake, and I still don't know,' says one exasperated auction house executive. Rolfe is proud of her role in forcing auction houses to request copyright permission before featuring an artwork in a catalogue, and does not care that her rates are higher than the industry standard. Of the accusation that she has damaged the Arkley market, she says:

> No, I don't agree, because the Arkley market is great. Look at what the auction houses get for quality work, you know, $300 000 for a painting. So it hasn't killed the Arkley market at all. It's actually not a valid argument, because the market is better if you can show that people are buying authenticated, verified works. It's better for the market, because suspicion in a market is what makes things difficult for an artist and for an estate.

The successful sale in 2012 of Arkley's 1994 painting *Spray Veneer* supports her point that works with an impeccable provenance still do well. This painting was purchased by the architect Alan Powell from Tolarno Galleries in the year it was painted. Powell lent it back for Arkley's Venice Biennale exhibit, which toured to Melbourne and Brisbane in 2000, and for the NGV's Arkley retrospective. It also features in Arkley monographs by Ashley Crawford and Ray Edgar, and by Gregory. In an exceedingly tough year for the sale of art, *Spray Veneer* made $300 000 including auction house fee at Deutscher and Hackett in November 2012. Its $240 000 hammer price was below its

$250 000 to $300 000 estimate, but was still enough to make it the seventh-highest price paid for an Arkley at auction. In a bad market, that was a good result.

Gregory writes on the *Arkley Works* website that the record-setting 1988 painting *Family Home* appears to be a 'variant' on one sold through Tolarno with the same name in 1988 to Melbourne art dealer Peter Gant. Of *Family Home* Gregory writes, 'there appears to be no documented history prior to 2007', and for this reason he does not include it in his catalogue raisonné. Gregory says he would like to see further documentation about the painting's history, but that nobody has provided it thus far. He writes in *Arkley Works*:

> This is precisely the type of problem that has bedevilled the story of Arkley's art at auction since 1999, and will continue to do so, as long as some auction houses fail to provide full provenance details in their catalogues. After comparing the Joel's work with its original, the average well-informed viewer might be tempted to raise a number of serious questions about the dating and authenticity of some paintings claimed to be by Arkley.[4]

Jason Smith had to delve into this territory when curating the NGV's 2006 Arkley retrospective. With the backing of NGV director Gerard Vaughan, he decided to show only impeccably provenanced works. This did not endear him to those who owned Arkleys bought directly from the artist rather than through his galleries. It helps with provenance and future saleability for works to be shown on state gallery walls. It gives an instant badge of prestige and authenticity, crucial ingredients

when the time comes to sell a work. Dealers desperately want this badge. 'I had someone ringing me at 9 am on a Saturday morning just screaming down the phone, telling me I didn't know what I was doing if I didn't put this work in,' Smith says. 'And this was a work where provenance couldn't be demonstrated.' Also excluded were works owned by Robert Gould—owner of Gould Galleries in South Yarra—but for a very different reason. The NGV had been embroiled in a legal stoush with Geoffrey Smith, who had left the gallery and was suing Gould, his former long-time romantic partner, for a share of his assets. The gallery did not want to go near any artworks that might get caught up in that property dispute (which, as it happened, did not get to court until 2012). Gould was furious, and expressed his anger to Vaughan, but there was nothing to be done; his paintings did not appear in the retrospective either.

On top of issues about provenance and what to include came the human dimension. Jason Smith says that he felt a 'moral obligation' to protect both Alison and Gwen Lewis, for whom revisiting Arkley's oeuvre was emotionally draining. 'At all times we maintained a position, sometimes unsuccessfully, that we would remain impartial. It had to be about Howard Arkley, and not about anything else.' The retrospective, which attracted 42 000 visitors during its Melbourne run, was a bittersweet time for Alison. 'It was hard to go back over all that territory,' she says. 'It was a really emotional time for me, and I think I was caught by surprise, because it was seven years after Howard died, so I was a little shocked that it got to me.'

Rolfe has been active in licensing the use of Arkley images on books and other commercial ventures, the rates for which she decides on a case-by-case basis. 'If a book is selling for $100

and you want to reproduce a Howard Arkley painting on the cover, and the cover is a very important marketing tool, and you're not paying a designer to design the cover, I usually say the fee is $2000, take it or leave it.' She produced a batch of limited-edition silk ties dotted with Arkley's late 1980s image *Zappo Head*. Manufactured in Mexico and sold through gallery gift shops, they 'weren't such a huge commercial success, but it was fun', Rolfe says. She has also printed a $100 poster featuring Arkley's portrait of the musician Nick Cave and a series of fine art reproductions for five of Arkley's paintings, which sell for between $880 and $2200, depending on size. Alison has the final word regarding what is and isn't done, and tries to follow what she believes would be Arkley's wishes. 'I know for sure that Howard wouldn't want his work put on a tea towel, but that he wouldn't mind if it was a poster,' she says. 'I know he would have made a colouring book, or a jigsaw, that goes with his aesthetic. But not a tea towel.'

Alison has not donated any Arkley works to public galleries, but in 2010 the State Library of Victoria acquired his extensive source materials. The acquisition was half gift and half purchase, and included everything from working drawings, exercise books and albums of clippings, notes and photographs, old magazines, books and comics, to Arkley's extensive library. The negotiation for that sale/gift took three years, in part because the library had to find the funds. Gwen Lewis also donated nine boxes worth of matter on Arkley to the library, including a draft manuscript from 2005 of her own unpublished book on the artist.

Arkley's 1994 painting *Icon Head* sits against the wall in Alison's bedroom. It is the painting that was in the chapel at the artist's funeral, and Alison says she could never sell it. It was

not done as a self-portrait, but it has taken on the mantle of one. She does not have a new partner, and is not looking for one. 'I have no interest really in forming another relationship. If it happens, it happens,' she says. 'I can't imagine anyone else in my life after Howard. It just seems impossible.' Nor, she says, does she feel angry with Arkley for not being here. 'It's interesting that this is the thing you hear so much: "I'm so angry about what happened." I was just sad, devastated. I think I've had moments of frustration about what happened, but I'm not angry with Howard. He was a very loving person, very affectionate, generous. I just felt sad that his life had to end like that.'

Copyright has also been an effective tool for influencing what is written about an artist, and by whom. The reason it is so powerful in this particular sphere of publishing is that an art book without images of the artist's work is severely hobbled. Art historian Sasha Grishin has seen many battles between artists' widows and authors unfold over the years. They always remind him of the advice a senior person in the Australian art world once gave him: avoid writing about an artist until the widow is dead. 'There are two assumptions in that: one, that the artists worth writing about are men; and two, that the artist's widow will be the fly in the ointment that can wreck a book.' Grishin believes that Australian art history has been significantly sanitised as a result of copyright law. But perhaps self-censorship has been as pernicious as the overt actions of estate holders. Stuart Purves recalls with a chuckle the note a friend left for him inside the dust jacket of one of the many books on Sidney Nolan: 'Close to the truth, but superbly laundered.'

Arkie Whiteley was ferocious in her use of copyright follow-
ing her father's death, driven by grief, a desire to wrest the story
away from the tawdry and back towards the art, and outrage that
publishers were in such a rush to make money from her father's
shortened life. She withheld the right to reproduce Whiteley's
artworks from a number of books, including one by Graeme
Blundell and Margot Hilton, and a new version of Sandra
McGrath's 1979 book *Brett Whiteley*. Prior to Whiteley's death,
McGrath's book had been the main art text on Whiteley, but
when a publisher wanted her to update it with new information,
Arkie stopped it from happening.

Patricia Anderson, writer and editor of *Australian Art Review*,
also hit a copyright wall while finalising her manuscript for a
book about the artist and art critic Elwyn Lynn, whom she had
interviewed extensively while he was alive for just this purpose.
Anderson presented her manuscript to Lynn's widow, Lily, and
daughter, Victoria, after Lynn's death in 1997. In a preface to
the subsequent book, *Elwyn Lynn's Art World*, published in 2001,
Anderson writes that the Lynns spent two months making
changes and corrections, then decided to withdraw copyright
approval, not only for the images in the book, but also for quoting
from Lynn's published reviews and other writings. Anderson
writes that 'the book hit a snag. Lily and Victoria decided they
would prefer someone else to write the book'. Anderson's pub-
lisher dropped the project, following which the author set up
her own imprint, Pandora Press, in order to get the book out.
The copyright restrictions led Anderson to recast the book to
be more about Lynn's world than the artist per se. Anderson
won support from a range of influential people, including *Sydney
Morning Herald* art critic John McDonald, barrister Clive Evatt

and art historian Bernard Smith, who Anderson says wrote to her in 2002 asking if she would consider penning his biography. That project never eventuated.

It's easy to vilify the families in instances such as this. Reasons for denying copyright do not need to be given, and in any case, people are rarely blunt or often even able to articulate why they don't like something as complex as a book. The bottom line is that they have the legal power, and they use it. For her part, Victoria Lynn says the family had hoped for a book about her father as an artist, but that Anderson's manuscript was more of a broad biography. (Anderson says you can't write about the art without exploring the human being behind it.) The Lynns donated funds towards another book by the original publisher. Victoria Lynn, a curator and gallery director, rejects the idea that the family sanitised art history:

> She went ahead and published her book anyway. There has been an enormous amount published on my father, before and after that. I don't think it controlled art history or the way it was written. The thing was to honour his original intention, which was to collaborate with a writer to get a book out about my father as an artist. That was there, but was not the focus of her book.

By far the most celebrated copyright battle between an author and a widow was that between Barbara Tucker and art historian Janine Burke, who wrote the 2002 biography *Australian Gothic: A Life of Albert Tucker*. The widow's decision to deny Burke permission to reproduce images of Tucker's work set off a train of events that saw Burke nearly ousted from the board of the

Heide Museum of Modern Art. That remarkable saga, which made front-page newspaper headlines, brought into sharp relief just how much covert power the widows of Australia's best-known artists can have. It also highlighted the role of personal relationships in these kinds of battles, and how much goes unsaid when relationships break down.

The story begins when Tucker was alive. The artist had been working before his death with his dealer, Lauraine Diggins, on a plan to gift much of his work to public institutions. According to Diggins—who became an executor of Tucker's estate—the pair went through his collection in great detail, putting stickers on the back of various works specifying where they should go. Tucker still had many of his own works, the result of not selling well until later in life, but also owned many good paintings by friends and colleagues such as Sidney Nolan, Arthur Boyd and Danila Vassilieff. 'He saw himself as an artist of the urban culture, and was quite aware of the types of museums created overseas in private houses,' says Diggins.

Tucker had also witnessed donations on home soil, and the effect they could have on an artist's legacy. They included the part sale/part gift of a large batch of his works to the NGA, brokered by his son Sweeney; the gift of most of Nolan's first Ned Kelly series to the same Canberra institution by John and Sunday Reed in 1976; and the many gifts of Arthur Boyd, including Bundanon. Tucker had also become savvy in his own use of the federal government's cultural gifts program, too, which gives donors a tax deduction for works gifted to public collecting institutions such as galleries, museums and libraries. 'Once Bert started to make some money he became a considerable donor of artworks to public institutions, particularly the National Gallery

of Australia in Canberra,' recalls Diggins. 'He learned that skill very effectively, and he would donate to offset his income.'

Tucker considered numerous options. At first he wanted to gift his St Kilda home and collection to the National Trust, with the idea that the trust would run his home as a museum. There was also talk about making a Tucker gallery the centrepiece of then Victorian premier Jeff Kennett's new Federation Square project. That fell away, however, when a new NGV space devoted to Australian art was proposed for Federation Square, an idea that won the day. Tucker was initially not kindly disposed to the idea of donating to the Heide museum. Like his good friend Nolan, he had become sceptical about the wealthy Reeds who owned it and of the incestuous circle they drew around themselves. He had also fallen out with the couple over Sweeney, whom the Reeds had adopted when Tucker was in Europe. A 1997 Heide exhibition of Sidney Nolan's 1946–47 Ned Kelly paintings (many done on the kitchen table at Heide) helped rebuild the bridges. The exhibition was curated by Heide's then director Warwick Reeder, who interviewed Tucker extensively as part of his research and asked the artist to open the show, which he did. An exhibition of Tucker's photographs held the following year, curated by Janine Burke and called *Eye of the Beholder*, further strengthened the links. Reeder, Heide chairman Ken Fletcher, Burke and Diggins all helped smooth the path back towards Heide. Eventually, Heide was settled upon as the place for the gift. Diggins says not everything was to go to Heide. Some works were set aside to give to other institutions, and others still were earmarked for sale, to keep the name in the commercial sphere. 'We worked out what to give to Heide, and the idea was to give other works to other institutions around

Australia,' she says. 'He felt quite strongly that he wanted his work represented all around Australia, in regional galleries as much as the mainstream.'

Barbara expanded upon the Heide donation quite significantly after Tucker's death in 1999, and the proposed Tucker wing was redesigned to include a study area. Announced in 2000, the gift ended up including more than 200 paintings, photographs, sculptures and works on paper, not just by Tucker but also by peers such as Hester, Nolan, Boyd and Vassilieff. Including Tucker's extensive library of more than a thousand books, the gift was valued at the time at $15 million. Within a year of its announcement, however, it looked in danger of unravelling.

Janine Burke had, since 1995, been working on a biography of the artist as part of a PhD. Burke had conducted extensive interviews with Tucker, whom she had known for twenty-two years, as well as with countless others involved in his life story. She says she got along well with Barbara during Tucker's life and after, with the widow making many suggestions and useful factual corrections to the manuscript. Diggins suggests a personal conversation between the two shortly after Tucker's death had upset Barbara. Either way, after sending the corrected manuscript back to Barbara in 2001, Barbara sent Burke a fax: 'My feeling at the moment is that it is a highly coloured novel and, if I am to approve it, it must be rewritten as a balanced biography of an extremely intelligent, multi-layered and complex man.'[5] Barbara withdrew permission for Burke to reproduce Tucker's paintings. The copyright withdrawal found its way into the media, where Burke was quoted: 'To describe four years of research and writing—done with Bert's complete approval, involvement and encouragement—as a "highly coloured novel"

... is deeply offensive to both my reputation as a scholar and art historian and to Bert's memory.'[6] Burke's publisher, Random House, stuck by her and used Tucker's photographs instead, which had featured in the *Eye of the Beholder* exhibition and were out of copyright.

It's not hard to see what might have upset Barbara. Burke writes in *Australian Gothic* that the artist did his best work during his nine years with Joy Hester, and that his first wife remained something of an obsession for him throughout his life. She writes that Tucker's art went downhill from the 1960s, which she attributes in part to the end of three decades of struggle and the attainment of personal happiness. Barbara is not mentioned until two thirds of the way through the book, which deals mostly with the decades in which Burke says Tucker did his most important paintings, namely the 1940s and 1950s. Burke writes that Barbara 'did not inspire Tucker, as Hester had done, to change or challenge his art', notes that there are no life drawings of her, and writes that Barbara 'did not involve herself in Tucker's career'. Burke says that she never intended Barbara to be a postscript. But her duty was to art history, to writing it as she saw it. 'The problem in any biography, particularly of an artist, is that they all have their heydays,' she says. 'Bert's [peak] was in 1940s Melbourne.' Just as it was Burke's right to draw her own conclusions, so too it was Barbara's right to disagree with them. Tucker himself might have, too, had he been alive. That is the great unknown. The problem in all cases like this is that history is not objective. Offence can be taken over slights, both intentional and non-intentional, communication breaks down and distrust sets in. It happens in many fields; the difference here is the widow has a weapon up her sleeve.

The Burke–Tucker saga went a step further when, in the wake of publicity over the copyright issue, the chairman at Heide, Ken Fletcher, suggested that Burke might resign from the board, of which she had been a member since 1996. He was worried that her continued presence might jeopardise the Tucker gift, which had been agreed upon but not yet signed, sealed and delivered. Burke had written extensively about Heide and its circle, including a book on Hester, another on the letters between Sunday Reed and Hester, and a book on Tucker's photographs. She initially agreed to resign, but a short time later rescinded her decision, staring down a board that united behind Fletcher. Once again the dispute made the newspapers, after which the board released a statement saying it was, 'particularly conscious of securing the gift of significant artworks from the Tucker estate for the people of Victoria. It's important that these sensitive negotiations are completed and not clouded by the actions of any director'. Some members of the Heide board took the view that the matter should not have been aired publicly, especially given the long-term shakiness of the Tucker–Heide relationship. Among those who came out on Burke's side was Richard Llewellyn, a trustee of the estate of John and Sunday Reed, who told *The Age* newspaper: 'It's a disgrace if the executors of the Tucker estate are going to insist on asking for control of board positions as a prerequisite for the Tucker gift.'[7] Grishin summed it up this way: 'Heide is a government-funded museum and it is difficult to simply sack a board member because she wrote a book with which a potential benefactor disagrees.'[8]

Like the Lynns, Barbara helped fund the publication of another book on her husband. Published in 2005, this featured more than 200 colour reproductions of Tucker's work. Barbara

had not detailed her reasons for withdrawing copyright with Burke, but she outlined some of them three and a half years later in a feature article in *Good Weekend* magazine. Journalist Janet Hawley wrote that, among other things, Barbara felt 'the 37 years she spent with Tucker have been brushed over by Janine Burke'.[9]

Barbara did not want to be interviewed for this book, and responded via email through her friend and now estate advisor Geoffrey Smith to questions about the Burke saga. What did you dislike about Burke's book? 'It contains a multitude of factual inaccuracies.' Did you or someone on your behalf ask the Heide board to oust Burke? 'No.' Was the gift seriously in jeopardy? 'No.' Are you happy with Heide, how it has handled the gift, the recognition given through the Albert and Barbara Tucker gallery, and so on? 'Yes.'

Her staccato answers and general reluctance to talk reminded me of something she said in my 2008 interview with her. 'I walk away from things—it's the only way to survive.'

Chapter 9

Immortality

It is the artistic problem: how do you live on? Not you, your work. The greatest hope is that it will continue going on forever, across cultural differences and changes in taste.

REX BUTLER[1]

If immortality is the Holy Grail for artists, then having their work seen is a pretty basic requirement. But this isn't always straightforward. Museums can be closed, donations sold off or consigned to the dungeon, paintings traded rather than lovingly kept. Barbara Tucker and Mary Nolan have both experienced problems in these regards. Perhaps Yvonne Boyd is the luckiest of them all, free of so many of the concerns faced by other artists' wives. There are many reasons for this, not least being the 1993 gift of the family property, Bundanon, to the nation. But there's also another crucial ingredient: choice.

Most widows of important artists form a close relationship with someone in the art world, a dealer or curator who helps guide them through the quagmire. This will not always be a person with whom the artist was close. In Wendy Whiteley's case it is Barry Pearce, who knew her husband well; for Tess Baldessin it is Stuart Purves, who says he didn't get on particularly well

with George and has told Tess that; for Lyn Williams it has been Rex Irwin and Philip Bacon, neither of whom knew Fred, and James Mollison and Patrick McCaughey, who did. For Barbara Tucker that person has been Geoffrey Smith, one-time NGV curator, now chairman of Sotheby's Australia. Albert Tucker's long relationship with Lauraine Diggins, whom he had appointed an executor of his estate, with whom he had drawn up a detailed plan for his artistic legacy, and who had advised Barbara during the stoush over Burke's biography and the Heide gift, was replaced as the 2000s progressed by a new relationship, that between Barbara and Smith. And a whole new plan.

With slick, dark-brown hair and a wide grin, the 43-year-old Smith is of neat appearance and is a stickler for detail. He prides himself on his encyclopaedic knowledge of Australian art and artists, having built his own databases on dozens of artists since he was a teenager. Mentored at the NGV by former director James Mollison, Smith worked his way up over sixteen years to the position of curator of Australian art, during which he put together shows on Nolan, Streeton and Blackman, among others. He first met Albert and Barbara Tucker when he was a fresh-faced twenty-year-old helping out with the NGV's 1990 Tucker retrospective, which was curated by Mollison. Smith later became friends with Barbara through one of Barbara's close friends, Lisl Singer. Lisl's son Gary Singer, a lawyer and former deputy lord mayor of Melbourne, is a long-time friend of Smith's and is now his partner.

It was Smith's personal relationships that triggered a string of events that eventually brought down his public gallery career, making way for what he called his 'brilliant career part two'.[2] It is in this, his auction life, that the interests of Smith and

Barbara have dovetailed. In 2004 Smith broke off his fourteen-year relationship with Robert Gould, the owner of Gould Galleries in Melbourne's Toorak Road. Smith filed an affidavit in the Victorian Supreme Court to support his property claim for a share of Gould's wealth, in which he detailed how much work he had done in helping to build Gould's South Yarra gallery. The affidavit was picked up by the press, which raised questions about whether Smith's assertions amounted to a conflict of interest with his job at the NGV. The NGV stood him down while it investigated whether such a conflict existed, and if so, whether he had breached public service conduct guidelines. Smith fought the NGV legally, asking to be reinstated. A week before the case was due in court the warring parties reached a confidential out-of-court settlement in which Smith agreed to resign from the gallery. The months-long battle was stopped just before it got to open court, but not before multiple newspaper stories had been written about it, and animosity built to the extent that Smith was persona non grata at NGV openings. Suffice to say, nobody came out of it looking good. (The property dispute with Gould did not get to court until 2012, when Justice John Dixon of the Victorian Supreme Court awarded Smith $3 million of an asset pool assessed to be worth $22.8 million, plus costs against him. This was significantly less than the 40–50 per cent Smith had asked for. He is appealing the decision.)

Where others saw damaged reputations, Tim Goodman, then majority owner of the mid-tier auction house Bonhams and Goodman, saw opportunity. He wanted to move his auction house towards the serious end of the paintings market, the place where the big dollars were in the mid 2000s. High-end

paintings were selling, and with the auction houses taking a 20 to 23 per cent share of the hammer price of each artwork as their fee, they represented a better money-to-effort ratio than the middle to lower end, where Bonhams and Goodman had been playing. A former curator from the NGV was just the person to help him do that, coming as he did with knowledge about who owned what paintings, gleaned from working on numerous public exhibitions, relationships with the top end of town, and his own extensive database. Goodman hired Smith as his national head of art and the pair had a good few years together, building Bonhams and Goodman and then buying the licence to run Sotheby's in Australia. By the end of 2010, however, Smith, Singer and a handful of others were the new owners of the ten-year Sotheby's licence, and Goodman was out.

Smith has achieved new records for Tucker at auction, where since late 2006 he has put about twenty works from the estate under the hammer, with others also sold via private treaty. But the benefit has gone both ways, with Tucker playing a valuable role in Smith's career rehabilitation. Such are the mutually advantageous ways of the art world. For Smith's first sale at Bonhams and Goodman, in April 2007, he secured from Barbara an important early painting, the 1954 work *Flirtation*. Smith explains how he came to find it under a layer of dust in Tucker's former studio: 'I was looking for a cover picture, I wanted something exciting. I had been working on cataloguing works by Albert Tucker and I stumbled across this painting ... it was sort of a discovery. It was unframed at the time—its original frame had been taken off many years ago by Bert.' Smith realised that Tucker had painted it while living in Paris, and that he had exhibited it in 1957 at London's Imperial Institute. The artist

had brought it back with him, unframed, when he returned to Australia in 1960. Barbara agreed to consign it to Smith's first auction with Bonhams and Goodman, and the painting received front-page coverage in *The Australian* newspaper. 'Nothing like it had ever been to auction before. I said to Barbara, "This could be sensational." It was all very exciting,' says Smith. 'I also wanted to signal the fact that I was looking after the works of Albert Tucker.'

Flirtation was given a modest $120 000 to $180 000 estimate. It's a trick Smith has used successfully over many auctions to create a buzz around pictures that many insiders know will go higher. Yet nobody quite expected it to get to $700 000—pushed there by three competing bidders—or to see the winning bidder pay $840 000 including the auction house fee.

Flirtation got Smith's new career off to a flying start, and helped raise Tucker's prices at auction. A few weeks later another 1957 European painting by Tucker came up at rival auction house Deutscher and Hackett. It also sold above its high estimate. '[Sydney art dealer] Denis Savill turned to me at the auction and yelled out, "Mr Smith, what have you done?"' Smith says with a laugh. 'What was so good about it was that it wasn't a market I had created just at the auction house where I worked; it was a market in general.' Smith sold more Tuckers from the estate in the coming years, including the 1955 painting *Footballers*, which made $360 000 including premium in 2009. Its hammer price was at the low end of its $300 000 to $500 000 estimate, probably reflecting the turn in the market.

The record price for Tucker was not sustained in the downturn, and over the longer term it will be interesting to see what effect that flurry of high prices has on Tucker's reputation. Not

that he fell further than others; all artists' prices fell. The difference with Tucker was that there was a direct comparison because *Flirtation*, which had set a new artist's record in 2007, came back to market. The successful bidder for *Flirtation* in 2007 had been Melbourne property developer Lustig and Moar, but within a few years the company had privately disposed of most of the celebrated paintings it bought when times were good. Sydney prestige car dealer Steven Nasteski saw an opportunity for a bargain, and bought it from Lustig and Moar along with a few other things in a private treaty sale that was transacted, as it happens, through Smith. Nasteski wanted to buy some Whiteley paintings from Wendy, so consigned *Flirtation* to Deutscher and Hackett for its August 2012 sale to raise the funds. The painting made $576 000. It was a good result in a tough climate, but nevertheless it escaped no one's attention that *Flirtation* had lost nearly a third of its value in five short years.

Smith turned to Tucker for another important moment in his auction career, namely his first non-auction selling exhibition at Sotheby's. It was early 2010 and auction houses were feeling the pinch. With high fixed overheads—for staff and fancy premises—many began looking to stage exhibitions between their auctions as a way to bring people through the doors, and money through the till. Smith decided to hold a selling show of Tucker's landscape watercolours and paintings in February that year, typically a fallow month for auction houses. The exhibition featured fifty-four works, most executed in the 1970s and 1980s, and priced from $15 000 to $150 000, accompanied by a lavishly illustrated full-colour catalogue. Only about a quarter of the works sold. It looked like a strategic error, and indeed rival auctioneers and dealers muttered that the paintings were not of

particularly high standard and should never have been put up for sale. Smith does not agree:

> It's not about the short term; it's not about selling, sell-ing, selling as many pictures as possible. For me, it was primarily about publishing, not a book but a catalogue on Tucker's landscape paintings, and to show another dimension. People often say he didn't have this lyrical side to his work, but you find it in his landscape paint-ings. I also wanted to emphasise the conservationist aspect, how [the Tuckers] bought land in Queensland to preserve it. All those kinds of things come out in those images ... It was really clarifying that they're important pictures, their rarity, and giving them the importance they deserved.

Barbara has been happy to sell important paintings to the highest bidder, in part because she dislikes the idea of works donated to public institutions ending up in storage. It's an interesting stance given the vast majority of the works donated to Heide by the Tuckers are in storage, but under the terms of the gift Tucker does at least have a regular presence, through the permanent Albert and Barbara Tucker Gallery and an agreement that Heide will stage two shows involving Tucker each year.

Barbara put seventeen paintings on long-term loan with the NGV during Smith's time there, but when they hadn't been dis-played for eighteen months, and after Smith had left the gallery, she asked for them back. 'Paintings should be seen,' she told me in 2008. 'I like giving paintings away but I don't like them disappearing forever. If you donate to a public gallery—and this

happens—it becomes like a graveyard for paintings, and that's not right.' Smith supports her philosophy, and says it is better to spread donations around than to give a large number to a single institution. Giving to regional galleries is a particularly good idea, he says, because they are more inclined to value the artworks and put them on permanent display than the big state institutions, which have much bigger and more valuable collections. He dismisses the notion that Barbara took the works back from the NGV because she was unhappy with the way he was treated. 'It was Barbara's decision that if they weren't being utilised there was no point in them being there,' he says. 'If those works had been on the walls of the gallery, I would have been the first person to say ... You know, the question wouldn't have come up whether they should be there.'

Donations come not only with the risk that the work will go into storage rather than on the walls, but also that it might be sold off altogether. Patrick White donated the 1958 Ian Fairweather painting *Gethsemane* to the AGNSW in 1974, and in 2010 it was auctioned off to raise funds to buy what the gallery director considered a better work by the artist. There was an outcry over the gallery's decision, not least because *Gethsemane* had once hung above White's desk and thus had added cultural significance. Brisbane dealer Philip Bacon paid $960 000 for it at auction and has hinted that he will eventually donate it back to an institution. It's a safe bet it won't be the AGNSW. At one stage Helen Brack was considering donating a Brack picture to every public gallery in the country. She thought it a marvellous idea, but just before she began organising it a gallery rang to ask if she would mind if they deaccessioned, or sold off, some of Brack's work that was in their collection. Yes, she did mind—to the extent that she shelved her 'donation to every public gallery' plan.

The risk that the ground may shift under a donor is high-lighted by the closure in 2007 of the Nolan Gallery at Lanyon Homestead in the Australian Capital Territory. Like his brother-in-law Arthur Boyd, Sidney Nolan was a very generous donor to public institutions during his lifetime. Among his many gifts, he bestowed twenty-four important paintings to the Common-wealth in 1974, for which in 1980 then prime minister Malcolm Fraser opened a dedicated Nolan gallery at Lanyon. Other benefactors also donated paintings to the cause, and Nolan and his wife Mary put 360 works on long-term loan with the gal-lery. In 2007, however, the Nolan Gallery was closed due to very high humidity levels and temperature fluctuations in the gallery spaces, which had not improved despite much work. The fed-eral government had entrusted the ACT government with the collection, which it duly moved to the Canberra Museum and Gallery. Mary Nolan was outraged, not least because nobody had bothered to tell her. She asked for the 219 loaned works (141 had been converted to gift) to be sent back to her in the United Kingdom. Talking via email about the closure of Lanyon, she says she is 'utterly devastated on Sidney's behalf to know what they did to him', adding that 'this is unlikely to encourage gifts to the Australian government by major artists in the future'. She refers back to the original gift:

> Gough Whitlam, when he was prime minister, agreed with Sidney that if he gave an important collection to Australia he would see to it that Sidney's choice of location at Lanyon would be made available to house the Sidney Nolan Gallery. Malcolm Fraser continued this agreement and a gallery was built on the property. Sidney was delighted and at the opening promised

to gift further works each year—a promise that he honoured with donations of major paintings.

A spokesperson for the Canberra Museum points out that attendances at Lanyon had averaged only 6000 to 7000 a year. A new purpose-built Nolan gallery within the Canberra Museum, which opened in August 2010, will likely draw a bigger audience.

Low visitation and attendant financial concerns beset many museums devoted to the memory of one artist. The family of landscape painter Hans Heysen opened his picturesque home and studio in the Adelaide Hills, The Cedars, to the public in 1994. Its operations are funded by revenue from shop sales and tours, but the family ends up tipping in its own money each year. They would like some government assistance but are wary of the loss of control this would necessarily entail. In 2006 The Cedars' long-time curator, Allan Campbell, warned that it might be forced to close if it didn't get some government assistance. At that stage attendances were about 11 000 a year; Campbell felt they needed to grow to 20 000 to be sustainable.[3] The Cedars is still going, without government help, and with about the same number of visitors as before. Sometimes it's the little things that are infuriatingly difficult to organise says Chris Heysen, a grandson of Hans Heysen. Like signage. 'That might seem tiny but it's actually a terribly important matter,' Chris says. 'There's a lovely freeway bypassing Hahndorf. We're not allowed to put a sign on it but the Melba's chocolate factory has one. Everyone we talk to about it is going to look into it, but it never happens. Many visitors complain about it, but we're more worried about the ones who don't visit.' The family is in the process of moving ownership of The Cedars into a trust, which would be able to

accept tax-deductible donations. They would like help from the state government and private donors, but know it is a difficult ask. Like the Brett Whiteley Foundation, they think a fund of about $10 million would be ideal, with the interest to be spent on running costs. Not that that's a certainty. 'I've seen so many good intentions dissipate over time. There have been very, very few successful artist residences that have been kept,' says Chris Heysen. 'Even in the hands of a trust or the government, the future is not certain. It always depends on the people in power at the time.'

When Margaret Olley died in 2011 there was the knee-jerk call for her Paddington home to be turned into a museum. Her long-time friend, dealer and co-executor Philip Bacon astutely knocked the idea on the head, choosing instead to give $1 million from the estate for the re-creation of three rooms from Olley's home in the Tweed River Art Gallery. That $4 million extension will open early in 2014. National Museum of Australia director Andrew Sayers believes there are very few artist studio museums worldwide that truly work. 'And that's because there's something rather sad about a studio without the artist in it,' he says. 'You have to deal with all these preservation issues, taking stuff out of the light to stop it fading and so on, and then you destroy the ambience. So it's tricky to get right.'

One place that went through its own financial problems in the late 1990s, and before that a protracted fight just to get anyone to accept it, is Bundanon, the Boyd property on the banks of the Shoalhaven River just inland from Nowra.

It was back in 1979 that Arthur and Yvonne Boyd bought Bundanon. They spent more than a decade trying to convince various state and federal governments to accept their planned

gift of the property to the nation. They bought other parcels of land along the river before and after this, some purchased in the hope that if the gift were bigger a government minister would eventually have to say yes.[4] When asked by a journalist what exactly he wanted to give away, Yvonne recalls Boyd saying with a sweep of his hand 'everything, everything'. Finally, at the urging of federal arts minister Clyde Holding, the Keating government accepted the gift, announcing its intention to do so at the 1993 memorial service for Nolan. The gift included two associated properties, the total spanning 1100 hectares, and more than 2000 artworks by five generations of Boyds. It came on top of the 1975 gift of more than 3500 artworks to the NGA.

It is all now managed by the Bundanon Trust, which, with an annual budget of $2.6 million, $1.6 million of which comes from the federal government, runs education programs, concerts and touring exhibitions from its 3800-piece collection. The gift, valued at $8.7 million at the time of the donation, is now on the Bundanon Trust's books at $36.8 million.

Boyd's fellow artist and friend Leonard French said that Boyd 'might just have been the greatest operator of all'.[5] If he is right, then one of Boyd's masterstrokes was deciding—in conjunction with Yvonne—to give Bundanon away. By doing that, and ensuring that the government took its reciprocal obligations seriously, Boyd bought the woman who supported him throughout his life the ultimate gift: freedom from being the artist's widow in anything other than fact. The deed of gift gives Yvonne and her children the right to stay and work on the estate for fifty years, but they tend to visit only every few years. Daughter Polly stepped down in late 2011 from the Bundanon Trust board,

but had not attended meetings for the previous two years. It seems a gift in the truest sense, a place that the family has well and truly let go of. 'I couldn't have done it, and that was partly why we wanted to pass it onto the public, to be in somebody else's hands, somebody sympathetic to the art thing,' Yvonne says. 'The idea of leaving it to our children would have been a mixed blessing because, you know, there are three of them, with families of their own. How would they work it? It would be used as a holiday house or something like that, and we thought to make it more useful than that.' That Yvonne does not seem to carry this burden is also a testament to her own personality. She did not get involved when the Bundanon Trust got into financial difficulty in the wake of opening a new education centre. She is not active in Bundanon, and rarely visits. The trust handles most requests for copyright clearance and other matters, contacting Yvonne only if it's absolutely necessary.

And it means that Yvonne Boyd really *is* free. Free of the need to promote Arthur Boyd; free of the trappings of wealth; free of the necessity to sell paintings, deal with copyright requests, or raise the alarm on fakes. Whatever combination of responsibilities and privileges weigh on the shoulders of other artists' widows, they don't, it seems, sit on those of Yvonne, now in her early nineties with silver hair, blue eyes, a slight build and a warm smile.

Boyd did not die young—he was seventy-eight when he died, in April 1999—nor was his career cut short. He was the most famous member of Australia's most celebrated artistic dynasty, enjoying a wealth and esteem that few artists and their families ever know. When it comes to reputation, Boyd's neither needs pumping up, nor is it in danger of slipping away.

Other widows have used their copyright powers to influence the publication of books by authors they did not think worthy of the task, or whose content they did not agree with. Yvonne, by contrast, gave Darleen Bungey the nod to write a biography of her late husband despite the author having never met him. Bungey was not an art historian, nor was she terribly immersed in the art world. She had enrolled in a course on life writing in London, but in the often closed and cliquey Australian art scene there are many for whom anything less than academic fine art credentials would have been insufficient. Not so Yvonne. Her willingness to let in an outsider paid off. Bungey spent nearly seven years on the project, and her resulting 630-page book, *Arthur Boyd: A Life*, won much praise and Biography of the Year at the 2008 Australian Book Industry Awards. Nor does Yvonne seem fussed about the content of Bungey's book, which details Yvonne's affair with Tim Burstall and Arthur's with Jean Langley; Yvonne's depression after the birth of the couple's third child; and Arthur's heavy drinking towards the end of his life. Some wives might have tried to wash that kind of detail out of a biography of their late husband, but Yvonne was there, standing next to Bungey at the 2007 launch of the book. She is proof that not trying to control things can sometimes be the smarter approach. There were no shock headlines over the revelations in Bungey's book; to the contrary, they passed with relatively little comment.

Many of the other widows of top modernists—Mary Nolan, Lyn Williams and Barbara Tucker—were cautious about participating in this book. There was little merit in them opening up about their lives; they were already well known, their husbands' reputations well established. The art world comes to them.

Yvonne stands in the same place, but was happy to talk. The walls of her home are covered with Boyd family pictures, but they are not all by Arthur. She runs through them, laughing at the fact that with a number of them she can't tell if they are by Arthur, his daughter Polly or his son Jamie (the art market would know the difference). To her they're memories, not saleable assets, and they hang alongside family photos and the odd yellowed, plasticised newspaper clipping.

Just as Yvonne doubts that the wives of artists contribute much to their husbands' work, she also questions whether what they do and don't do has much tangible effect on the reputation, apart from ensuring that they are held by big public institutions. 'It really does depend how well they were collected by museums or galleries,' she says. 'Private collectors can lose their enthusiasm or die off, and their heirs don't necessarily feel the same [about the paintings in their collections]. It has to be collected by a stable institution. Then it will last.'

This is, of course, what everyone says, and it is partly true. But the reality is far more complicated. So many factors feed into an artist's reputation, particularly when production is finished, the oeuvre finite. Wives, husbands, children, friends, collectors, curators and dealers all play their part. The art's the thing, but the humans who attach themselves to it are crucial. Their decisions can be driven by a complex web of factors, some of which they will not understand themselves. Having said that, the ultimate test of an artist's reputation will come when their court is gone—when the widow, the children, the friends and supporters are no longer around to promote, cajole, intimidate. Only then will it become clear whether an artist has stood the test of time. If they have, that's when mythology takes over.

Notes

Chapter 1: The Power of One

1 Advice once given to Professor Sasha Grishin, head of art history, Australian National University by a senior figure in the Australian art world. As relayed to the author in an interview with Grishin in Melbourne, 7 April 2011.

2 The royalty is applicable to the resale of works bought since the scheme took effect. That is, it only affects the sale of work bought after the scheme came in, and applies when that buyer resells that work. The primary market is the first sale of an artist's work, which typically occurs in a gallery or art centre that represents living artists. All subsequent sales of that work fall into the secondary market, whether through auction houses, galleries, dealers or consultants. The resale royalty applies to the secondary market.

3 Patrick McCaughey, *Fred Williams 1927–1982*, rev. edn, Murdoch Books Australia, Sydney, 2008 (1987), p. 362.

Chapter 2: Before the Widow Comes the Wife

1 Sydney art dealer Ray Hughes, quoted in Katrina Strickland, 'The Grand Salon of Ray Hughes', *Australian Financial Review*, 7 March 2009.

2 Catherine Hunter, *Mask and Memory*, screened on ABC Television in 2009 in conjunction with a retrospective on Nolan at the AGNSW.

3 Helen Brack, 'A Tribute to John', speech given at the NGA, Canberra, 16 February 1999, transcript NGA Research Library.

4 Barbara Blackman, *Glass After Glass: Autobiographical Reflections*, Viking, Melbourne, 1997, pp. 175, 181.

5 Blackman, p. 327.

6 Brenda Niall, *The Boyds*, Melbourne University Press, Melbourne, 2002, p. 334.

7 Darleen Bungey, *Arthur Boyd: A Life*, Allen & Unwin, Sydney, 2007, p. 331.

8 John Gregory, *Carnival in Suburbia*, Cambridge University Press, Melbourne, 2006, p. vii.

9 Ben Gascoigne, 'The Artist-in-Residence', in *From the Studio of Rosalie Gascoigne*, exhibition catalogue, Drill Hall Gallery, Australian National University, Canberra, 2000, p. 10.

10 Rosalie Gascoigne, quoted in Janet Hawley, 'A Late Developer', *Good Weekend*, 15 November 1997.

11 Hawley, 1997.

Chapter 3: The Crimson Line

1 Tess Edwards Baldessin, interview with the author, 12 May 2011.
2 All auction figures from the Australian Art Sales Digest, John Furphy Pty Ltd, Melbourne, www.aasd.com.au (viewed January 2013).
3 Peter Timms, 'Undeserving of Obscurity', *The Age*, 12 November 1997.
4 Sebastian Smee, 'Worth the Work', *The Australian*, 19 May 2007.
5 Harriet Edquist, *George Baldessin: Paradox and Persuasion*, Australian Galleries Publishing, Melbourne, 2009, p. 15.
6 Edquist, p. 225.
7 Barry Dickins, 'Preface', in *Black and Whiteley: Barry Dickins in Search of Brett*, Hardie Grant Books, Melbourne, 2002.
8 Brook Turner, 'Daughter Claims Lost Whiteley Will Leaves Bulk of Estate to Her', *Australian Financial Review*, 12 May 1993.
9 Larry Schwartz, 'Still Life', *Sunday Age*, 4 December 1994.
10 Barry Pearce, 'Persona and the Painter', in Barry Pearce, *Brett Whiteley: Art and Life*, exhibition catalogue, Thames & Hudson with AGNSW, Sydney, 1995, p. 15.
11 Kathie Sutherland, *Brett Whiteley: A Sensual Line 1957–67*, Macmillan Art Publishing, Melbourne, 2010.
12 This number includes prints, drawings, sculpture and ceramics, as well as paintings.
13 David Bentley, 'Whiteley's Last Love: Portrait of a Pigeon Among the Wolves', *Sunday Age*, 15 October 2000.
14 Janet Hawley, 'Still Life', *Good Weekend*, 2 July 1994.
15 Joanna Mendelssohn, 'Buying a Piece of Brett', *The Australian*, 16 September 1995.

Chapter 4: The F Word

1 Gabriella Coslovich, 'Whiteley Genius in the Flesh', *The Age*, 6 November 2010.
2 Matthew Drummond, 'Fraud Couple Gets Three Years', *The Australian Financial Review*, 10 November 2007.
3 Ben Gascoigne, 'The Artist-in-Residence', *From the Studio of Rosalie Gascoigne*, exhibition catalogue, Drill Hall Gallery, Australian National University, Canberra, 2000, p. 15.
4 Michiel Dolk, 'Are We Strangers in This Place?', in *Paddy Bedford*, exhibition catalogue, MCA, Sydney, 2006, p. 19.
5 Russell Storer, 'Paddy Bedford', in *Paddy Bedford*, p. 12.
6 Nicolas Rothwell, 'A Dream of a Studio', *The Australian*, 21 July 2007.
7 Katrina Strickland, 'Paddy Factor a $500,000 Ray of Light', *Australian Financial Review*, 26 February 2009.
8 Katrina Strickland, 'Grand Design Draws to a Close', *Australian Financial Review*, 29 April 2010.

Chapter 5: Boom Times

1 Peter Carey, *Theft: A Love Story*, Vintage Books, New York, 2007, p. 41.
2 Katrina Strickland, 'MONA's Old, New and Off the Wall', *The Australian Financial Review*, 8 January 2011.
3 Katrina Strickland, 'Sotheby's Raises Bar on Price', *The Australian Financial Review*, 12 April 2006.
4 Helen Brack, 'A Tribute to John', speech given at the NGA, 16 February 1999.
5 Katrina Strickland, 'Big Spending Sign of "Nutty" Art Market', *The Australian Financial Review*, 9 May 2007.
6 Australian Art Sales Digest, John Furphy Pty Ltd, Melbourne, www. aasd.com.au (viewed January 2013).
7 Barry Humphries, quoted in an article in *The Mercury* by Charles Miranda, 10 January 2009.
8 Australian Art Sales Digest.
9 Pamela Williams, 'ACCC Warns Menzies on Reports', *The Australian Financial Review*, 17 March 2010.
10 Australian Art Sales Digest.

Chapter 6: The Gold Standard

1 John Brack, eulogy for Fred Williams, 23 April 1982, as recounted in Patrick McCaughey, *Fred Williams 1927–1982*, rev. edn, Murdoch Books, Sydney, 2008 (1987), p. 347.
2 Pamela Williams, 'New Home For Williams' Work', *Business Review Weekly*, 31 May 1991.
3 Rebecca Lancashire, 'The Wife, the Painter and the Land', *The Age*, 9 December 2000.
4 John Monks, 'The Interpreter of the Odd Land', *The Australian*, 24 May 1976.
5 Australian Art Sales Digest, John Furphy Pty Ltd, Melbourne, www. aasd.com.au (viewed January 2013).
6 Australian Art Sales Digest. This price was paid for the 1965–67 painting *Landscape with Water Ponds*, sold at Deutscher-Menzies in Sydney in September 2007.
7 Sasha Grishin, 'Fresher Eyes View Dobell', *The Canberra Times*, 11 April 1997.
8 Elizabeth Donaldson, *William Dobell: An Artist's Life*, Exisle Publishing, Wollombi, NSW, 2011, p. 153.
9 Shireen Huda, *Pedigree or Panache: A History of the Art Auction in Australia*, ANU E Press, Canberra, 2008, p. 63.
10 Donaldson, p. 145.
11 Huda, p. 104.
12 Huda, p. 159.

Chapter 7: Contemporary by Nature

1 Chris Deutscher, co-owner of Deutscher and Hackett auction house, interview with the author, 24 June 2011.
2 Patrick McCaughey, 'Native Grounds and Foreign Fields', *Australian Book Review*, June 2011, p. 11.
3 Deborah Edwards, *Robert Klippel*, exhibition catalogue, AGNSW, Sydney, 2002.

Chapter 8: Copyright Wars

1 Alison Burton, interview with the author, 8 April 2011.
2 Ashley Crawford, 'Treasures Lost and Found', *The Age*, 11 November 2006; and 'Arkley Will Concerns Sour Art Tour', *7.30 Report*, ABC Television, Melbourne, broadcast 3 January 2007.
3 Alison Burton made the comments contained in this chapter in an interview conducted in April 2011, before Lewis's death.
4 Arkley Works, 2007, www.arkleyworks.com (viewed January 2013).
5 Susan McCulloch-Uehlin, 'Art Widow Demurs', *The Australian*, 21 September 2001.
6 McCulloch-Uehlin.
7 Gabriella Coslovich, 'Art Gift in Doubt as Author Stays Put', *The Age*, 13 December 2001.
8 Sasha Grishin, 'Controversy Surrounds Artist Who Knew How to Shock', *Canberra Times*, 23 February 2002.
9 Janet Hawley, 'Possession', *Good Weekend*, 19 February 2005.

Chapter 9: Immortality

1 Rex Butler, associate professor of art history, University of Queensland, interview with the author, 8 July 2011.
2 Gabriella Coslovich, 'NGV Estranged Curator Resigns for Secret Sum', *The Age*, 4 October 2006.
3 Louise Nunn, 'Heysen Studio Under Threat of Closure', *The Advertiser*, 20 September 2006.
4 Brenda Niall, *The Boyds*, Melbourne University Press, Melbourne, 2002.
5 Leonard French, quoted in Darleen Bungey, *Arthur Boyd: A Life*, Allen & Unwin, Sydney, 2007, p. 519. Bungey writes that French said this in the 1950s at the Swanston Family Hotel.

Select Bibliography

Anderson, Patricia, *Elwyn Lynn's Art World*, Pandora Press, Sydney, 2001.

Blackman, Barbara, *Glass After Glass: Autobiographical Reflections*, Viking, Melbourne, 1997.

Brett Whiteley Studio Handbook, AGNSW, Sydney, 2007.

Bungey, Darleen, *Arthur Boyd: A Life*, Allen & Unwin, Sydney, 2007.

Burke, Janine, *Australian Gothic: A Life of Albert Tucker*, Random House Australia, Sydney, 2002.

——*The Heart Garden*, Random House Australia, Sydney, 2004.

Carey, Peter, *Theft: A Love Story*, Vintage Books, New York, 2007.

Coppel, Stephen, *Out of Australia*, exhibition catalogue, British Museum Press, London, 2011.

Crawford, Ashley & Ray Edgar, *Spray: The Work of Howard Arkley*, rev. edn, Craftsman House, Sydney, 2001.

Dickins, Barry, *Black and Whiteley: Barry Dickins in Search of Brett*, Hardie Grant Books, Melbourne, 2002.

Donaldson, Elizabeth, *William Dobell: An Artist's Life*, Exisle Publishing, Wollombi, NSW, 2011.

Edquist, Harriet, *George Baldessin: Paradox and Persuasion*, Australian Galleries Publishing, Melbourne, 2009.

Edwards, Deborah, *Robert Klippel*, exhibition catalogue, AGNSW, Sydney, 2002.

Featherstone, Don, *Difficult Pleasure: A Portrait of Brett Whiteley*, documentary, Featherstone Productions, Sydney, 1989.

From the Studio of Rosalie Gascoigne, exhibition catalogue, Drill Hall Gallery, Australian National University, Canberra, 2000.

Gellatly, Kelly, *Rosalie Gascoigne*, exhibition catalogue, NGV, Melbourne, 2008.

Grant, Kirsty, *John Brack*, exhibition catalogue, NGV, Melbourne, 2009.

Gregory, John, *Carnival in Suburbia: The Art of Howard Arkley*, Cambridge University Press, Melbourne, 2006.

Harding, Lesley & Kendrah Morgan, *Sunday's Kitchen*, Melbourne University Publishing, Melbourne, 2010.

Hart, Deborah, *Fred Williams: Infinite Horizons*, exhibition catalogue, NGA, Canberra, 2011.

Huda, Shireen, *Pedigree and Panache: A History of the Art Auction in Australia*, ANU E Press, Canberra, 2008.

Hunter, Catherine, *Mask and Memory*, documentary, 2009.

McCaughey, Patrick, *Bert and Ned*, Melbourne University Publishing, Melbourne, 2006.

——*Fred Williams 1927–1982*, rev. edn, Murdoch Books Australia, Sydney, 2008 (1987).

Niall, Brenda, *The Boyds*, Melbourne University Press, Melbourne, 2002.

Paddy Bedford, exhibition catalogue, MCA, Sydney, 2007.

Pearce, Barry, *Brett Whiteley: Art and Life*, exhibition catalogue, Thames & Hudson with AGNSW, Sydney, 1995.

Preston, Edwina, *Howard Arkley: Not Just a Suburban Boy*, Duffy & Snellgrove, Sydney, 2002.

Pugh, Judith, *Unstill Life*, Allen & Unwin, Sydney, 2008.

Sutherland, Kathie, *Brett Whiteley: A Sensual Line 1957–67*, Macmillan Publishers Australia, Melbourne, 2010.

Zdanowicz, Irena & Stephen Coppel, *Fred Williams: An Australian Vision*, exhibition catalogue, British Museum Press, London, 2003.

Cast of Characters

The Main Players

Howard Arkley and Alison Burton
Howard Arkley was a Melbourne artist who was born 1951 and died in 1999, aged forty-eight. He is best known for his colourful air-brush paintings of Australian suburbia. He had an eleven-year relationship with Alison, also an artist, whom he married a week before his death.

George and Tess Baldessin
George Baldessin was a Melbourne artist who was born in 1939 and died in 1978, aged thirty-nine. He married Tess in 1971, and the couple had two children. Baldessin is best known for his printmaking—mostly in black, white and silver—and sculpture, including the giant steel pears out the front of the NGA.

Paddy Bedford
Paddy Bedford, a Gija man, was an artist from Warmun in the Kimberley, in Western Australia. He was born c. 1922 and died in 2007 in his mid eighties. Bedford is best known for his minimalist abstract paintings in a palette of black, white, grey and pale pink. His estate is being managed by lawyer Peter Seidel and linguist Frances Kofod.

Arthur and Yvonne Boyd
Arthur Boyd was a Melbourne artist and the best-known member of the Boyd artistic dynasty. He was born in 1920 and died in 1999, aged seventy-eight. He married Yvonne in 1945, and the couple had three children. The Australian Government announced in 1993 that the Boyds were gifting their New South Wales property, Bundanon, to the public. Valued at the time at $20 million, the gift included artworks and an adjoining property, co-owned with Sidney and Mary Nolan. The Bundanon Trust now runs artist-in-residence and education programs, concerts and touring exhibitions.

John and Helen Brack

John Brack was a Melbourne artist who was born in 1920 and died in 1999, aged seventy-eight. He is best known for his paintings of Melbourne in the 1950s and later paintings featuring pencils and wooden dolls. He married Helen in 1948, and the couple had four daughters. Helen is an artist who practises under her maiden name, Helen Maudsley.

William Dobell

William Dobell was a Sydney painter who was born in Newcastle in 1899 and died in Wangi Wangi in 1970, aged sixty-nine. He is best known for his portraits of society figures of his day. Dobell's estate went into the Sir William Dobell Art Foundation for the benefit and promotion of art in New South Wales.

Rosalie and Ben Gascoigne

Rosalie Gascoigne was born in New Zealand in 1917 and died in 1999, aged eighty-two. She lived in Australia from 1943, on Mount Stromlo in the Australian Capital Territory and in Canberra, with her astronomer husband Ben, with whom she had three children. She is best known for her assemblages made from old soft-drink crates, retro-reflective signs and other found materials.

Hans Heysen

Hans Heysen was an Adelaide painter who was born in Germany in 1877 and died in 1968, aged ninety. He is best known for his Australian landscapes, including gum trees. His family has turned his property, The Cedars, in the Adelaide Hills, into a privately owned and run public museum. Heysen's grandson Chris owns copyright in his work; another grandson, Peter, manages other estate issues in conjunction with the manager of The Cedars, Alan Campbell.

Roger and Michel Kemp

Roger Kemp was a Melbourne artist who was born in 1908 and died in 1987, aged seventy-nine. He is best known for his abstract paintings. Kemp married Merle in 1943 and the couple had four children, including Michel, who manages her father's estate.

Robert and Andrew Klippel

Robert Klippel was a Sydney sculptor who was born in 1920 and died in 2001, aged eighty-one. He is best known for his sculptures, made from wooden and metal machine parts. His partner for his last twenty-eight years was fellow artist Rosemary Madigan. Andrew is his only child, by former wife Cynthia, and it is he who handles Klippel's estate.

Sidney and Mary Nolan

Sidney Nolan was a Melbourne artist who was born in 1917 and died in 1992, aged seventy-five. He is best known for his *Ned Kelly* series. Nolan was married three times, the last in 1978 to Mary, sister of Arthur Boyd and former wife of John Perceval. Sidney Nolan has an adopted daughter, Jinx Nolan, to second wife Cynthia. The Sidney Nolan Trust in the United Kingdom runs art and music programs.

Bronwyn Oliver and Huon Hooke

Bronwyn Oliver was a Sydney sculptor who was born in 1959 and died in 2006, aged forty-seven. She is best known for her copper sculptures, which reference items from nature, such as seeds and nuts. Oliver was in a de facto relationship for twenty-two years with Huon, a wine writer.

Arthur and Oliver Streeton

Arthur Streeton was a Melbourne painter who was born in 1867 and died in 1943, aged seventy-six. He is best known for his depictions of rural landscapes and seascapes, including Sydney Harbour. His grandson Oliver Streeton researches his life and work, and is called upon to help with authenticity issues.

Albert and Barbara Tucker

Albert Tucker was a Melbourne artist who was born in 1914 and died in 1999, aged eighty-five. He is best known for his *Images of Modern Evil* series of the 1940s. In 1941 he married Joy Hester, and the couple had a son, Sweeney. In 1964 he married Barbara. The couple made a large gift of artworks and books to Melbourne's Heide Museum of Modern Art, announced in 2000 and valued at the time at $15 million.

Brett and Wendy Whiteley

Brett Whiteley was a Sydney artist who was born in 1939 and died in 1992, aged fifty-three. He is best known for depicting Sydney Harbour. He married Wendy in 1962, and the couple divorced in 1989. Their daughter, Arkie, was born in 1964 and died in 2001, aged thirty-seven, of adrenal cancer. The Brett Whiteley Studio was sold to the New South Wales Government in 1993, and opened to the public in 1995.

Fred and Lyn Williams

Fred Williams was a Melbourne artist who was born in 1927 and died in 1982, aged fifty-five. He is best known for his landscape paintings and extensive print oeuvre. He married Lyn in 1961, and the couple had three daughters.

The Supporting Cast

Philip Bacon—owner of Philip Bacon Galleries in Brisbane

Lauraine Diggins—owner of Lauraine Diggins Fine Art in Melbourne

Sasha Grishin—professor of art history at the Australian National University in Canberra

Rex Irwin—formerly of Rex Irwin Art Dealer, now co-partner of Olsen Irwin Gallery in Sydney

Frances Kofod—linguist based in Kununurra

Rudy Komon—influential Sydney art dealer, died 1982

Tom Lowenstein—accountant and founder of Lowenstein Arts Management in Melbourne

Patrick McCaughey—art historian, director of the NGV from 1981 to 1987

Rodney Menzies—owner of the auction house Menzies Art Brands

Jan Minchin—owner of Tolarno Galleries in Melbourne

James Mollison—director of the NGV from 1989 to 1995, acting director of the NGA from 1971 to 1977 and inaugural director until 1989

William Mora—owner of William Mora Galleries in Melbourne

Steven Nasteski—Sydney prestige car dealer and art collector

Roslyn Oxley—owner of Roslyn Oxley9 Gallery in Sydney

Barry Pearce—curator at the AGNSW from 1978, head of Australian art from 1998 to 2011

John Playfoot—Melbourne art dealer

Stuart Purves—owner of Australian Galleries, which has outlets in Sydney and Melbourne

Ron Radford—director of the NGA since 2005

Kalli Rolfe—owner of Kalli Rolfe Contemporary Art in Melbourne

Denis Savill—owner of Savill Galleries in Sydney

Peter Seidel—partner at law firm Arnold Bloch Leibler in Melbourne

Robyn Sloggett—director of the Centre for Cultural Materials Conservation at the University of Melbourne

Geoffrey Smith—a curator of Australian art at the NGV from 1997 to 2006, chairman of Sotheby's Australia since 2011

Ian Smith—corporate and political consultant, chairman of Jirrawun Arts

Jason Smith—curator of contemporary art at the NGV from 1997 to 2007, director of Heide Museum of Modern Art since 2008

David Walsh—founder of MONA in Hobart, which opened in 2011

Interviews

Julian Agnew, 3 June 2011, London
Philip Bacon, 20 May 2011, Brisbane
Tess Edwards Baldessin, 12 May 2011, Melbourne
Yvonne Boyd, 4 April 2011, Melbourne
Helen Brack, 16 October 2008 and 4 March 2011, Melbourne
Janine Burke, 10 October 2011, telephone
Alison Burton, 8 and 13 April 2011, Melbourne
Rex Butler, 8 July 2011, Brisbane
Chris Deutscher, 24 June 2011, Melbourne
Lauraine Diggins, 16 June and 11 October 2011, Melbourne
Elizabeth Donaldson, 22 July 2011, telephone
Rod Eastgate and Jillian Holst, 17 June 2011, Melbourne
Mark Fraser, 13 May 2011, Melbourne
Matthew Gale, 2 June 2011, London
Martin Gascoigne, 16 April 2011, Canberra
Alec George, 6 October 2011, Sydney
Peter Goulds, 24 August 2011, telephone
Sasha Grishin, 7 April 2011, Melbourne
Deborah Hart, 20 May 2011, telephone
Chris Heysen, 27 July 2011, Melbourne
Huon Hooke, 27 March 2011, Sydney
Ian Howard, 13 October 2011, telephone
Rex Irwin, 1 March 2012, Sydney
Kevin Kelly, 25 October 2011, telephone
Michel Kemp, 27 July 2011, Melbourne
Andrew Klippel, 21 June 2012, Sydney
Beverley Knight, 4 November 2011, telephone
Frances Lindsay, 24 June 2011, Melbourne
Robert Lindsay, 26 August 2011, telephone
Tom Lowenstein, 13 May 2011, Melbourne

Victoria Lynn, 27 October 2011, telephone
Patrick McCaughey, 21 June 2011, Melbourne
John Meacock, 28 June 2012, Sydney
Jan Minchin, 23 June 2011, Melbourne
William Mora, 22 June 2011, Melbourne
William Neill, 2 August 2011, telephone
Jo Onus, 14 May 2011, Melbourne
Roslyn Oxley, 19 April 2011, Sydney
Maudie Palmer, 1 September 2011, telephone
Barry Pearce, 22 December 2011, Sydney
Stuart Purves, 10 May 2011, Melbourne
Ron Radford, 12 August 2011, Canberra
Michael Reid, 26 October 2011, telephone
Kalli Rolfe, 10 May 2011, Melbourne
Denis Savill, 26 April 2011, Sydney
Andrew Sayers, 11 August 2011, Canberra
Peter Seidel, 24 June 2011, Melbourne
Robyn Sloggett, 10 May 2011, Melbourne
Geoffrey Smith, 20 May and 17 June 2011, Melbourne
Ian Smith, 26 October 2011, Sydney
Jason Smith, 6 April and 11 May 2011, Melbourne
Alida Stanley, 6 October 2011, Sydney
Russell Storer, 27 October 2011, telephone
Oliver Streeton, 28 July 2011, Melbourne
Paul Sumner, 27 May 2011, Hong Kong
Jennifer Thompson, 7 September 2011, telephone
Barbara Tucker, 16 October 2008, Melbourne
Wendy Whiteley, 28 October 2010 and 16 April 2012, Sydney
John Wicks, 11 October 2011, telephone
Lyn Williams, 26 November 2008 and 15 March 2012, Melbourne

Acknowledgements

So many people helped in the realisation of this book. My first and most important thank you is to the women and men who entrusted me with their stories. Thank you for your openness and honesty in exploring what was often difficult emotional terrain. Thanks also to every person interviewed for this book for your time, information and opinions, and in many cases for helping me formulate my ideas, and check facts, quotes, paragraphs and chapters. I acknowledge my debt to those who have written books about the particular artists mentioned in these pages, from which I learned a great deal.

Thank you to Elisa Berg, my first editor on this project, whose wise words about structure and tone remained with me throughout subsequent drafts; to Michelle Klinger for helping with some interview transcriptions; and to the readers of my initial manuscript, Ardyn Bernoth, Susan McCulloch and Sophie Ullin, who ploughed through it when the writing and structure were far from optimal. My heartfelt appreciation to Martin Browne, Miriam Cosic, Kate Dezarnaulds, Mark Fraser and Dalia Stanley for their incisive comments on the manuscript, and to Lauraine Diggins, Deborah Ely, Damian Hackett, Chris McAuliffe, Margo Neale, Barry Pearce, Stuart Purves,

Denis Savill and Robyn Sloggett for advice on specific parts of it. Doug Hall and Brook Turner deserve special mention, not only for providing detailed notes on the manuscript, but also for helping me through the psychological torture that was my first book. I am thankful to Glenn Burge and Paul Bailey for giving me time off to begin the project, and to Jeni Porter for her advice and understanding at the other end of the process.

To John and Miriam Strickland, thanks for the free food, board and use of a car during my many trips to Melbourne to research this book, and beyond that, for a lifetime of love and encouragement. I am ever thankful to chief executive Louise Adler for seeing a book in all of this, for so enthusiastically commissioning it and for waiting patiently for it to be completed, and to all who worked on it at Melbourne University Publishing. I am indebted to Paige Amor for editing the final manuscript so adroitly, to Cathy Smith for project managing it through to completion, and to the wonderful Sally Heath, whose job extended beyond editing to counselling, cajoling and, on occasion, cracking the whip. I could not have done it without you.

Last but by no means least, thanks to Hugh Lamberton, who is not only the best in-house editor, wise counsel and rock-solid supporter a girl could ask for, but is also, quite simply, the best.

Index